Dressed to Kill

BRITISH NAVAL UNIFORM, MASCULINITY
AND CONTEMPORARY FASHIONS,
1748–1857

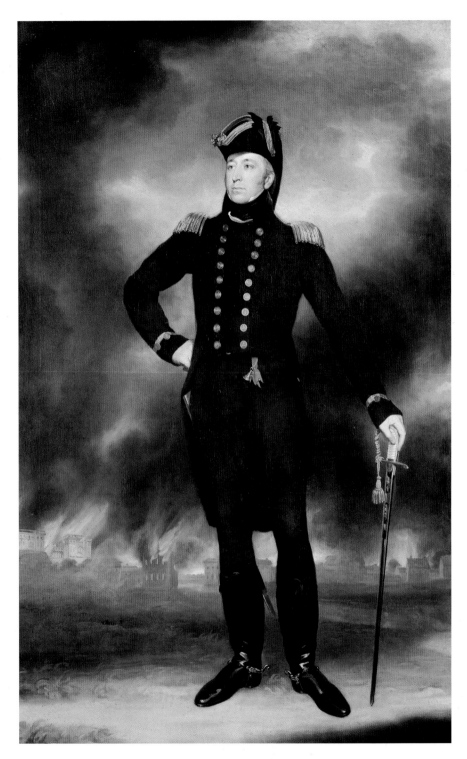

Rear-Admiral Sir George Cockburn, 1772–1853, John James Halls, c. 1817. **BHC2619.**
Cockburn is shown wearing rear-admiral's undress coat and hat, 1812–25 pattern, hessian boots and dark green breeches. In the background are the burning Capitol buildings in Washington.

Dressed to Kill

BRITISH NAVAL UNIFORM, MASCULINITY
AND CONTEMPORARY FASHIONS,
1748–1857

Amy Miller

THE AUTHOR

Amy Miller is Curator of Decorative Arts and Material Culture at the National Maritime Museum, London. She studied at the Bard Graduate Center for Studies in Decorative Arts, Design, and Culture in New York and has worked at various national institutions including the National Museum of Ireland and the Embroiderer's Guild based at Hampton Court Palace. She has written and lectured on uniform, fashion and masculinity.

ACKNOWLEDGEMENTS

I should like to thank my colleagues at the National Maritime Museum and the staff at Meyer & Mortimer, Savile Row, London.

AUTHOR'S NOTE

This catalogue seeks to show naval uniforms from a new perspective because it is important that the development of uniform be viewed alongside contemporary civilian fashions. The essays at the beginning not only examine the progression of regulations but also, more significantly, place the uniforms in their economic, social and historical contexts. They are followed by a catalogue of selected uniforms from the rich collection of the National Maritime Museum, which serve to reinforce the themes drawn out in the essays. The last section of line drawings of selected patterns provides an insight into the construction of the garments, particularly the way in which tailoring could both alter and accentuate body shape, in line with current fashions. The period 1748–1857 has been chosen because 1748 saw the official introduction of naval uniform for commissioned officers. However, it was not until 1857 that ratings, or sailors, were given a regulated uniform.

Contents

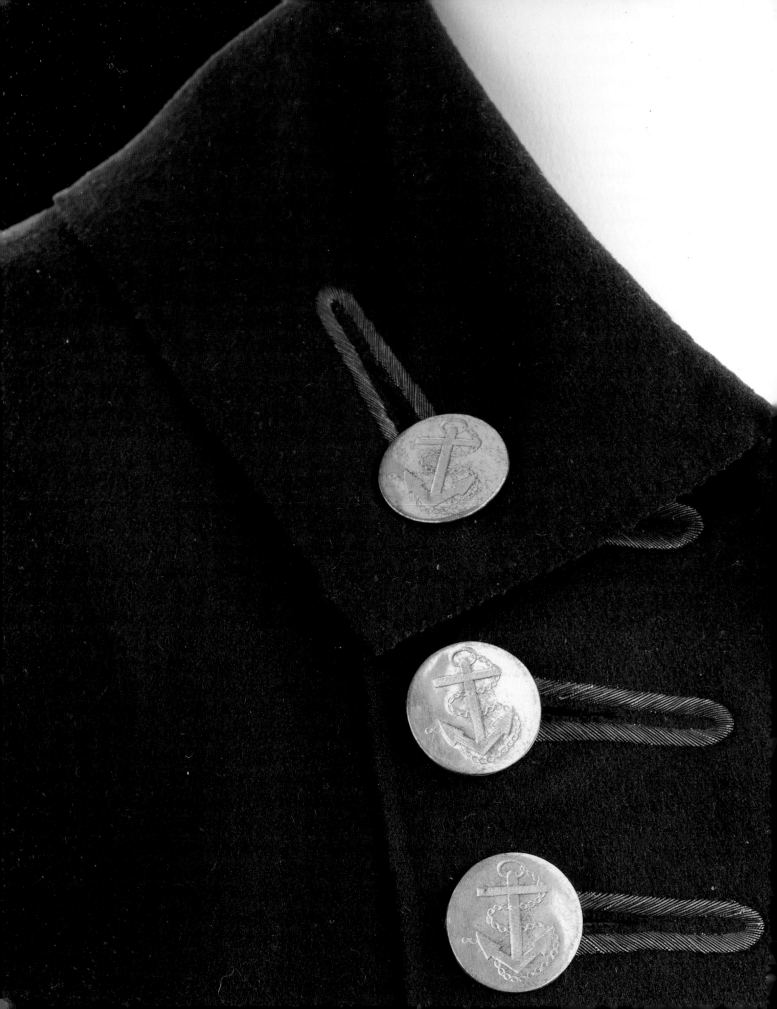

Introduction

Hail! Tars of England, brethren, hail!
Hail, lads of the *true blue*!
The tree may fall, the stream may fail,
But *never* COMRADES you!
Imperishable shall ye be,
Creatures of immortality!
Gentleman's Magazine of Fashions[1]

The uniform of the Royal Navy, the 'true blue' that was so firmly associated with it in 1828, when the passage above was written, was not by that time a tradition, certainly not one that stretched back to the days of England's victory over the Spanish Armada. Instead, it was only eighty years old. Regulated naval uniform had been worn only since 1748; before that the naval officer wore his own clothing, although there were certain occasions when royal livery was worn by specific officers. One of the earliest dates from 1604, when James I provided red and gold livery to six Principal Masters of the Navy.[2] Their rich clothing was detailed in a royal warrant, being made from 'two yards of fine red cloth … two yards of velvet … two dozen buttons of silke and golde'[3], the whole 'richlie imbrodered with Venice golde, silver, and silke, and with spangle of silver and silke'.[4] Clearly such clothing would have had limited use, being suitable only for court attendance and ceremonial functions. It is telling that, in 1676, the Masters Attendant, as they had become known, petitioned to be paid a cash allowance in lieu of livery.[5]

In comparison with other nations, the Royal Navy was quite slow in adopting a uniform. The French navy was granted theirs during the second half of the seventeenth century, although Sweden and Spain got theirs in the late eighteenth century. While military uniform was not a particularly innovative concept, what is interesting is that the desire for it within the navy emerges during a period when a brilliance and correctness in dress was perceived as exercising a civilizing influence. As Joseph Baretti pointed out in 1760, 'People well dressed have in general a kind of respect for themselves.'[6] As the navy had a chronic image problem during the course of the eighteenth century, when sailors were perceived as crude and coarse, it is likely that uniform was seen as one way of addressing this issue.

The aim of this catalogue is to explore the relationship between uniform and contemporary fashions, which in turn not only allows for a greater understanding of the navy itself, but also of the complicated social messages encoded in its clothing. An examination of the amendments to uniform in conjunction with period literature, pamphlets and tracts gives a sense of the changing public perceptions of the Royal Navy during the period 1748–1857 and the role that uniform played in visually reinforcing these views. Male dress, particularly something so heavily regulated as uniform, illustrates the shifting standards of masculinity and provides insight into what British society in the eighteenth and nineteenth centuries valued as the 'ideal man'.

1
Detail of the undress coat of a captain over three years' seniority, 1774. UNI0012 / F2210.1.
Rank was distinguished by the buttonholes outlined in silver, grouped in threes, and the buttons with their fouled anchor motif.

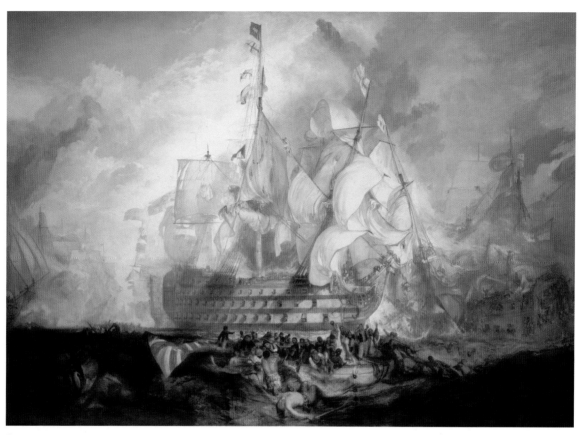

2

The Battle of Trafalgar, 21 October 1805, Joseph Mallord William Turner, 1822–24.
BHC0565 / BHC0565.

The uniforms introduced in 1748 developed in part out of a need to provide a clear visual definition of rank and status within the navy and to society at large. This stemmed from growing concerns – especially in Britain where society was more fluid – that the appearance of a higher social rank was easier to attain, as noted in a London paper in 1744: 'Every illiterate coxcomb who had made a fortune by sharpening or shop-keeping will endeavour to mimic the great ones.'[7] Definitions of class, particularly of the term 'gentleman' were rapidly changing in the second half of the eighteenth century. The concerns about social mobility were expressed in period literature and were apparent in the navy, where the subtleties of rank and status were not as clearly delineated through dress as some would prefer. The new uniform, worn only by commissioned officers and featuring a dress and undress coat, codified naval rank and status. The dress uniform, which took as its source French-influenced court clothing, implied that the wearer either moved in the company of those who frequented court or had occasion to be there himself. It not only served to reinforce the social rank of the commissioned officer but also created a clear social division within shipboard society.

As styles and tastes changed throughout the second half of the eighteenth century, the uniform changed with them, albeit at a slower pace. Both dress and undress – that is, normal working uniform – reflected some of the major fashion trends in eighteenth-century Britain, specifically the impact of the 'macaronies', young men lately returned form the Grand Tour of the Continent, who favoured very tight clothing in flamboyant colours. In the 1770s, the macaronies were marked not only by their effeminacy of dress and manners but by their links with

homosexual scandals which, by the time the navy adopted the cut and tailoring of the macaronies (cat. 12), seem to have been overlooked – if not completely forgotten. In addition, the trend toward informality in late-eighteenth-century fashions is seen in the undress styles of the 1795–1812 patterns (cat. 25). Yet, while naval uniform followed contemporary fashion throughout the eighteenth century, by the early decades of the nineteenth the two were on divergent courses as uniform regulations changed very little and retained the styles of the late eighteenth century. This old-fashioned costume, so out of step with contemporary fashion, immediately marked the wearer as a naval officer.

The identity of the British naval officer himself was something that had undergone a great deal of change in the course of the second half of the eighteenth century. In the middle decades, officers were largely seen as base, coarse and unrefined, but by the end of the century they were viewed as desirable masculine types. This change was due in part to the fact that, by the end of the eighteenth century, the navy had become the largest employer in Britain when its status was further reinforced through a series of important naval victories against the French, Dutch and Spanish which firmly established British supremacy of the seas. Trafalgar (see Figure 2), one of the last great naval battles of this period, ensured that the navy held an iconic status within British society. However, the newly desirable social status of the naval officer was also due to changing perceptions in ideals of manliness. Representations of the officer in the popular fiction of the early nineteenth century show him as both a moral and masculine antidote to the overly refined gentleman or macaroni-type of the eighteenth century.

In 1827, the Admiralty introduced a radical change in naval uniform, replacing an outmoded style with one that drew directly on contemporary fashions. The new uniform was only to be worn by commissioned officers; (cat. 43) warrant officers would continue to wear the old uniform, and ratings did not have a regulated uniform. While the causes behind the change are unclear or unknown due to a lack of documentary evidence, it is probable that one factor behind the change was linked to concerns about morality, as the old uniform, drawn from the clothing worn in the late eighteenth century, was by the 1820s associated with the dissipated, spend-thrift lifestyle of the Prince Regent, later George IV, whose attempted divorce in 1820 engendered a scandal that was at odds with the increasing entrenchment of evangelical ideals within mainstream society. The large number of public pamphlets and tracts produced in the 1820s on the subject of morality in the navy indicate that this was a growing concern. While a connection between morality and dress was one issue which may potentially have influenced the uniform changes of 1827, a more prosaic reason might have been that the navy was undergoing rapid technological change with the transition from sail to steam. Like the uniform of the 1780s, which drew on tailoring made popular by the macaronies, the new uniform featured the wasp-waist styles associated with the dandies of the 1820s and '30s. However, while the debt owed by naval tailoring to the macaronies may have been overlooked in the late eighteenth century, the relationship between the new uniform of 1827 to the clothing of the effeminate dandies did not go unnoticed and was the subject of caricatures questioning the masculinity of the naval officer (see Figure 3).

The uniform change of 1827 also occurred at the same time that the navy was being forced to redefine its role during the prolonged period of peace in the first half of the nineteenth century. Instead of being a predominately military force, there was an increased emphasis on polar exploration. The explorers came to provide an appropriate construct of masculinity for the navy and one that served as an antidote to the feared 'dandifying' effects of the new uniform. Amendments to the uniform in the 1840s which added to its expense generated criticism among the officers of the navy that were linked to the longer-running issues of pay and promotion. During this period, several changes were introduced to give the uniform a more splendid appearance. These changes included the addition of gold lace to the skirts of the dress coat as well as extending the epaulette to more junior ranks. However, the cost associated with these alterations was a concern not only to those within the Admiralty, such as Secretary George Gillott, but to officers who saw no promotion or increase in salary but were forced to buy a more expensive uniform.

In 1855, the Crimean War brought with it naval hopes for a return to military glory. This proved not to be the case, as both the army and the navy came under criticism. However, in the ensuing enquiries, the navy appeared better organized, supplied, and more humane than the army. Furthermore, the masculine type of the naval officer was now a fixture within Victorian society: he was seen as brave, humane and resourceful – a construct of an ideal

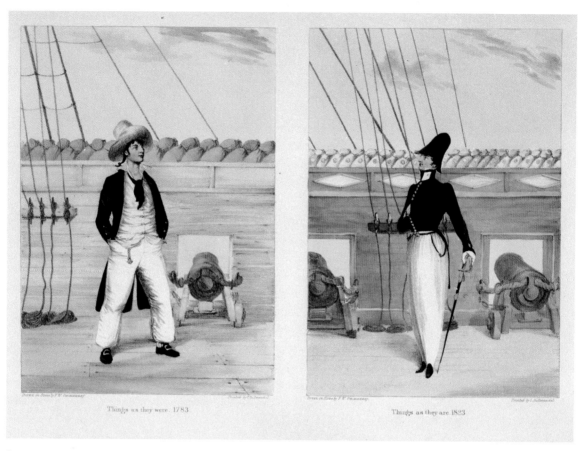

3
Detail *Things as they were. 1783* and *Things as they are. 1823*, Charles Joseph Hullmandel
(artist), F.W. Ommanney, 1823. PAF3721 / PW3721.
This detail illustrates the effeminised, dandy midshipman.

hero who was immediately recognized by the uniform he wore. At around the same time, in 1857, ratings were given a regulated uniform. Although the sailor had always been a familiar figure within society through his occupational dress, naval supply systems in place from the early eighteenth century had also ensured a certain uniformity in his appearance. The introduction of the uniform for ratings, which was based on that worn by sailors on the Royal Yacht, served to put all seamen in regulated clothing. While this in part reflected the increasing professionalism of the organization, it also meant that there was a clear codification of rank and status: the world of the ship mirroring the increasing stratification of mid-Victorian society. This brief overview of the social history of naval uniform reflects not only the way in which the image of the naval officer was conveyed through his appearance, but the relationships between contemporary fashion and uniform, and the mutual influence they exerted on each other. How this evolved in greater detail will be seen in what follows.

1 *Gentleman's Magazine of Fashions, Fancy Costumes, and the Regimentals of the Army,* vol. I, no. 4., 1 August 1828, p. 1.

2 Originally there were six Principal Masters who received a salary from the Royal Navy. However, in 1618, two were found to be also in the employment of the East India Company and were removed from their posts.

3 British Museum, MSS5752f19, quoted in Commander W. E. May, *The Uniform of Naval Officers,* NMM typescript, n.d., 3 vols., vol. 1, p. 2.

4 *Ibid.*

5 May, *The Uniform of Naval Officers,* p. 3.

6 J. Baretti, *A Journey from London to Genoa, through England, Portugal, Spain and France,* 2 vols. (London, 1770), vol. 1, p. 10 quoted in Aileen Ribeiro, *Dress in Eighteenth-century Europe, 1715–1789,* revised edition (London: Yale University Press, 2002), p. 6.

7 Ribeiro, *Dress in Eighteenth-century Europe,* p. 6.

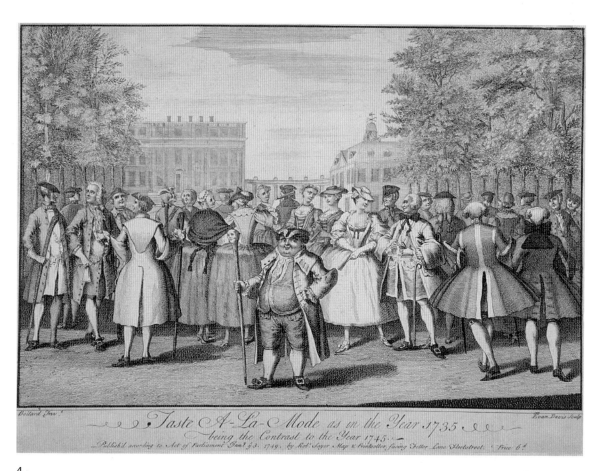

4

Taste a-la-mode, Boitard, 1749. Guildhall Library, Satirical Print Collection, Satires 1749, catalogue no. p5437782.

While this print illustrates the excesses of fashion, it also makes the point that, in gatherings such as this, dress was used as a means of displaying social mobility. The man on the far right wears an enormous bag wig and justacorps with exaggerated stiffened skirts, both evidence of the prevalence of French fashions.

CHAPTER I

The First Patterns

In the mid-eighteenth century, in one of his instructive letters to his son, Lord Chesterfield wrote, 'Dress is a very foolish thing, and yet it is a very foolish thing for a man not to be well dressed according to his rank and way of life.'[1] In this period, clothing, particularly fashionable dress, provided a visual construction of rank, status and social aspirations. It was in this last instance that clothing proved most useful: Giacomo Casanova, the son of an actress, recounts in his *Histoire ma Vie* (*History of My Life*) that when dressed as a gentleman he was able to move easily through the society of the European courts. His use of dress as a tool of social ambition was quite clear, as each new identity or profession he adopted brought with it a new suit of clothing, which he meticulously described. At one point he began a career in the military wearing a uniform of his own making; as he comments, 'I wore an [*sic*] uniform; it seemed to me that I was right in showing that sensitive and haughty pride which forms one of the characteristics of military men.'[2] The example of Casanova illustrates two points in the relationship between dress and perception in the eighteenth century: the use of costume achieved a type of social mobility, and specifically regulated clothing, like uniform, not only served as a visual representation of rank, but also of other, sometimes less palatable, aspects such as behaviour. The construction of appearance through dress (and more specifically dressing above social rank) was a great cause of anxiety in the mid-eighteenth century, for it meant that appearance was an increasingly unreliable means of ascertaining social standing. It was felt that this could threaten both the order and underpinnings of society (see Figure 4).

In Britain, within organizations like the Royal Navy, the use of dress to transcend rank was an equal concern. The clothing worn by sailors (excluding their working dress) and warrant officers was no different from that worn by commissioned officers – hence there was no strong visual delineation between the various ranks, with the exception of the very wealthy or very poor. A group of officers proposed the uniform to the Admiralty in 1746 in order to remedy the situation. Their petition reflected a number of anxieties; one of the chief issues was that the role and importance of naval officers within society should be acknowledged. To this end, the introduction of a uniform would clearly identify them as officers in the Royal Navy, assuring them the respect due to those in the service of the Crown, whose function was that of 'Guardians of the National Honour'.[3] Furthermore, the new uniform would serve not only to provide an *esprit de corps* among officers, but when abroad it would also mark them out immediately as British. In addition, it was also hoped that by refining their appearance, the popular perceptions of naval officers as both coarse and base might be allayed.

This chapter traces the evolution of British naval uniform from its introduction in 1748 through the eighteenth century, ending with the 1795 pattern which would last with few changes into the early decades of the nineteenth century. It examines the relationship between contemporary fashion and naval uniform as well as the changing perceptions of naval officers within British society, and the way in which their image was constructed – and to a certain extent refined – through uniform.

Before uniforms

The uniform introduced in 1748 was intended to be worn specifically by commissioned officers. Certain warrant officers and ratings already wore an occupational dress that readily identified them as sailors (see Figure 5). Its elements included chequered shirts, short coats, trousers or loose, full petticoat breeches and a hat described as having the 'sides uniformly tacked down to the crown … as if they carried a triangular apple pasty upon their heads'.[4] This clothing gave the sailor relative ease of movement and a degree of safety as well, as tail-less coats did not catch in rigging. An additional feature on the coat was a slashed sleeve with a button closure, which meant that the cuff could be unbuttoned and rolled back on the arm, thus keeping it relatively clean and dry. Ready-made clothing, or 'slops', could be purchased from the purser, and inventories of blue wool jackets and breeches, chequered shirts, wool waistcoats, Monmouth (knitted) caps and worsted stockings survive in Admiralty records.[5] These indicate not only the type of clothing available for purchase, but also the size of the average sailor, as ready-made clothing was issued for sizes 36, 38 and 40, which represented the average chest measurements (in inches) during this period.[6] The coats, breeches and waistcoats were of ticken, a strong, closely woven fabric that was usually twilled and often featured distinctive stripes (see Figure 6) or, more generally, the heavier kersey, which

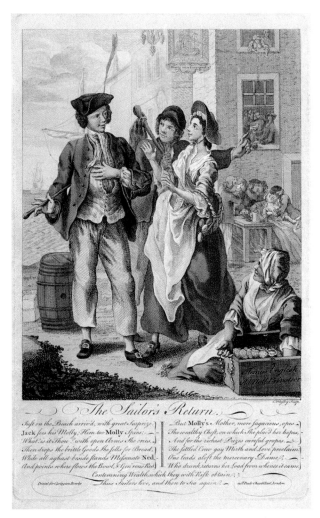

5
The Sailor's Return, Mosley, 1750. PAF3801 / PW3801.
Shows the occupational dress of sailors in the mid-eighteenth century, which is typified by the loose trousers and short tailless coat. His left arm shows the mariner's cuff, partially unbuttoned.

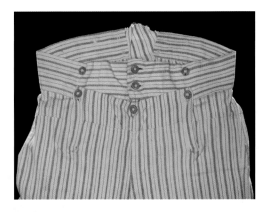

6
Ticken trousers, circa 1810. UNI0092 / F4886-001.
An example of the ready-made clothing worn by the sailor.

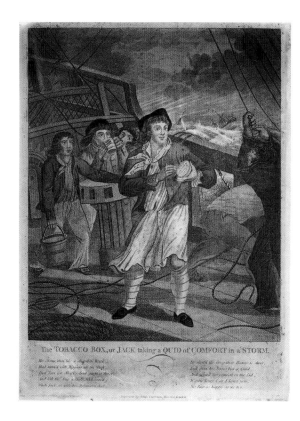

7

The Tobacco Box, John Fairburn (publisher). PAF3762 / PW3762.
An example of the 'uniform' appearance of sailors with short tailless
jackets, and trousers or petticoat breeches worn with chequered
shirts.

was a hard-wearing weatherproof wool cloth, particularly suitable for wet or windy weather. Kersey's virtues were extolled by Joseph Gay in his book-length poem, *The Petticoat* (1716), 'The garment best the Winter's Rage defends/Whose shapeless Form in ample Plaits depends.'[7] Much has been written on the quality of slops, often noting that they were substandard;[8] however, this does not in reality appear to be the case. Admiralty contracts for the supply of slop clothing could be quite lucrative, particularly during periods of conflict such as the American Revolutionary War (1775–83), when crew numbers increased.[9] Records from 1738 indicate that a type of quality control was practised which consisted of between three to five officers from the ships that were being supplied comparing bales of slops when they arrived on board. Notations were made as to their quality, and bales that were recorded as containing 'inferior and bad sew'd' frocks [*i.e.* a loose coat worn in the eighteenth century], moth-eaten caps, stockings that were too short and shoes with the leather dead, very much mildewed and many of them thin', were rejected by the committee and reported to the Navy Board.[10] The usual result of unfavourable reports was that the supplier's contract was revoked.

The supply of slops meant that there was among ratings a type of 'uniform' already in existence which was recognizably that of the sailor (see Figure 7). However, the clothing worn by the navy's officers was little different from that worn by civilians. Portraits of the 1740s reveal naval officers, such as Captain Richard Chadwick (see Figure 8) to be expensively dressed in a suit of pale silks with a fashionably deep boot-cuff and a bag wig in the French style. His coat, waistcoat and hat were trimmed with silver lace, which was notoriously difficult to keep free of tarnish; in fact, it could never really be cleaned satisfactorily but had to be removed and replaced, making it an expensive embellishment. It was specifically the brightness of lace that was a visual indicator of social status, as can be seen in popular literature, such as the 1754 novel *The History of Joshua Trueman*, in which the title character shares a prison cell with '… women of the town, that fluttered in ragged silks; and beaus, that glimmered in tarnished embroidery'. [11]

8

Captain Richard Chadwick, attributed to George Knapton, **1744. BHC2604 / BHC2604.**

Chadwick is fashionably dressed in pale silks, his waistcoat and hat are laced with silver. He wears the French bag wig. It should be noted that while he is wearing this clothing specifically for his portrait, he is clearly fashion conscious.

While the 'beaus' of *Joshua Trueman* were clearly delineated by the fact that their clothing was not of the first order, others were less easily detected. The use of dress to attain a type of social mobility was a repeated theme in popular literature: it features in novels such as Samuel Richardson's *Pamela* (1740), in which the title character, a maid, is made a gift of her late mistress's clothing, including 'a suite of my late lady's clothes, and a half dozen of her shifts, and six fine handkerchiefs, and three of her cambric aprons, and four holland ones'.[12] Demonstrating her awareness of the relationship between clothing and rank, Pamela adds that 'the clothes are of fine silk and too rich and too good for me to be sure'.[13] However, by wearing the accessories she still approximates the appearance of a lady and eventually marries into the family in which she once served. *Pamela* is one example in literature of this period where the character, who acts on her social aspirations by dressing above her station, is made to suffer – as does Pamela when her virtue comes under threat. Certainly, it is not merely one character, but an entire family that suffers in Oliver Goldsmith's 1766 novel *The Vicar of Wakefield*. In it, the vicar's wife, Deborah, and eldest daughter, Olivia, cherish social ambitions far above their station. These desires are manifest in their dress, as they appear one morning for church:

> … down came my wife and daughters, drest [*sic*] out in all their former splendour: their hair plaistered [*sic*] up with pomatum, their faces patched to taste, their trains bundled up into an heap behind, and rustling at every motion. I could not help smiling at their vanity, particularly that of my wife, from whom I expected more discretion. In this exigence, therefore, my only resource was to order my son, with an important air, to call our coach. The girls were amazed at the command; but I repeated it with more solemnity than before. 'Surely, my dear, you jest,' cried my wife, 'we can walk it perfectly well: we want no coach to carry us now.' 'You mistake,

child,' returned I, 'we do want a coach; for if we walk to church in this trim, the very children in the parish will hoot after us.' 'Indeed,' replied my wife, 'I always imagined that my Charles was fond of seeing his children neat and handsome about him.' 'You may be as neat as you please,' interrupted I, 'and I shall love you the better for it, but all this is not neatness, but frippery. These rufflings, and pinkings, and patchings, will only make us hated by all the wives of all our neighbours.'[14]

The family's pride and attempt to ally Olivia to their landlord, the devious Squire Thornhill, ends with Olivia's ill-judged attempt to elope with Thornhill and the vicar being imprisoned as a debtor.

It was not only attempts at a social rise that were documented through clothing, however, but the fall as well, as seen in the case of Tobias Smollett's villain Ferdinand Fathom, whose descent is minutely chronicled in the 1753 novel that shares his name:

> His watch, with an horizontal movement by Graham, which he had often mentioned, and shown as a very curious piece of workmanship, began, about this time, to be very much out of order, and was committed to the care of the mender, who was in no hurry to restore it. His tie-wig degenerated into a major; he sometimes appeared without a sword, and was even observed in public with a second day's shirt. At last, his clothes became rusty; and when he walked about the streets, his head turned round in a surprising manner, by an involuntary motion of his neck, which he had contracted by a habit of reconnoitring the ground, that he might avoid all dangerous or disagreeable encounters.[15]

The fact that clothing could be used to blur the lines between classes was such a concern that in 1734, the *Gentleman's Magazine* felt that sumptuary laws should be reinstated which would be instrumental in 'preserving the distinction and order so necessary to the different ranks of men'.[16] The pursuit of fine clothing – or at least the appearance it gave – was also a motivation for thieving among the poorer classes. In Daniel Defoe's *Moll Flanders* (1722), the eponymous heroine steals cloth and other small objects that might be sold to purchase fine clothing 'to set me off'.

9
Detail of Figure 4, *Taste a-la-mode*, Boitard, 1749. Guildhall Library, Satirical Print Collection, Satires 1749, catalogue no. p5437782.
While probably from the ranks of the upper classes, this man has adopted rural dress style, including the small hat and large, cudgel-like walking stick. Affectations in dress like this confused the idea of dress as a visual representation of rank and status.

Henry Fielding felt in *An Inquiry into the causes of the late increase in Robbers* (1751) that a fashionable boot-cuff, an example of which is seen in the portrait of Richard Chadwick, was 'particularly useful as a receptacle for stolen goods'.[17] Popular literature of the eighteenth century, specifically that of mid-century, make it clear that the use of clothing as a means to transcend one's social rank caused a great deal of uncertainty. This situation was further confused, as it was not merely a case of the lower classes attempting to dress above their station, but also that the upper classes adopted the clothing of the working classes, as Chesterfield points out: 'Some of our young fellows … go in brown frocks, leather breeches, great oaken cudgels in their hands, their hats uncocked and their hair unpowdered, and imitate grooms, stage-coachmen and country bumpkins'[18] (see Figure 9).

These concerns penetrated the Royal Navy as well, where rank was not only social, but professional. In terms of dress, it should follow that as the majority of ratings came from the working classes, while commissioned officers and certain warrant officers were drawn from the upper and middle classes, the divisions between ranks in the crew should be readily apparent. However, as practical clothing was needed at sea, officers were often rendered indistinguishable from their men on voyages.[19] In addition, records of both warrant officers' clothing and that of commissioned officers auctioned off at the mast on their deaths reveals that their non-occupational dress was not terribly dissimilar (see Figure 10). Two inventories, one belonging to Gunner James Bearcroft, the other to Alexander Ferguson, a midshipman, show that each man had clothing of similar quality: silver

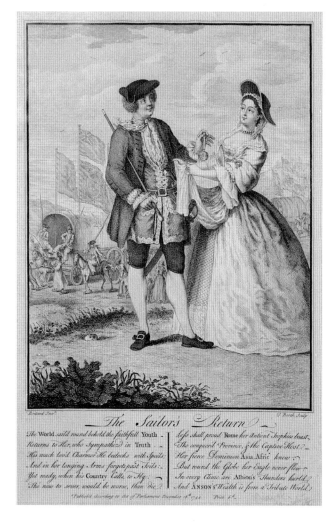

10
The Sailor's Return, Boitard, 1744. PAF3819 / PW3819.
Depicts a sailor made wealthy with prize money. While he still wears his short coat and 'apple-pasty hat' he shows the trappings of gentility with his laced waistcoat, sword and walking stick.

buckles, silk handkerchiefs, gold-laced coats and nankeen waistcoats are found in both.[20] If either were dressed in these clothes, there would be no clear differentiation between the 'young gentleman', as a midshipman was termed, and Bearcroft, who was a warrant officer. It is interesting to note that the main differences between the possessions of the two men lie in the fact that Ferguson had nothing that could be described as occupational clothing, whereas in addition to his finery, Bearcroft possessed chequered shirts, 'old stockings', and an 'old cloth coat'. Finally, Ferguson owned both a wig and a sword – an acknowledged mark of gentility – as well as pens, books, and papers: markers not only of refinement and education but indications that Ferguson was a commissioned officer in training (he would need to pass an examination to gain his promotion to lieutenant). However, what this underscores is the fact that the midshipman's situation was somewhat ambiguous. The gunner was traditionally in charge of the midshipmen, who messed in the gunroom; yet the midshipman would, most likely, have come from a higher social rank. He would easily have been classed as a gentleman, while the gunner would not.

With little initially to differentiate those in command from those who were subordinate, the introduction of a uniform to define rank became a pressing concern, and the first regulated naval uniforms came out of discussions held by a group of officers known as the 'Navy Club', who met regularly at Will's Coffee House in Scotland Yard. The decision was taken over two meetings in 1746, the first in February in Bedford Head Tavern in Southampton Street when '… a Motion was made: That a Uniform of Marine Dress might hereafter be worn by the Sea Commission Officers, meaning Captains and Lieutenants. Agreed by the whole Navy Club – That a Uniform is necessary …'[21] At the following meeting, at their regular venue of Will's, they arranged to take their proposal forward:

> That three or more of the Members wait on the Duke of Bedford and Admiralty Board with an Address drawn up by a Committee appointed for that purpose, acquainting them, that it is the opinion of thirty Captains who are in Town, and is believ'd the general sense of the Service, that an Uniform Dress is useful and necessary for the Commissioned Officers, agreeable to the practice of other Nations; and they desire their Lordships' opinion; and if they approve of it, that they will be pleased to introduce it to His Majesty.'[22]

This new uniform would distinguish commissioned officers and create an *esprit de corps* among them; it would differentiate the Royal Navy from any other force and it would create a strong visual identity for the naval officer in British society.

The new uniform

The proposal was accepted by the Admiralty, and a number of officers were invited to design their own uniform to wear at court for the King's approval. Correspondence survives from two officers asked to create their version of the naval uniform: Captain Philip Saumarez, who has been credited with the creation of the undress uniform,[23] and Captain (later Admiral) Augustus Keppel. Exchanged through a mutual acquaintance, Timothy Brett, these letters offer insights into the social factors that influenced the appearance of the new uniform. Brett wrote to Saumarez in August 1747, describing Keppel's design and commenting, 'I told Keppel of your uniform; I find it is going to be general. He is going to have one made up, which is to be gray faced with red, and laced in the manner you describe yours; this and two or three others are to appear at court for the King's approbation.'[24] Keppel sent a separate letter to Saumarez on the same date noting, 'Timothy Brett tells me you have made an uniform coat etc. of your own. My Lord Anson is desirous that many of us should make coats after our own taste, and then a choice of one be made to be general, and if you will appear in yours he says, he will be answerable *your* taste will not be among the worst.'[25]

The idea or concept of taste that Keppel references in his letter is one that first emerged in France during the mid-seventeenth century, and was quickly taken up in Britain[26] (see Figure 11). Initially, taste was a means to convey refinement and civility through dress, manners and possessions. It was not an expression of luxury, but

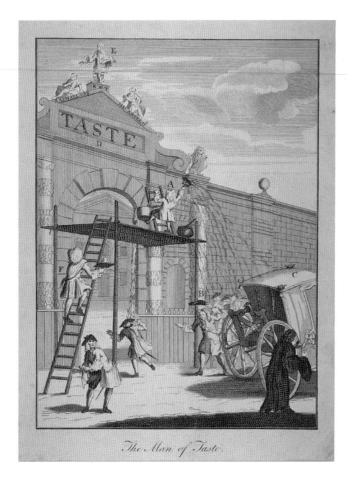

11
The Man of Taste, William Hogarth, 1731. Guildhall Library, Satirical Print Collection, Satires 1731, catalogue no. p5448366.
This print satirises the arbiters of taste in the first half of the eighteenth century. The architect and designer William Kent's statue stands at the top of Burlington Gate, and Pope is shown whitewashing the front of the gate on the scaffold. The idea of taste permeated many aspects of eighteenth century society and was a cause of great debate.

rather it was marked by restraint and refinement. It was also a means of social distinction, yet one that was not commensurate with rank; taste was innate, it could not be acquired and one did not have to be well-born to possess it, although it is worth noting that both Keppel and Saumarez came from upper-class backgrounds. This refinement, the period term being *honnêteté*, was advocated by Lord Chesterfield in the letters which he began in the latter part of the 1740s, roughly the same time as the Keppel/Saumarez correspondence. However, taste was something that could only flourish in an upper-class environment; while it may have been a means of social distinction, it was, like the uniform, a way of reinforcing social division.

The uniform introduced in Admiralty regulations in April 1748 consisted of two suits – dress and undress – both of blue wool with white facings and varying degrees of embellishment of either gold lace or metal thread embroidery according to rank. The official announcement of the new uniform quite clearly laid out the visual codification of rank and status:

> Whereas we judge it necessary, in order the better to distinguish the rank of sea officers, to establish a Military Uniform Cloathing [*sic*] for Admirals, Captains, Commanders and Lieutenants; and judging it necessary, that Persons acting as Midshipmen should likewise have a Uniform Cloathing in order to their carrying the Appearance which is necessary to distinguish their Class to be in the Rank of Gentlemen, and give them better Credit and Figure in executing the Commands of their Superior Officers; You are hereby required and directed to conform yourself to the said Establishment, by wearing Cloathing accordingly at all proper Times; and to

12
Detail, dress coat, lieutenant, pattern 1748-67.
UNI0003 / F2185-3.
The dress coat reflects fashionable dress with the contrasting deep white boot cuffs, embellished with three buttons and non-working buttonholes, which matches the white waistcoat.

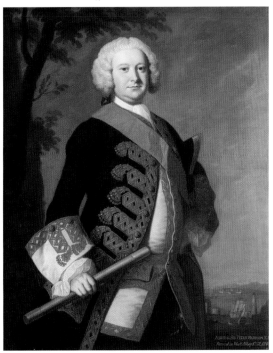

13
Admiral Sir Peter Warren, Thomas Hudson, 1748–52.
BHC3079 / BHC3079.
An example of the 1748–67 pattern worn by an Admiral. The waistcoat is laced, while the cuffs and front of the coat are both embroidered and laced.

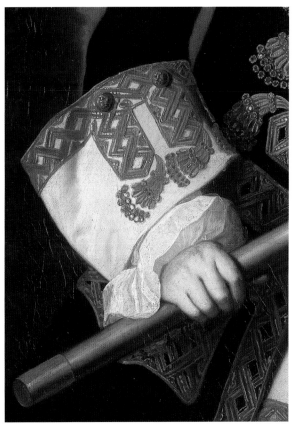

14
Detail of cuff, *Admiral Sir Peter Warren*, Thomas Hudson, 1748–52.
BHC3079 / BHC3079.
This detail gives an idea of the combination of embroidery and gold lace used to embellish the Admiral's dress uniform. The cuff features lace in a crossed pattern with embroidered floral motifs using gold metal thread with centres of gold spangles. The buttons, another indication of rank, are covered with gold lace in an interwoven pattern.

take Care, that such of the aforesaid Officers and Midshipmen, who may be from Time to Time under your Command do the like; and it is our farther Direction, that no Commissioned Officer, or Midshipman, do presume to wear any other Uniform than what properly belongs to his Rank …[27]

With this regulation, the Admiralty was not only clarifying the role of rank and dress, but was also attempting to end the practice of dressing outside one's station. Not only was uniform a means of regulating appearance, but the order also reinforces the assumption that social class corresponds to rank. This is particularly clear in the case of midshipmen who were given a uniform to 'distinguish their Class to be in the rank of Gentlemen' yet since they were, in theory, officers in training, they were only given a frock or undress uniform and not the dress uniform reserved for commissioned officers (cat. 7). It should be noted that, in the mid-eighteenth century, the terms 'dress' and 'undress' did not have the military association they do today, but referred specifically to the costume of the middle and upper classes: dress was formal or court attire, while undress was informal or day dress.

The uniforms of 1748 drew directly on contemporary fashion. The dress uniform featured a formal coat of wool (cat. 4), superfine if the wearer could afford it, but extant examples in the collection of the National Maritime Museum indicate that frise, a more hard-wearing wool, was favoured. The deep cuffs of the coat (see Figure 12) matched the waistcoat, a fashionable style at the time, and the uniform was completed with blue breeches (cat. 6). The dress coat for the rank of admiral (see Figure 13) was luxuriously embroidered with spangles and gold *file* (metal thread) on the front and cuffs (see Figure 14), while that worn by a captain and commander had gold lace in the 'mousquetier' pattern. The captain's undress featured the mariner's cuff as did that worn by the midshipman (see Figure 15). The lieutenant's dress was by the far the plainest, the dress uniform featuring a deep white boot-cuff while the undress was a simple blue frock. This lack of distinction prompted one lieutenant to comment that it was 'only a common Blue Frock (such as almost every Person wears) without any thing Military to distinguish it, and of consequence, creates not the least respect, either at home or abroad.'[28] (Cat. 5.) However, the dress uniform,

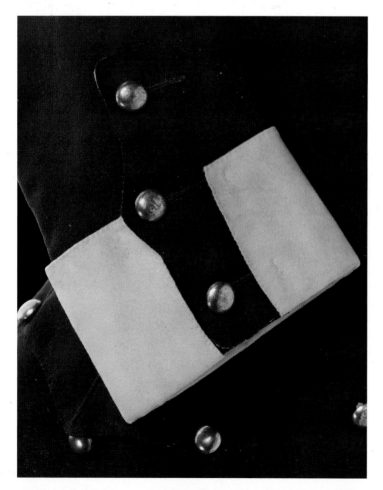

15
Detail, midshipman's frock, pattern 1748–67.
UNI0006 / F2206-4.
The midshipman's frock features a mariner's cuff which would cross over into fashionable dress.

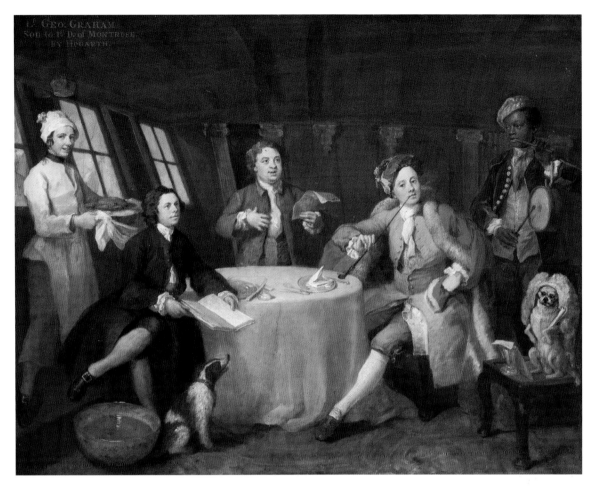

16
Captain Lord George Graham, 1715–47, in his Cabin, William Hogarth, circa 1745. BHC2720 / BHC2720.
The servant in the centre of the image wears a frock similar to the midshipman's uniform while to his left
Lord George Graham wears the fashionable brown/grey suit with contrasting, laced waistcoat.

with its use of hard-wearing wools and gold lace or embroidery, represents a hybrid of the excesses of high fashion paired with the practicality of working clothing.

The undress uniform and midshipman's coat are both versions of the frock. The midshipman's coat was single-breasted with a turn-down collar, while the officer's undress coat featured the button-back lapel unique to uniform. The frock was a garment specific to male costume in Britain in the eighteenth century (see Figure 16). It was originally worn by the working classes in the early decades of the century and gradually adopted as gentlemen's country dress. In its original incarnation, it was a relatively loose-fitting, double-breasted coat that could be buttoned across the chest for added warmth, which would also have been a desirable feature in clothing worn at sea. The frock gained in popularity both in Britain and abroad, becoming the definitive male garment of the eighteenth century. In the mid-1720s, Swiss visitor César de Saussure wrote that Englishmen wore 'little coats called frocks'[29] and in 1733 Charles Pöllnitz wrote that an Englishman 'rises late, puts on a Frock, and leaving his sword at home, takes his Cane and goes where he pleases'.[30] By 1753, the frock had become not only an indispensable element of the wardrobe, but emblematic as well, as the comments of an 'Englishman in Paris' in *Gray's Inn Journal* indicate:

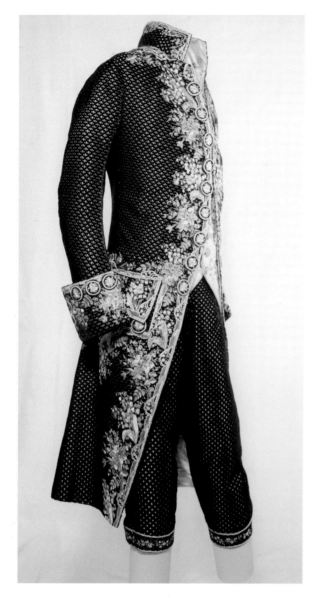

17
Court Dress, France, 1770–85. Platt Hall, no. 1952.359.
This heavily embroidered silk court suit is an example of the formal clothing worn in the second half of the eighteenth century. It features the coat in which an 'Englishman in Paris' felt 'deprived of my Liberty'.

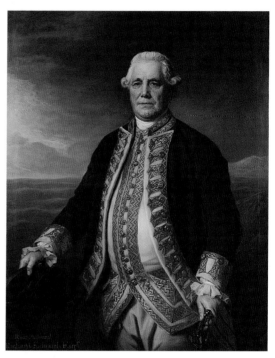

18
Admiral Richard Edwards, Nathaniel Dance, 1780.
BHC2679 / BHC2679.
Edwards wears the new dress uniform for flag officers, which features a frock which had been elaborately laced. In keeping with contemporary fashions, the sleeves, lapels and cuffs have narrowed.

In my full-dressed Coat, with hellish long Skirts, which I had never been used to, I thought myself as much deprived of my Liberty, as if I had been in the Bastille; and I frequently sighed for my little loose Frock, which I look upon as an Emblem of our happy Constitution; for it lays a Man under no uneasy Restraint, but leaves it in his Power to do as he pleases[31] (see Figure 17).

In 1767, the formal dress coat, which drew on French-influenced fashion, was abolished and replaced by a dress frock (see Figure 18). It is interesting to note that this particular garment, the frock, which had become representative of Britain itself, was that worn by her navy. There is a further maritime influence in that iconic garment, as a 1767 caricature 'An Englishman in Paris' features a stout bluff Englishman in a frock with mariner's cuffs (see Figure 19).

19
An Englishman at Paris, Henry Bunbury, 1767. The Lewis Walpole Library, Yale University.
This caricature features a short stout Englishman with his lapels buttoned across his chest and mariner's cuffs.

This pride in British dress had both a political and economic aspect to it. Popular publications of the eighteenth century, such as the *Gentleman's Magazine*, highlighted the perceived relationship between the consumption of French goods and financing conflicts such as the Jacobite Rebellion of 1745. One piece to appear in the *Gentleman's Magazine* noted:

> It is amazing to me, at a time when we are, or ought to be seriously engaged in a war with France; at a time when not only our immediate safety, but the liberties of Europe are also at stake, that we are giving the French all the encouragement we can, by consuming their commodities, affecting their dress, and speaking their language. O infatuation, astonishing infatuation! By the foppery of their dress, and the smoothness of their dialect, they have already corrupted all the courts of Europe, and laid the foundation of universal monarchy. [Should] we Britons, then, the only free remnant of the globe, hearken to their siren voice, and bewitching arts? No, heaven Keep us as we ought to be, Keep us honest, brave and free.[32]

Given the uneasy relationship between France and Britain throughout the 1740s–60s, with the Jacobite Rebellion and the conflicts of the Seven Years War, it is possible that when the dress uniform, which drew directly

on formal, French-influenced clothing worn at court, was temporarily abolished in 1767, it was done so in part to visually disassociate the navy from French styles. The frock was left as the sole uniform coat of the navy, and the formal coat was only briefly reinstated from 1783–87, after which two versions of the frock, dress and undress, were worn by the Royal Navy. However, if this were indeed the case, it is interesting to note that the French had no such qualms about adopting British dress, as the frock appears in F. A. de Garsault's *L'Art du Tailleur* (*The Art of the Tailor*, 1769) as 'a kind of light coat newly in fashion'.[33]

Since uniform was provided at the wearer's expense rather than by the navy, there were those who were understandably reluctant to pay the cost of two new suits of clothing, particularly one that was expensively embellished with gold lace. One approach was to retain a coat that all might use. After the uniform regulations were put into effect, the junior officers of one ship's company had 'but one uniform coat to be put on by any of the lieutenants, when sent on duty to other ships, or on shore'.[34] Others simply chose to ignore the regulations, as seen in one account of a visit to Portsmouth Dockyard in 1749 by a party headed by the First Lord of the Admiralty, Lord Sandwich. When the various ships' companies were reviewed, it was noted that all was in order, '... except the Gentlemen on the Quarter Deck not being dressed in the Uniform, many of whom had Blue trimmed with White, but almost everyone made in a Different Manner, and the Lords Observing themselves that some of the Officers when on Duty neglected to wear their proper cloathing [*sic*]'.[35] However, a disciplinary order was subsequently sent throughout the navy; seven days later, when the same visitors viewed the dockyard at Plymouth, they found everything in '... exceeding good order ... the Officers and Young Gentlemen in their proper uniform'.[36]

The cost of uniform varied in terms of what the wearer was prepared to pay. By the late 1770s, the accounts of John Borlase Warren[37] (see Figure 20) reveal that his uniforms were an extravagant expense. In April 1779, Warren spent a total of £5.7s on an undress uniform which included the non-regulation embellishment of a velvet lined collar for three shillings. Later that year, in July, he had a dress uniform made of superfine wool, for which he spent £22.14s.5d. The most expensive element of the coat by far was the 'rich gold lace for the suite' at £6.16s.6d, particularly when compared with the superfine wool for the coat, which was £2.4s.6d or the cost of labour, which

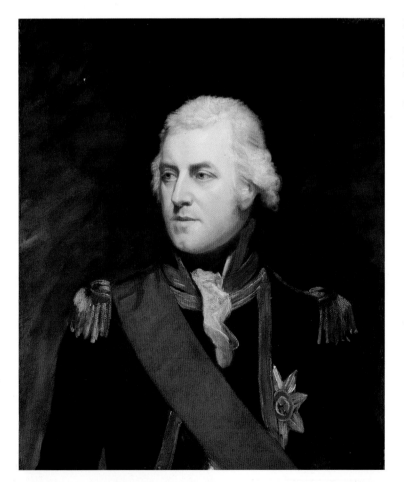

20

Captain John Borlase Warren (1753–1822), Captain Mark Oates, circa 1798. BHC3078 / BHC3078.

While this portrait shows Warren in the 1795–1812 pattern, he spent an exorbitant amount on his uniforms throughout the 1770s.

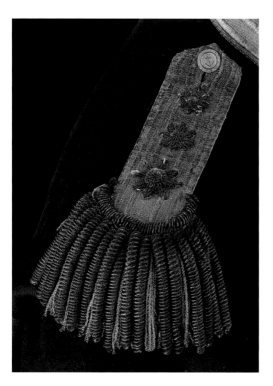

21
Epaulette, 1795–1812 pattern. UNI0034 / F2187.4.
Epaulettes were not introduced into regulations until
1795, although evidence indicates that many officers,
like John Borlase Warren, chose to wear them before
Admiralty regulations were issued. This epaulette was
worn by Admiral Sir William Cornwallis (1744–1819);
the three stars, made of spangles and wire, indicate
his rank.

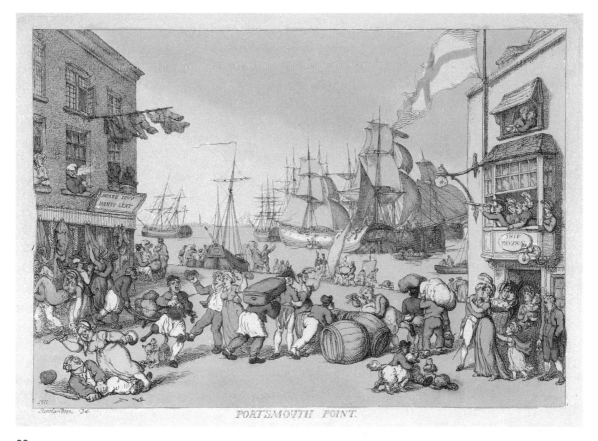

PORTSMOUTH POINT.

22
Portsmouth Point, Thomas Rowlandson, 1811. PAF3841 / PW3841.
Over 80 years after de Saussure commented on the behaviour of the navy
at Portsmouth, Rowlandson's print reveals the way in which the image of
the navy as being manned by uncouth characters had become entrenched
in popular culture.

was 15s. To give an idea of just how expensive this uniform was, Warren also paid for the livery, another type of uniform, for his footman and coachman at a cost of £4.1s.3d each. One way in which he could have financed his expensive new suits was through the sale of old clothing, as there was a thriving second-hand clothing trade. In 1775, he arranged to have his clothes sold in London for the sum of £39.18s.6d, which was immediately paid into his bank. Another means that officers could use to finance their uniforms was through prize money. Prize money was the net worth of a ship captured at sea, which was divided in unequal shares among the crew, the higher proportion going to commissioned officers and smaller amounts going to ratings. The potential profits to be made were a powerful incentive to join the navy. One of the richest prizes was the Spanish treasure ship *Hermione*, captured in 1762 by two British frigates. The two captains each received £65,000 while every seaman got £485. It should be noted that during the French Revolutionary and Napoleonic wars, Warren captured 220 enemy ships: a record number of prizes.

Epaulettes were another non-regulation addition to uniform which appear regularly in Warren's accounts of the 1770s. The epaulette was a mark of distinction that originated in France and quickly gained in popularity throughout Europe. They appeared in regimental dress in Britain in the eighteenth century, but were not introduced into naval uniform regulations until 1795 (see Figure 21). Yet Warren and other officers could not resist personalizing their uniforms with epaulettes, which were another added expense, as Warren paid £3.17s. for 'Rich Epaulettes'.[38] While some naval officers felt that this embellishment brought an added distinction to the uniform, others, like Horatio Nelson, could not refrain from condemning this adoption of a 'Frenchman's uniform'.[39] He wrote to his friend and mentor William Locker in 1783, 'Two noble Captains are here – Ball and Shepard, you do not know, I believe, either of them; they wear fine epaulettes, for which I think them great coxcombs: they have not visited me, and I shall not, be assured, court their acquaintance.'[40] However, in 1795, when the epaulette was included in regulations, Nelson wrote to his wife: 'I have just been ordering what I fancy are the proper epaulettes. However, I was obliged to take a young friend of mine, a soldier officer, or I might have made a bad choice. The navy lace for the strap very full, and long the bullions, so we shall all be bucks in old age.'[41] The adoption of the epaulette demonstrates the way in which British naval uniform was influenced by foreign military fashions. Finally, while regulated clothing was meant to end the use of dress as a means of attaining social mobility, officers still found ways of embellishing their uniforms to attain distinction, regardless of the displeasure voiced by the Admiralty as they flouted regulations.

The naval officer

The officers of the Royal Navy originally wanted a uniform to distinguish them by rank, but also to ensure that their status within society ashore might be made clear. They wanted a uniform that would serve to identify them instantly as officers in the King's service so that they might gain the respect appropriate to this role. Additionally, a dress uniform based on court clothing with expensive gold trimmings also provided a visual construct of refinement – a quality not often associated with officers or ratings, as de Saussure noted when he visited Portsmouth in 1729:

> Good Lord! what men! I found to my cost that the greater number were the most debauched, the most dissolute, and the most terrible swearers I had ever come across … Almost every day, or more properly every night, they got intoxicated, and would scour the streets, making a terrible row and breaking window-panes.[42]

This rough behaviour earned them the moniker 'sea monsters'[43] (see Figure 22). A uniform, particularly the full dress of a senior officer, instantly created a visual antidote, although their behaviour might fail to indicate gentility. It is this difference between appearance and behaviour that is a target in a 1757 edition of the Charles Shadwell play, *The Fair Quaker of Deal; or, the Humours of the Navy*, when his morally dubious character Mizen the 'Sea-Fop', a sexual predator declares: 'I am for a polite Navy – That is a Navy full of Sense and good Manners; a Navy of proper handsome well dressed Fellows; that when it appears abroad, may be the Wonder of the World, for Glittering shining Coats, powder'd Wiggs, Snuff-Boxes, and Fashionable Airs.'[44] What the uniform created in

the public eye were properly attired naval officers, dressed in the manner advocated by Chesterfield with a visual veneer of *honnêteté* that only disguised their roughness.

This image of the officer as base, coarse and largely unrefined became an accepted type within the popular culture of the eighteenth century. He can be seen in the rough and uncouth character of Captain Mirvan in the 1778 novel *Evelina* by Fanny Burney, who despises the Chesterfieldian notion of French civility and manners:

> 'I'm almost as much ashamed of my countrymen, as if I was a Frenchmen, and I believe in my heart there i'n't a pin to chuse [*sic*] between them; and, before long, we shall hear the very sailors talking that lingo, and see never a swabber without a bag and a sword.'

> 'He, he, he! – well, pon my honour,' cried Mr. Lovel, 'you gentlemen of the ocean have a most severe way of judging.'[45]

Although Captain Mirvan is rough, he is also a foil to the overly refined and foppish Mr. Lovel. The bag refers to the bag wig, a French mark of refinement, as was the sword, for Englishmen favoured walking sticks. These two elements in particular marked the fop or foreigner in British society, as one Continental visitor to London

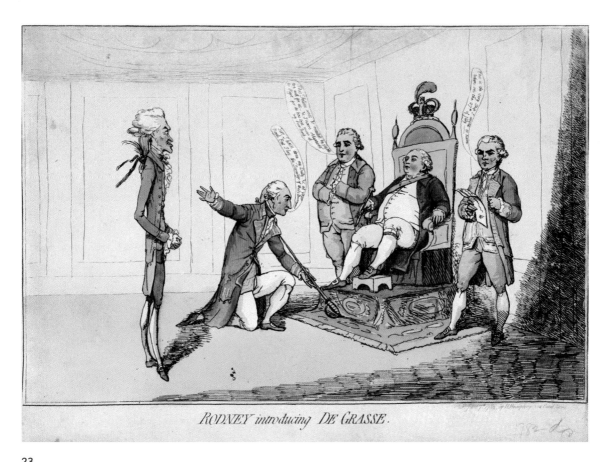

23
Rodney introducing De Grasse, H. Humphrey, 1782. PAF3710 / PW3710.
Rodney defeated De Grasse at the Battle of the Saintes. Here, as a British naval officer, he is contrasted with the effete French officer De Grasse. Rodney is shown as an exemplar of British manliness, while De Grasse is emaciated and effeminate.

remarked, 'I remember that a stranger could scarcely walk about with his hair in a bag without being affronted. Every porter and every street-walker would give a pull to his bag.'[46] Further, anyone wearing the combination of bag wig and sword through the streets of London in the 1770s and '80s was given the appellation 'French Dog'.[47] Mirvan, who was what Shadwell referred to as a 'Tar Captain'[48] – one who was not as refined as perhaps suited his rank – provides a British proof of antipathy towards French sophistication (see Figure 23).

However, the lack of refinement among officers of the Royal Navy gave rise to greater concerns than that of the public figure they presented. As guardians of the nation, their moral impact was cause for anxiety. In practical terms they were also guardians of the young midshipmen entrusted to their care. Midshipmen were generally sent to sea as adolescents, so that they might gain both practical experience and training from veteran officers and sailors; often they were even entered on the ship's books at an even earlier age, an illegal but generally accepted practice which gave a quicker chance of advancement. One of the best-known examples was Horatio Nelson who went to sea at the age of twelve in the *Raisonnable* under the command of his uncle, Captain Maurice Suckling. A ship was an environment that many felt (not unjustifiably) was rife with immorality, exposing the young boys – many of whom would become the next generation of naval commanders – to poor behavioural role models. This concern is voiced in John Moncreiff's 1759 publication, *Three Dialogues on the Navy*:

> Thus, without a proper Foundation of their own, without a Tutor to put them in the way, with many bad Examples before their Eyes, and but few good ones; I need not tell you … what dreadful Effects this Situation will produce, both with regard to their Understanding and Morals.
> … Can we with Reason expect, that such as School as this, should breed a Set of Officers fit to be Guardians of the Nation's Honour, and to realise our boasted Dominion of the Sea?[49]

It is this concept of being 'Guardians of the National Honour' and in service to King and country that parallels one of the great debates of the eighteenth century: the role and morality of servants. Servants were, according to Jonathan Swift in his popular publication *Directions to Servants* (1745), protectors of their 'Master's honour'[50] yet they were also, in popular literature and public perceptions, the byword for moral corruption.[51] This gave the term 'livery', the servant's uniform, a particularly negative connotation and it became a visual representation of the moral corruption of the servant. The behaviour of the naval officer could in turn be seen as threatening to cause their hard-won uniform to be downgraded to livery.

Civilian crossover

As mentioned earlier, the first uniform patterns drew directly on contemporary fashions, yet for 1748 they were already slightly outmoded. The long-sleeved waistcoat was already being replaced by the formal sleeveless gilet. The style of a contrasting colour for the waistcoat was incorporated into the new uniform, but it was, in deference to practicality, of the same wool as the coat and breeches, instead of following the new fashion for a waistcoat in a contrasting fabric such as satin, which would not have worn well. However, this really underlines again the way in which the uniform is a hybrid of fashion and functionality. There is a specific element of uniform that did influence fashionable dress: the mariner's cuff, which had already crossed over into civilian fashions before it became part of regulated uniform in officers' undress in the first patterns of 1748. The relationship between dress and uniform can be most clearly seen in the fashions of the late 1770s and early '80s. An example of contemporary dress reveals a vestigial mariner's cuff secured with extremely large buttons (see Figure 24). A comparison with a dress uniform from that period, with its large, flat buttons, reveals the way in which both civilian fashions and uniform influenced each other (see Figure 25).

However, it is the incorporation into feminine clothing of what was essentially a masculine style that caused uneasiness, and carried with it a complicated social message. Certainly the adoption of masculine elements into feminine clothing carried the implication that not only were women debasing their own femininity, but that by

24
Detail of silk coat in the collection of the Victoria & Albert Museum, showing the vestigial mariner's cuff and large fashionable buttons.

25
Detail dress coat, captain, over three years seniority, 1787. UNI0018 / F2212-2.
The large, flat buttons on the pocket and visible on the cuff, illustrate the way in which uniform followed popular fashion, albeit with a slight lag.

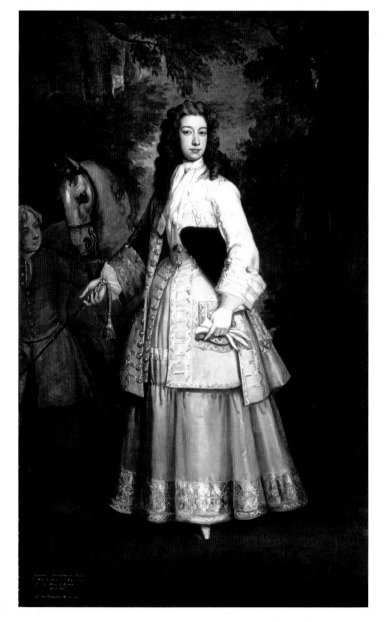

26
Frances Pierrepont, Countess of Mar, G. Kneller, 1715. In the collection of the Earl of Mar and Kellie

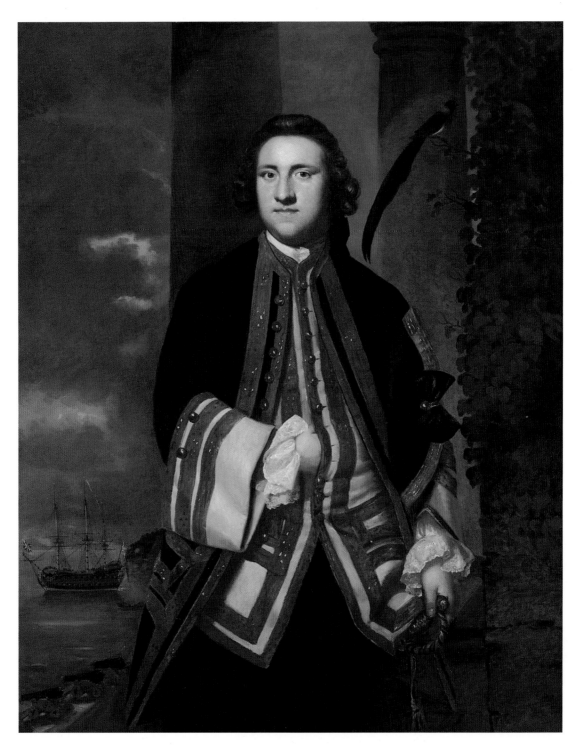

27
***Captain the Honourable George Edgcumbe** (1720–95), Sir Joshua Reynolds, 1748. BHC2677 / BHC2677.*
Edgcumbe wears the 1748–67 dress uniform for a captain of over three years' seniority. Both the style of the
coat and waistcoat and arrangement of lace echoes that of the riding habit worn by the Countess of Mar.

association with and use in female dress, these elements were also being robbed. The debate is perhaps most clearly encapsulated in the history of the riding habit, that staple of the feminine wardrobe in the eighteenth century. As early as 1666, the diarist Samuel Pepys complained about the masculinization of women's clothing, writing on the appearance of the Queen's ladies of honour:

> ... in their riding garbs, with doublets and deep skirts, just for all the world like men, and buttoned their doublets up the breast, with periwigs and with hats; so that, only for a long petticoat dragging under their men's coats, nobody could take them for women in any point whatever – which was an odd sight, and a sight that did not please me.[52]

Kneller's 1715 portrait of Frances Pierrepont, Countess of Mar (see Figure 26) illustrates this point well, as the upper half of the body was dressed in a masculine style which included a well-tailored formal coat, a waistcoat, shirt, cravat, wig and hat. Further, a comparison of this portrait with that of George Edgcumbe (see Figure 27) a captain of over three years' seniority, in his full dress uniform of 1748 shows not only the relationship between the riding habit and masculine clothing, but how slowly changes in male dress were effected in the first half of the eighteenth century. While the riding habit was influenced by and imitated the upper half of the male silhouette, it also included elements of naval uniform: specifically the button-back lapel and the mariner's cuff, which only served to heighten its masculine associations.

The attitude regarding the female appropriation of male dress changed little throughout the eighteenth century as, in 1741, the novelist Samuel Richardson remarked, 'One cannot easily distinguish your Sex by it. For you neither look like a modest Girl in it, nor an agreeable Boy.'[53] Regardless of the criticism it attracted, the riding habit remained an extremely popular and practical garment and a fixture in the female wardrobe throughout the eighteenth century, illustrating the way in which uniform and elements of sailors' occupational dress impacted on the mainstream fashions of the eighteenth century.

Conclusion

The regulated naval uniform that was created in the eighteenth century was very much a product of social and economic changes that brought with them anxieties about rank and status as well as a need to delineate one's role clearly within society. It was also a way to present a positive visual construct of the naval officer within society. Yet in addition, it reflected warring political and social elements within society. This can be seen in the exchanges in popular fiction concerning the dominance of French fashions and manners and the need to maintain a certain type of Britishness. Furthermore, the naval uniform and the occupational dress of sailors had an impact on British fashions within this period, specifically in the inclusion of elements of this costume in mainstream fashions as well as the impact on feminine dress.

Although the uniform may have clothed the naval officer in a degree of refinement, behavioural refinement was still an unresolved issue. In the late eighteenth and early nineteenth centuries, the gap between appearance and behaviour would become the target of earnest efforts at reform as religious evangelicalism began to gain ground within society.

1 Philip Dormer Stanhope, 4th Earl of Chesterfield, *Letters written by the late Right Honourable Philip Dormer Stanhope, Earl of Chesterfield to his Son ... Together with several other pieces on various subjects*, 4 vols., (London: J. Dodsley, 1774), vol. 1, p. 183.

2 Casanova, Giacomo, *History of my life*; trans. Willard R. Trask, 12 vols. (Baltimore: Johns Hopkins University Press, 1997), vol. 1, vol. 2, p. 54.

3 John Moncreiff, *Three Dialogues on the Navy; containing I. A plan of Education for Officers. II. The Plan of a standing Force by Sea. III. Scheme of Discipline and Government* (London: D. Wilson, 1759) p. 14.

4 *London Chronicle or Universal Evening Post* (18 March 1762) vol. XI, no. 816, p. 263, quoted in Rina Prentice, *A Celebration of the Sea* (London: National Maritime Museum, 1994) p. 55.

5 The National Archive, ADM49/35, Admiralty account book of clothing contractors covering the years 1765–93.

6 *Ibid.*

7 Joseph Gay (pseud. Francis Chute), *The Petticoat; an heroi-comical poem* (London: 1716), p. 4.

8 Dudley Jarrett, *British Naval Dress*, (London: J. M. Dent and Sons, Ltd., 1960) pp. 18–22.

9 The National Archive, ADM49/35, pp. 36–43 covering the period of the American Revolutionary War (1775–83) when suppliers were providing between 500–1,000 sets of clothing to the navy every fortnight. For example, on 29 December 1777, John Baker supplied 500 waistcoats at £0.3s.9d. each which would have come to a total of £93.15s – a good sum, particularly in light of the fact that this most likely would not have been factory-produced, but done as piece-work by women in the home. Baker would not have had large overhead costs.

10 The National Archive, ADM106/909/71 is an account of slops provided by Thomas Blackmore in July 1737. The bales were opened and rejected in February 1738. Blackmore, who was supplying Portsmouth dockyard, lost the contract, and the fact that the navy was looking for a new supplier was posted at the dockyard gate and throughout the town.

11 Anon. *The History of Joshua Trueman Esq. and Miss Peggy Williams*, 2 vols. (London: 1754), vol. 1, p. 11.

12 Samuel Richardson, *Pamela: or Virtue Rewarded. In a series of familiar letters from a beautiful young damsel, to her parents.* 2 vols. (London: C. Rivington, J. Osborn, 1741). vol. 1, p. 11.

13 *Ibid.*

14 Oliver Goldsmith, *The Vicar of Wakefield* (Dublin: 1766), p. 40.

15 Tobias George Smollett, *The Adventures of Ferdinand Count Fathom*, 2 vols. (London: T. Johnson, 1753) vol. 2, p. 117.

16 *Gentleman's Magazine*, January 1734, p. 13.

17 Henry Fielding, *An Inquiry into the Causes of the Late increase in robbers, &c. with some proposals for remedying this growing evil, etc.*, second edition, (London: A. Millar, 1751), p.69.

18 Chesterfield, *Letters*, p. 306.

19 N. A. M. Rodger, *The Command of the Ocean*, (London: Penguin Books; National Maritime Museum, 2004), p. 392.

20 The inventory for James Bearcroft is reproduced in Commander W. E. May, *The Uniform of Naval Officers*, typescript, n.d., 3 vols., vol 1, p. 23. According to May, 'The following list has been extracted from the entry in the Pay Book of HMS *Gloucester* when the effects of the late James Bearcroft, Gunner, were sold at the mast on 14 March 1750. This Pay Book was pulped at the Public Record Officer many years ago, but an extract was printed in the *Naval Miscellany* Vol. II, 1910, p289. The inventory for Alexander Ferguson is in The National Archive, ADM106/1149/113, his clothing was sold at the mast on the 11 May 1761.

21 May, *The Uniform of Naval Officers*, NMM typescript, vol. 1, p. 5.

22 *Ibid.*, p. 6.

23 Jarrett, *British Naval Uniform*, p. 28.

24 Thomas Keppel, *Life of Augustus Viscount Keppel, Admiral of the White, and First Lord of the Admiralty 1782-3*, 2 vols. (London: 1842), vol. 1, p. 105.

25 *Ibid.*, p. 107.

26 For a full discussion of taste and its history, Philippe Ariès and Georges Duby, General Editors, *A History of Private Life*, 4 vols., vol. 2, *Passions of the Renaissance*, Jean-Louis Flandrin, 'Distinction through Taste', pp. 265-307.

27 The National Archive, ADM2/71.

28 Yorkshire, Mulgrave Castle MSS VI, I/122 (quoted by kind permission of the marquess of Normanby) quoted in N. A. M. Rodger, *Journal of the Institute of Historical Research*, 'Honour and Duty at Sea, 1660–1815' 2002, vol. 75, p. 433.

29 Saussure, C. de, *A Foreign View of England in the Reigns of George I and George II* , trans. and ed. M. van Muyden (London 1902), p. 112 quoted in Aileen Ribeiro, *Dress in Eighteenth-Century Europe 1715–1789*, (London: Yale University Press, 2002) p. 22.

30 Pöllnitz, Baron von, *Travels from Prussia thro' Germany, Italy, France, Flanders, Holland, England, etc.*, 5 vols., 3rd ed. (London 1745) vol. 3, p. 289, quoted in Ribeiro, *Dress in Eighteenth-Century Europe*, p. 22.

31 C. Ranger (pseud. Arthur Murphy), *Gray's Inn Journal, September 29, 1753 – September 21, 1754*, (London: 1753, 1754).

32 *Gentleman's Magazine* (London: 1746), vol. 16, p. 224.

33 F. A. de Garsault, 'la Fraque, espèce de justaucorps leger, nouvellement en usage', *L'Art du Tailleur*, (Paris: Académie Royale des Sciences, Descriptions des Arts et Métiers, 1769) p. 9 quoted in Ribeiro, *Dress in Eighteenth Century Europe*, p. 126.

34 Sir John Barrow, *Life of George Lord Anson: Previous to, and during, the Seven-Years' War*, (London: John Murray, 1839) p. 107.

35 National Archives, Minutes of the Visitation of the Dock Yards, 1749, ADM7/658, quoted in May, *The Uniform of Naval Officers*, p. 21.

36 *Ibid.*

37 All information is taken from the account books of Sir John Borlase Warren, National Maritime Museum, WAR/97, Bills and Accounts of Sir J. B. Warren 1775–79. Sir John Borlase Warren (1753–1822) was best known for his feat of capturing or destroying 220 enemy ships in 1795 during the French Revolutionary War. He was also instrumental in frustrating the French fleet in its attempts to land in Ireland at the beginning of the 1798 Uprising. In 1799 he was promoted to rear-admiral and in 1805 he became a vice-admiral. His last appointment was as Commander-in-Chief of the North American station in 1813.

38 National Maritime Museum, WAR/98 Bills and Accounts of Sir J. B. Warren, 1790–1822.

39 Sir Nicolas Harris Nicolas, *Dispatches and Letters of Lord Nelson*, 7 vols. (London: Henry Colburn, 1844) vol. 1, p. 86.

40 *Ibid.*, vol. 1, p. 89.

41 George Naish, ed., Nelson's Letters to his Wife and other documents, 1785–1831 (London: Routledge & Kegan Paul in conjunction with the Navy Records Society, 1958) p. 102.

42 C. de Saussure, *A Foreign View of England in 1725–9: The Letters of Monsieur César de Saussure to his Family*, ed. and trans. van Muyden (1902; repr. 1995), p. 224 quoted in N. A. M. Rodger, *Journal of the Institute of Historical Research*, 'Honour and Duty at Sea, 1660–1815', (Oxford: Blackwell Publishers Ltd, 2002), vol. 75, p. 433.

43 Rodger, 'Honour and Duty at Sea', p. 434.

44 Charles Shadwell, *The Fair Quaker of Deal; or, the Humours of the Navy, a comedy, etc.* (Dublin: W. Smith, 1757), p. 31.

45 Frances Burney, *Evelina; or the history of a young lady's entrance into the world*, 3rd edition, 3 vols. (London: 1779), vol. 1, p. 197.

46 J. Baretti, *A Journey from London to Genoa, through England, Portugal, Spain and France*, 2 vols., (London: 1770) vol. 1, p. 143 quoted in Ribeiro, *Dress in Eighteenth-Century Europe*, p. 168.

47 *Ibid.*

48 Shadwell, *The Fair Quaker of Deal*, p. 2.

49 Moncreiff, *Three Dialogues on the Navy*, p. 14.

50 Jonathan Swift, *Directions to Servants in general; and in particular to the Butler, Cook, Footman, Coachman, Groom, House-Steward, and Land-Steward, Porter, Dairy-Maid, Chamber-Maid, Nurse, Laundress, House-Keeper, Tutoress or Governess, etc.* (London: R. Dodsley & M. Cooper, 1745), p. 2.

51 Jenny Davidson, *Hypocrisy and the Politics of Politeness: Manners and Morals from Locke to Austen*, (New York: Cambridge University Press, 2004), pp. 26–43.

52 R. Latham and W. Matthews (eds.), *The Diaries of Samuel Pepys* (London: Bell & Hyman, 1969–83), 12 June 1666, VIII, p. 162 quoted in Cally Blackman, 'Walking Amazons: The Development of the Riding Habit in England during the Eighteenth Century', *Costume: The Journal of the Costume Society*, no. 35 (London: Maney Publishing, 2001), p. 48.

53 Samuel Richardson, *Letters Written to Particular Friends on the Most Important Occasions* (London: C. Rivington, J. Osborn, 1741) p. 124 quoted in Blackman, 'Walking Amazons', *Costume*, p. 49.

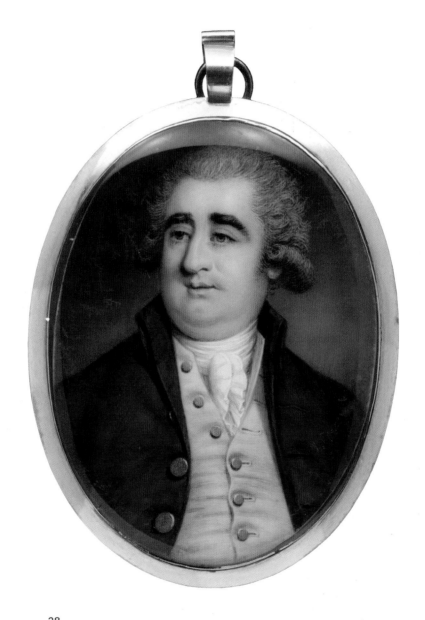

28
Miniature of Charles James Fox, by Thomas Day, 1787. National Portrait Gallery, NPG6292.
(Enlarged; actual size of miniature 67 × 51 mm)
Fox is shown here in the blue coat and buff waistcoat which he wore as a sign of sympathy
with American Revolutionaries.

CHAPTER II

War and Revolution

By the last decades of the eighteenth century – particularly during the period of the French Revolutionary and Napoleonic wars (1793–1815) – codes of dress came to represent much more than social aspirations or constructions of rank. In Britain, politician Charles James Fox adopted the plain blue coat, buff waistcoat and breeches worn by the American revolutionaries (see Figure 28). This soon became a symbol of Whig support, as did wearing hair simply without either powder or in a cropped style. Naval uniform, as part of the identity of the officers, came to hold particularly potent associations in this period of social and political upheaval, as first the French Revolution led to worries over social unrest, followed in the early nineteenth century by widespread fears of a potential French invasion. The Royal Navy was seen as Britain's strongest line of defence, as the *Gentleman's Magazine* declared: 'We are the barrier between civilization and barbarism; our naval superiority is the only security left that mankind shall not again be reduced to savage tribes of the desert.'[1] (See Figure 29.)

It was during this period of prolonged conflict that the navy became the largest employer in Britain, maintaining an infrastructure of dockyards, suppliers and administrators. Its public popularity was further enhanced through a series of victories such as the Glorious First of June (1794), which sought quite literally to starve the French Revolution by capturing grain transports, the battles of Cape St Vincent and Camperdown, both in 1797, in which the Spanish and Dutch, respectively, were defeated and the Battle of the Nile in 1798, which decimated the French fleet (see Figure 30). It was after the latter that the *Morning Post and Gazetteer* noted 'Almost all the noble families in this country have sons or brothers in the navy. It is now become more fashionable to enter that service than to enter the army.'[2] The greatest naval victory of this period, the Battle of Trafalgar on 21 October 1805, effectively defeated the combined French and Spanish fleets and forced Napoleon to abandon his maritime ambitions. As a result, Britain held supremacy over the seas and the navy was seen as the saviour of both trade and empire. However, Trafalgar came at a cost: the loss at the moment of victory of the man many considered to be Britain's greatest naval hero (see Figure 31). Following the death of Horatio Nelson, the country was plunged into national mourning and the officers of the navy who, in a break with protocol, were represented as the chief mourners at Nelson's state funeral by Admiral of the Fleet Sir Peter Parker, were viewed as both the heirs to his genius and national heroes. However, this new elevation was difficult to reconcile with the popular image which still saw the naval officer as someone whose behaviour was of a 'different and grosser cast'[3], as Mary Wollstonecraft wrote in *A Vindication of the Rights of Women* (1792).

While attempts to refine the behaviour and image of the naval officer were not new, society itself was undergoing a change, particularly with the rise in and influence of evangelicalism and a rejection of the ideals of aristocratic behaviour as defined by Lord Chesterfield (as discussed in the previous chapter). Even as the naval officers were being recast as more palatable heroes, societal concepts of masculinity were also changing, and on this basis the officer was becoming a more desirable masculine model even before Trafalgar thrust him into the role of national

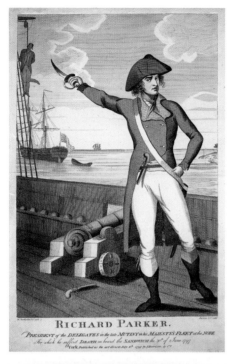

29

Richard Parker. President of the Delegates in the late Mutiny in his Majesty's Fleet at the Nore. For which he suffered Death on board the Sandwich *the 30th of June 1797*, Harrison after William Chamberlain, published 8 July 1797 by J. Harrison and Co. PAH5441 / A3700.

Richard Parker, the leader of the naval mutiny at the Nore in May and June 1797 was court-martialled and hanged on his ship. The principal figure in this print is not Parker, but an idealised and heroically cast naval officer who points to the figure of Parker as a warning for future subversives.

30

The Destruction of 'L'Orient' at the Battle of the Nile, 1 August 1798, George Arnald, 1825-27. BHC0509 / BHC0509.

The Battle of the Nile was fought at night at Aboukir Bay. At the height of the battle, the French flagship the *L'Orient* exploded and fighting ceased for a full ten minutes. The Nile secured British control of the Mediterranean and decimated the French fleet.

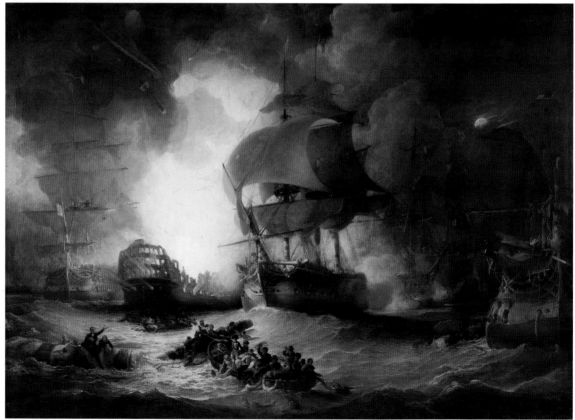

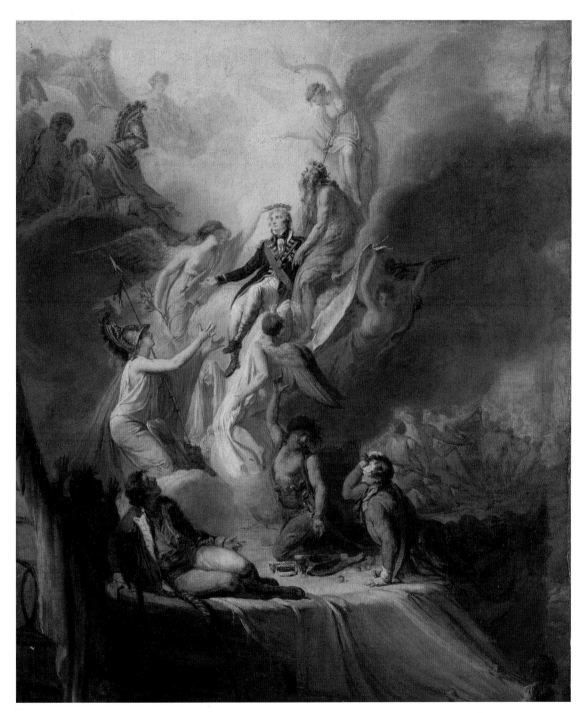

31

Apotheosis of Nelson, Scott Pierre Nicolas Legrand, circa 1805–18. BHC2906 / BHC2906.

Although the victory at Trafalgar on 21 October 1805 was a cause for celebration in Britain, it resulted in the loss of Nelson. His death at the height of his fame inspired a cult of hero-worship. Legrand's interpretation hovers between the romantic and heroic and adapts a classical reading of an apotheosis, depicting a deified Nelson being received into immortality among the gods on Olympus.

hero. This chapter explores the construct of the naval officer during this period and the way in which the uniform played a role in creating his visual image.

Naval uniform and contemporary fashion 1787–1812

When regulations were first introduced in mid-eighteenth century, the style of the dress uniform was taken directly from the formal clothing worn at both French and British courts, while the undress uniform followed the British 'sporting styles', particularly in the use of the frock, which was favoured for day dress. As uniform evolved throughout the second half of the eighteenth century, the formal suit coat, with its overt relationship to court dress, was discarded in favour of the frock, which was adopted for both dress and undress, and was more in keeping with the increasingly prevalent British taste for informality (cat. 21). The uniform retained its gold lacing, which was indicative of rank but, following contemporary fashion, the waistcoat became shorter and lost all

32
Detail, waistcoat of a flag officer, 1795–1812 pattern.
UNI0028 / F2149.2.
Gold lace was no longer in use in the waistcoat patterns of 1795. Instead, rank was indicated by the pattern of the button. This waistcoat features the buttons worn by a flag officer which have an outer border of a laurel wreath. The buttons are of gilt brass.

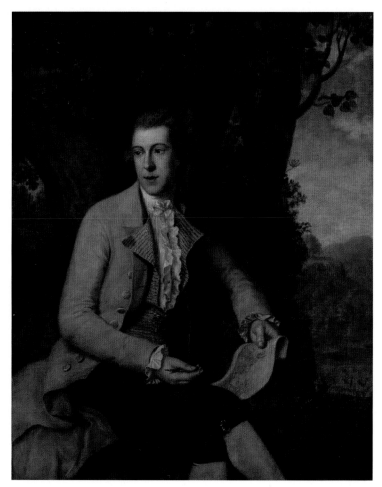

33
Robert Pollard, Richard Samuel, 1784. National Portrait Gallery NPG1020.
Pollard's portrait epitomizes the sober hues and informality of dress favoured in the latter part of the eighteenth century.

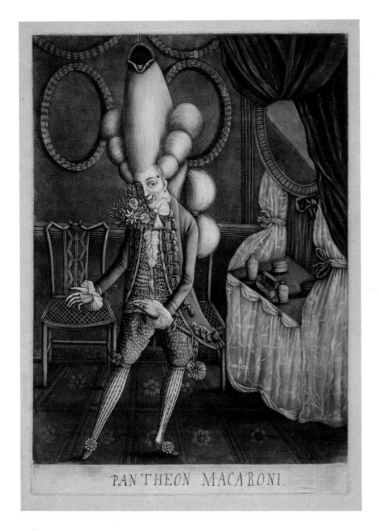

34

The Pantheon Macaroni, [A Real Character at the Late Masquerade], Philip Dawe, printed for John Bowles, 1773. British Museum BM Sat 5221.
The outrageous fashions of the Macaronies were also used as fancy dress for the masked balls at both the Pantheon and Teresa Cornelys' Carlisle House. The infamous Captain Jones reportedly frequented the latter.

embellishment (see Figure 32). During the 1780s, as part of the trend towards more relaxed styles, suits of plain wool in sober or drab colour were worn with very plain but good quality starched linen instead of lace, which was still retained for court wear. This fashion for a simpler style of dress can be seen in a 1784 portrait of the painter Robert Pollard, who wears a grey coat and waistcoat of the same fabric, with a linen cravat (see Figure 33).

Further changes in fashionable dress for men in the final decades of the eighteenth century included the growing importance of a much leaner, longer and tighter silhouette, which costume historian Aileen Ribeiro points out places the 'emphasis on a slim figure [that] helped to improve the quality of tailoring and the shape of the average man'. 'No longer, by the 1780s,' she continues, 'could a moderately fashionable man be pot-bellied in baggy breeches'.[4] One social group in particular had a great impact on this shift in fashion: the macaronies (see Figure 34). Coming to prominence in the 1770s, they were a group of young men who had at various times been on the Grand Tour of the Continent; their nickname was said to come from the Italian word *maccherone* – 'a boor'. They dressed in exaggerated styles that featured brightly hued, tightly cut clothing with large buttons and wigs of enormous height set off with tiny hats. Horace Walpole mentioned them in 1764 as 'The Maccaroni Club [although they were not a formal organization] (which is composed of all the travelled young men who wear long curls and spying glasses)'. This dress was seen as extreme and foppish, prompting Giuseppi Baretti to comment

in his 1775 publication, *Easy Phraseology* …: 'Strange, that this word has so much changed of its meaning in coming from Italy to England! that in Italy it should mean a block-head, a fool; and mean in England a man fond of pompous and affected dress!'[5] Further, the macaronies as a group were, in the case of Captain Robert Jones, associated with homosexual scandal. Jones was at one point dubbed a 'military macaroni.' Convicted of sodomy in 1772, he was sentenced to death but the sentence was eventually commuted; it was later reported in *The Times* in 1788 that 'The Grand Seignior has a Captain Jones … in his service. He was formerly an officer in our artillery, but being convicted of a certain crime, more congenial with the Turkish climate, than ours, was transported for life.'[6]

The impact of the macaronies is apparent in the naval uniform of the late 1780s. A 1787 dress coat for the rank of captain with three years' seniority, belonging to Alexander Hood (1758–98), clearly demonstrates this relationship, with its extremely tight sleeves and small round cuffs with very large, flat, gilt-brass buttons

35

Detail of a dress coat for a captain over three years' seniority, belonging to Captain Alexander Hood (1758–1798). UNI0018 / F2212.1.

This detail highlights the impact of popular fashion on the naval uniform, with both the narrower cut of the skirts and the large flat buttons. However, the uniform still retains the three-point pocket flap, popular in the mid-eighteenth century.

36

Detail, *The Sailor's Journal. Sung by Mr Incledon at Covent Garden Theatre, &c*, Robert Laurie & James Whittle (publishers), 28 Sep 1805. PAD4777 / PU4777.

This illustration emphasises the trend for extremely tight and fitted clothing in the late eighteenth and early nineteenth centuries.

(cat. 12.) However, in keeping with general fashion trends not solely associated with the macaronies, the coat also illustrates the lean figure of the later part of the century. Unlike the first uniform patterns, the lapels are extremely narrow and the skirts less full-cut from significantly less fabric (see Figure 35). The front of the lapels have an extreme curve back from the waist, making it no longer possible to button the coat; instead hook-and-eye fastenings were used. An additional element that indicates the relationship with contemporary fashions is the rather high-standing collar. The only aspect of this coat to recall the early patterns of 1748 is the large three-point pocket flap. Among the fashionable, the pocket had moved to the interior of the coat by the late 1770s, so as not to spoil the line.

By adopting this very tightly fitted clothing, the navy was following the lead of fashion, rather than practicality (see Figure 36). An anecdote concerning the uniform worn in the 1780s in the memoirs of Sir Thomas Byam Martin describes the clothing he was expected wear as a young midshipman on the *Andromeda* under Prince William, '… the boy of twelve years old was to be rigged out as a man, and so squeezed into a tight dress as to leave no chance of growing unless, perchance, nature's efforts should prove more than a match for tailor's stitches'.[7] Climbing rigging did prove more than a match for his tailor's work, and after spending more than two hours aloft, he found that 'the rents in the lower garment admitted more of the sharp north-west wind than was agreeable'.[8] When he returned to the deck, he went to his commanding officer to show him the effect activity had on fashionable tight clothing and was sharply told to inform his tailor that in future he should 'get better materials, and sew them stronger'.[9] However, by way of contrast and perhaps indicative of the pervasive taste for informal clothing, in 1805 Edward Codrington wrote to tell the father of a young midshipman, George Perceval, who was soon to be in his care, that

37
Detail of the undress coat for a vice-admiral, pattern 1795–1812, worn by Horatio Nelson at the Battle of the Nile. UNI0022 / F2148-2.
This narrow sleeve features a small slit to enable the hand to pass through and a self-covered button to secure the fit. The single stripe indicates the rank of vice-admiral while the three buttons are the pattern worn by a flag officer.

in regard to clothing 'the putting of youngsters into perfect uniform with large cocked hats … [was] in my opinion improper and ridiculous'.[10]

By the early 1790s, the sober shades worn by Robert Pollard became the uniform of the British gentleman, which consisted of 'a short white waistcoat, black breeches, white silk stockings, and a frock, generally of a very dark blue cloth which looks black'.[11] This blue-black colour would actually infiltrate naval uniform, as the coats of the 1790s and early nineteenth century became progressively darker. Because there is nothing in regulations to indicate that this was a deliberate choice made by the Admiralty, it would appear to be an almost unconscious following of a fashion trend. It is not the dress coat, with its abundance of gold lacing, that reflects the sober changes in male fashion, but rather the undress which eschews almost all ornament. An example of the undress of the 1795–1812 pattern, worn by Horatio Nelson at the Battle of the Nile in August 1798, reveals a relatively plain garment (cat. 22). Its chief embellishments – the large brass buttons stamped with a fouled anchor (that is, an anchor tangled in a cable) and laurel wreaths, and the narrow stripe of gold lace on each sleeve – are solely to designate rank (see Figure 37).

While undress may have followed the prevalent fashion for plain but well-cut clothing, the dress uniform kept all the associations of court finery, as can be seen in Nelson's uniform for the rank of vice-admiral. It is heavily embellished with gold lace in what was known as the 'vellum and check' pattern (cat. 21). The gold lacing outlines certain elements of the coat: the lapels, collar, cuffs, pocket flaps and buttonholes. Again, this quantity of lace corresponds directly with rank. Nelson's coat also features his chivalric orders, which include the Order of the Bath, the Order of the Crescent, St Joachim and the Order of Ferdinand and Merit – all of which are embroidered with

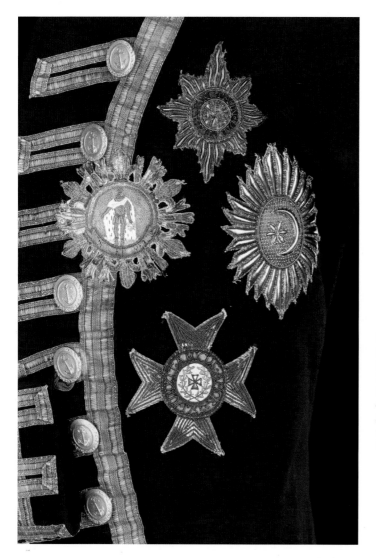

38
Detail of full dress coat worn by Vice-Admiral Horatio Nelson, pattern 1795–1812. UNI0023 / F2147.3.
Nelson's orders of chivalry (clockwise from top): the Order of the Bath, the Order of the Crescent, the order of St. Joachim and the Order of St. Ferdinand and Merit. Orders and even peerages were given as a reward for military services. Nelson constantly wore his on his uniforms, as was the custom.

metal threads, spangles and coloured silks (see Figure 38). However, practical elements of uniform have also been discarded; one very obvious example of this is in the lapels of Nelson's uniform. Three of the orders are sewn over the lapel, making it impossible to fasten them across the chest for extra warmth. Oddly, though, the back as well as the front of the lapel is still edged with gold lace.

The dress uniform is also an amalgamation of stylistic elements both new and archaic. For example, the back of the uniform reveals a further retention of an old-fashioned style, seen in male dress in the early to mid-eighteenth century, which was, in effect, a hold-over of a late-seventeenth-century style: that of buttonholes and buttons along the edges of the back vent. Vestigial buttonholes, which originated in this seventeenth-century style, were retained in male coats until the mid-eighteenth century. Like the pocket flaps, this outmoded element recalls the fashionable styles of the period when the first uniforms were introduced. Yet, in keeping with prevailing fashion, the sleeves of both Nelson's full dress and undress uniforms are extremely tight. In both coats, the cuffs have a small slit to allow the hand and shirt cuff to pass through. However, in the undress, in addition to the slit there is a small self-covered button to ensure the fit.

The undress uniform worn by Nelson when he was fatally wounded at the Battle of Trafalgar in 1805 shows very little change stylistically from his undress uniform worn seven years before: with the exception of the insignia of rank and the inclusion of his chivalric orders, he does not appear to have altered his uniform to accommodate any changes in civilian fashions (see Figure 39). His undress still retains the sloping lapels, long, narrow tails and standing collar. The fashion-conscious Prince William, the future William IV, commented on Nelson's appearance as a young captain of twenty-four:

> I had the watch on deck when Captain Nelson of the *Albemarle* came alongside in his barge. He appeared to be the merest boy of a captain I ever beheld, and his dress was worthy of notice. He had on a full laced uniform; his lank unpowdered hair was tied in a stiff Hessian tail of extraordinary length; the old-fashioned flaps of his waistcoat added to the general quaintness of his figure, and produced an appearance which particularly attracted my attention, for I had never seen anything like it before, neither could I imagine who it was or what he came about.[12]

While Nelson may not have been sensitive to changes in fashion, others in the navy were. Although uniform regulations remained unchanged for nearly twenty years, it is apparent that officers could not resist having their uniforms tailored along more stylish lines. A captain's undress coat from the early years of the nineteenth century features a notched roll collar and the beginnings of a cutaway front as well as slightly shorter, more squarely cut tails (see Figure 40).

The uniform patterns of 1795–1812 reflect issues other than just the changing relationship between uniform and contemporary fashion. They are also indicative of the economic patriotism prevalent in this period, specifically in regard to the woollen cloth used to make the uniform. The late eighteenth century was a period of economic competition between Britain and Spain in the wool market. The latter led the market in the manufacture of superfine wool, the very type of wool that was now dictated by fashion to be an integral part of male dress and which, extant uniforms in the National Maritime Museum collection reveal, was also favoured for the naval uniform. During the early nineteenth century, Britain was attempting to manufacture a superfine wool to rival that of Spain. Beneath the economics was the underlying patriotic contradiction of clothing Britain's navy in Spanish imports. One pamphlet, published in 1800 and titled *Facts and observations tending to shew the practicability and advantage of producing in the British Isles clothing wool equal to that of Spain*, stressed the perceived economic detriment caused by the British consumption of this product: 'We find, that on an average of three years, ending January 1799, there has been imported into this country from Spain wool, which at the Custom-house value of 3s.6d. per lb. has amounted to £621,420.'[13] The author queried, 'Does Spain take any of our superfine clothes in return for its fine wool, from which they are fabricated?'[14] The article concluded that 'It is evident that every affirmation of the dependence of our prosperity on the woollen manufacture proves the necessity of securing to ourselves, beyond the reach of external accident or design, an abundant supply of the raw article.'[15] This was a similar situation to the debate in the mid-eighteenth century about wearing French styles, particularly as at this point Spain was allied with France

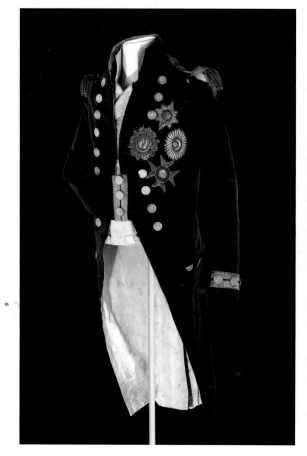

39
Undress coat for a rear-admiral, pattern 1795–1812, worn by Horatio Nelson at the Battle of Trafalgar in October 1805. UNI0024 / F2160.5.
Unlike other officers, Nelson appears not to have altered the style of his uniform to reflect changes in civilian fashions.

40
Undress coat for a captain over three years seniority, pattern 1795–1812. UNI0042 / F2151.0.
The wearer of this uniform was much more fashion-conscious than Nelson. He had a roll-collar, cut-away front and shorter, more squarely cut tails.

against Britain. It underlined the idea that the consumption of Spanish imports was not only potentially crippling to domestic industry, but could finance Spain in its endeavours against Britain.

A uniform for warrant officers

The warrant officer was essentially a specialist designation, and included surgeons and pursers, carpenters and gunners. Unlike commissioned officers, who were commissioned by the Admiralty and were executive officers, the warrant officer was issued a warrant by the Navy Board. By 1787, the uniform was no longer to be worn solely by commissioned officers, because warrant officers, with the exception of physicians and surgeons, were also given a uniform. However, like that given to midshipmen in 1748, it consisted of a single coat without the option of dress or undress. The uniform coat featured lapels and a fall-down collar and was of blue wool lined with white (see Figure 41). Additionally, the coats of masters' mates were edged in white. This new uniform

41

Samuel Crowley, Purser, attributed to Italian School, 1807–8. BHC2639 /
BHC2639.
In 1806 masters and pursers were given an undress as well as a dress uniform.
However, they were not laced and the ranks of master, purser and surgeon did not
have three buttons on their cuffs in undress.

was in part a recognition of the importance of the role performed by the warrant officer and an indication of a growing degree of professionalism within the navy. It also reflected a deeper societal change as prior to 1787 those who wore the uniform were commissioned officers with the exception of midshipmen, although they were specified as having the rank 'of a gentleman'. By having uniforms, warrant officers were also acknowledged as holding that rank.

Changes in the concept of what a gentleman was had been gaining ground since the early eighteenth century, with the steady expansion of the middle classes and the rise of mercantilism. This is reflected in publications of that period, particularly Addison and Steele's *Spectator*, which contributed to shifts in the perception not only of rank, but of British masculinity, as social historian Shawn Maurer notes in *Proposing Men: Dialectics of Gender and Class in the Eighteenth Century English Periodical*:

> By challenging the belief that aristocratic birth entails noble behaviour as well as the view
> that the well-born are the only people capable of virtuous thought and action, their [Addison

42
Button, purser, 1806. UNI7154 / F2169.1.
A new button was introduced in uniform regulations of 1806
for both pursers and masters. That worn by the purser had the
arms of the Victualling Office while those worn by the master
had the arms of the Navy Office.

and Steele's] works redefined masculine excellence, and thus contributed significantly to the codification of a new form of masculinity.'[16]

This was based on mercantile principles of honesty and credibility which, by the later half of the century, were compatible with the rise in religious virtues advocated by the evangelicalism that had been gaining ground since the latter part of the 1780s. However, while being more than just a visual construct of the identity of the gentleman, there is another interpretation of the new uniform for warrant officers. In *Command of the Ocean*, historian Nicholas Rodger points out that in the latter part of the eighteenth century, 'Just as the French navy abandoned its tradition of choosing officers from the nobility in favour of the career open to talent, the British navy started moving in the opposite direction.'[17] The introduction of a uniform for warrant officers served to further visually codify rank. Their uniforms were not embellished with gold lace, nor did they have a full dress evocative of court clothing, but instead a relatively simple blue coat with brass buttons (see Figure 42). The visual associations are therefore linked with the middle classes. While the uniform indicates a recognition of the importance of the warrant officer and deeper societal change, it also reflects the increasing stratification of the Royal Navy by visually reinforcing the place of the warrant officer to be firmly below that of the commissioned officer.

Uniform for medical officers

In 1805, medical officers (physicians, surgeons, dispensers in hospitals, assistant surgeons and hospital mates) were given a regulated uniform. This was in response to an 1804 petition from a group of officers who felt that they 'should wear a distinguishing Uniform and have a similar rank with the officers of the same class in His Majesty's Land Service...'[18] . The group included a pattern of the proposed uniform with the petition. An additional letter dated April 1805 from the physicians and surgeons of the Royal Hospital at Haslar clarified

43
Detail, surgeon's collar, pattern 1805. UNI0076 / F2153.2.
This uniform was worn by Joshua Horwood (died 1850). Rank is indicated by the twist on the collar, embroidered with metal thread, and the warrant officer's button which features an anchor on a rayed ground.

the need for a uniform and epaulettes as '... the claim We have, as field Officers to wear Epaulettes as have been awarded to Officers of similar Rank in the Staff of the Army'.[19] There was also a particularly pressing need to have epaulettes as '... from our being daily liable to meet with Army Medical Officers'.[20] It is interesting to note that physicians and surgeons tended to be educated men who, in terms of their roles outside the navy, would have been considered gentlemen. In keeping with their status, they were given full dress and undress uniforms, which featured velvet collars and silver-twist embroidery. However, dispensers in hospitals and assistant surgeons had only one uniform that was slightly superior to that worn by warrant officers in that it had a velvet collar and cuffs. Further, all medical officers had epaulettes. Because this new uniform was supplied at the wearer's expense, it may have been more than a surgeon's wages could bear, as evidenced by an extant uniform worn by Joshua Horwood (cat. 30). The fabric is not superfine wool, but is much rougher in quality and tailoring; the work on the collar is particularly clumsy and not of the best quality (see Figure 43). What is interesting is that Horwood appears to have spent most of his money on his hat, which is not the beaver felt usually worn by officers in the navy but is instead the more expensive French plush, a type of velvet (cat. 31).

The naval officer in society

By 1800, the old-fashioned aspects of naval uniform, particularly that of the full dress uniform, marked it out as a completely distinct costume within society and one that was representative of a certain type of masculinity. The officers of the navy were popular figures within British society, not least due to their celebrated naval victories in the last decade of the eighteenth and early years of the nineteenth centuries. There are myriad examples of objects of daily domestic use such as mugs, jugs, and punch bowls (see Figure 44) as well as glass pictures and furnishing and dress textiles commemorating not only the great battles, but also heroes such as Duncan, Howe, Jervis, Rodney and, of course, Nelson (see Figure 45). The importance of the navy was reinforced by journals such as *The Lady's Monthly Museum* which, when comparing the navy with the local militias formed for the defence of Britain against potential French invasion, stated: 'The first wish I can form in their favour, is, that – protected as we are by the wooden walls of old England – they may never be called upon to prove their skill and courage in any real engagement.'[21] They occupied an increasingly important place within society, and in fact their image was not stagnant, but progressively evolving.

In popular literature, the novel *The Post-Captain: A View of Naval Society and Manners*, first published in 1805 before the Battle of Trafalgar, illustrates the evolving image of the naval officer. The naval characters of the novel could be rough: Lieutenant Tempest was 'a man of unsubdued confidence'. 'It was not in the power of female modesty to call a blush to his cheeks, or suspend the volubility of his tongue.'[22] While Tempest does not measure up to the idea of a Chesterfieldian gentleman, this is clearly meant as an asset to his character. The continued comparisons throughout the novel are not to cast the officers of the navy negatively, but to highlight the hypocrisy

44
Tea bowl and saucer commemorating Admiral of the Fleet, Adam Duncan (1731–1804) and Vice-Admiral Horatio Nelson (1758–1805).
AAA4401 / E5701.
Inside the saucer is an unrecognisable portrait of Duncan. These commemoratives were incredibly popular and covered a wide economic range. Nelson's image appears on the outside of the bowl.

45
'Trafalgar Chintz', printed calico furnishing fabric commemorating Vice-Admiral Horatio Nelson. TXT0119 / F4322.
The design features monuments to Nelson including urns and obelisks commemorating his victories, specifically
the Battle of the Nile (1798) and the Battle of Trafalgar (1805), interspersed with large floral motifs. Inscriptions
include: 'To the memory of the hero of Aboukir, Copenhagen and Trafalgar', 'The Nile', and 'Lord Nelson's last Signal /
England Expects every man to do his Duty'.

inherent in the mode of manners advocated by Chesterfield. When Chesterfield's volume of letters was published
posthumously in 1774, it was for an audience whose values had altered from the 1740s when he began writing,
as evinced in initial criticisms which noted the absence of religion and morality.[23] In March 1775, the *Gentleman's
Magazine* published 'Lord Chesterfield's Creed':

> I believe that hypocrisy, fornication, and adultery, are within the lines of morality; that a woman
> may be honourable, when she has lost her honour, and virtuous when she has lost her virtue…
> This, and whatever else is necessary to obtain my own ends, and bring me into repute, I resolve
> to follow; and to avoid all moral offences, such as scratching my head before company, spitting
> upon the floor, and omitting to pick up a lady's fan.[24]

Inexpensive editions of *Letters written …* meant that Chesterfield was within economic reach of a larger section
of society, thus making the approximation of aristocratic manners and attitudes available to the working classes,
specifically servants. It was thought that this would have a disastrous effect on the already questionable morality

of these individuals. The idea that Chesterfield was studied by all was picked up in *The Post-Captain*, as Captain Brilliant interrogates one of his midshipmen: 'Damnation! I thought you had read Lord Chesterfield! I am sure you had it in your berth.' He is told in reply, 'No sir; it belonged to the boatswain.'[25]

The moral and behavioural codes advocated in *Letters* were at odds with the growing evangelical movement and what has been termed the increasing 'middle-class sensibility of morality'[26] that was evident in the final decades of the eighteenth century. This changing view in society can be seen in the terminology used: the idea of 'honour', a code used by the aristocracy, has been replaced by 'honesty', which holds more of a mercantile connotation. Although the characters of *The Post-Captain* lack aristocratic refinements, they are honest and have rejected the ideals of Chesterfield. Further, part of the effeminate behaviour popularized by the macaronies gave way in the 1790s to what Jenny Davidson in *Hypocrisy and the Politics of Politeness* describes as a 'crisis in the concept of gender': manliness was perceived to be under attack as feminine behaviour such as blushing and tears was advocated for men as a polite show of sensibility. The officers of *The Post-Captain* illustrate these warring behaviours of manliness and sensibility. The character of officer Factor is easily moved to tears and, as a result, the legitimacy of his emotion falls into question. In contrast, there is the manly example of the newly promoted Captain Tempest, who tells his wife: 'Now go to your father. Make him my compliments. Tell him the husband of his daughter, an officer in the navy – a man that dares do all that becomes a man – tell him Captain Tempest desires his company.'[27] Tempest, a naval officer, represents a masculinity that is the antithesis to the morally doubtful, foppish and overly refined behaviour that is the legacy of the macaronies.

The naval uniform worn by the characters of *The Post-Captain* is also associated with this new sense of masculinity. The blue coat is contrasted with the red worn by the local militia, whose members are portrayed as being chiefly interested in drilling and parties but who are firmly not men of action. Initially, as the comparisons to Chesterfield suggest, it is the navy that is seen to be wanting, as for example in an exchange between Captain Brilliant and the father of Caesar, an officer in the militia:

> 'Between you and me and the post, he has recruited lately to some purpose; he has enlisted the heart (whispering) of Miss Spa, the young lady who sits next to my eldest daughter. It was his red coat did this. Woman, like mackrel [*sic*], (raising his voice) ha! ha! ha! are caught with a red bait.'
>
> 'True, sir,' said Captain Brilliant, 'The blue jacket stands no chance.'[28]

Yet, when this novel was published, the uniform of the navy and its representation of a desirable masculinity prove far more attractive than that of the foppish militia, as noted at the close of the novel, 'notwithstanding the vaunted powers of a red coat, you preferred a true-blue to it'.[29]

The role of the officers – really the military man in general – held within it a contradiction that placed it at odds with the societal changes of the early nineteenth century. The growing emphasis on morality and religion in British society and the ideals of honesty and duty which, in *The Post-Captain*, are also part of the identity of the naval officer, meant that the expected role of the officer became to a certain extent less palatable. The officer and his uniform become inextricably linked with what nineteenth-century art historian Charles Blanc referred to as '... their original purpose, as shown in their style of dress, of slaying their fellow creatures'.[30] How does a society, where morality and religion are placed at a premium, reconcile the image of officers as national heroes with their necessary role? Mary Julia Young's 1807 novel *A Summer at Brighton* provides one attempt to make this role not only acceptable, but celebrated, as a disabled sergeant attempts to explain this morality to the wife of his commanding officer:

> Do you know, when I received this wound that your brave spouse, madam, was wounded in the sword arm? I will tell you how it happened, for it is to his honour. It was in the battle of ----, which though very desperate, turned out at last, as thank God, our battles generally do, glorious for old England: it was in the very heat of our attack that my noble young Captain beheld a

French officer aiming at the life of our valiant General, whom he rushed forward to defend, and his sword fell from his brave hand; I saw it fall, recovered it, he took it in his left hand, and gave the French officer a mortal stab, which brought him to the ground; I cried 'huzza!' and he had strength enough left to give me this fatal wound above my knee, as a check to my triumph. It was just; I ought not to have exulted over a vanquished foe; I deserved my fate: we must kill in the defence of our country; but it is inhuman to express joy at the death of a fellow creature.[31]

Sergeant Remnant is punished for not adhering to this moral code: he is left disabled, and is taken in by his commanding officer as a family servant. This relates to societal perceptions of naval officers in that their actual role – to defend their country from its enemies, which implies killing – can be reconciled with the idea that they are also fast becoming exemplars of a desirable masculine type.

Uniform patterns 1812–25

There were two significant additions to the uniform regulations of 1812. The first was the introduction of a uniform for the Admiral of the Fleet, which included an additional row of distinction lace on the sleeves (making it five laces) and having white lapels instead of blue in undress, while flag officers were given white lapels in their dress uniform. The other important change was allowing captains of under three years' seniority and commanders to wear full epaulettes (see Figure 46), while lieutenants were granted one to be worn on their right shoulder. Previously a captain of under three years' seniority had a single epaulette on his right shoulder, while a commander wore a

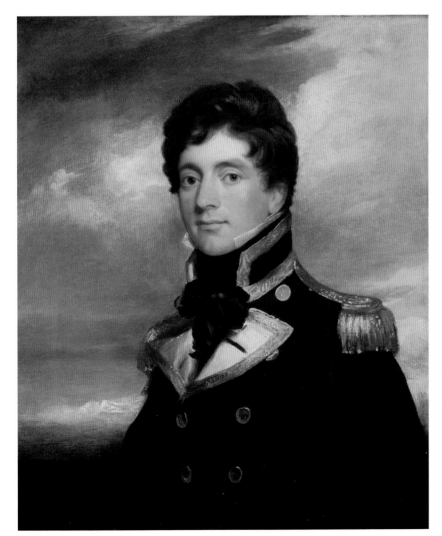

46
Captain Frederick William Beechey, George Duncan Beechey, circa 1822. BHC2543 / BHC2543.
This portrait shows Beechey in the captain's full dress uniform 1812-25, which features white lapels.

single one on his left shoulder. The epaulettes of a captain of over three years' seniority were now distinguished by the addition of a crown over the silver anchor on his epaulettes, while captains of under three years' seniority were allowed silver anchors on theirs (see Figure 47).

The new regulation for epaulettes, issued in March 1812, was to take effect in August of that year; however the order came with the caveat that 'such Officers of the Royal Navy as may have occasion, before this period, to make up New Uniforms, are at liberty to have them made up according to the New Patterns'. As the order came on the birthday of the Prince Regent, verses in his honour were published in *The Naval Chronicle* 'addressed to the Lieutenants of the Navy, upon the change of uniform, adopted August 12 1812'[32]; one stanza in particular highlights the importance of the epaulette to an officer's social standing, not only in comparison to the army, but in society:

> No longer at the splendid ball,
> Or party, or assembly, shall
> The haughty fair-one scorn you;
> For now, as well as soldier fine
> Or of militia or the line,
> Shall golden 'swab' adorn you,
> Now with slash'd-sleeve, and epaulet,
> And rim cock'd hat, with neat rosette,
> You yield the palm to no men:
> With regulation sword and knot,
> So bold and smart, – you will, I wot,
> Be the delight of women.[33]

Captain John Harvey Boteler noted in his *Recollections of my Sea Life from 1808–1830*, that several were quick to take up the Admiralty order before August: 'The first two or three days some lieutenants began to mount the swab. The signal man would report a post captain coming and the guard turn out to received him, when it proved to be *only* a lieutenant.'[34]

Because the regulations changed little between 1812–25, there was less expense connected with the uniform. The tailor's bills for Captain Palmer RN survive in the records of Meyer & Mortimer.[35] In March 1811, Palmer ordered a full dress uniform and, as in Borlase Warren's expenditures in the 1770s, the most expensive element of the uniform was the lace: 15 1/2 yards of 'rich gold Navy lace' was required for his dress uniform at a cost of £10.17s. By contrast, the 'superfine blue cloth' was only £3.11.3d, while the lining of white silk serge was £2.5. Overall, the cost was still substantially less than that spent by Borlase Warren when he was a captain. Further, in 1815, Palmer's only bills were for altering the

47
Detail of a captain's epaulette, pattern 1812–25. UNI0098 / F2179-3.
While the silver anchor is worked in metal thread and spangles, it would later feature a cast base metal anchor or, if the wearer could afford it, an anchor embroidered in silver plate.

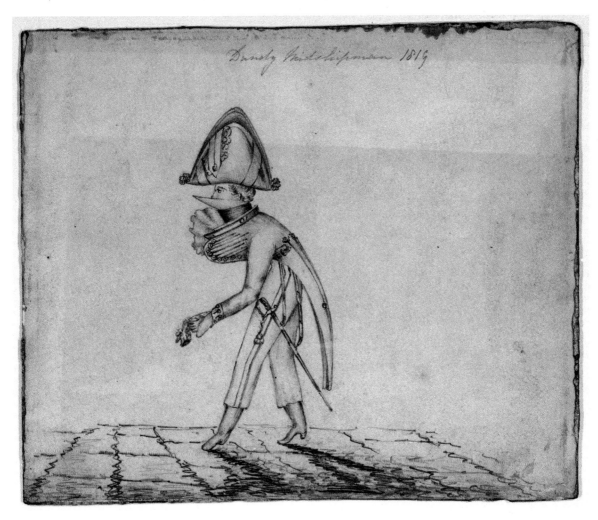

48
Dandy midshipman 1819, William Henry Smyth. PAF0613 / PW0613.
Uniforms of the period feature padded chests, to achieve a more rounded shape as
well as extremely tight wasp-waists which could really only be achieved with a corset.

lapels of a dress uniform coat, for 16s.6d., and for ordering two frock uniform coats, most likely undress, at a cost
of £7.15s.10d. each.

With regard to the relationship between uniform and civilian dress, by 1812 breeches, still part of uniform, were
going out of fashion for civilians, with choices being either for pantaloons, which were skin-tight and could extend as
far as the ankle, or trousers worn tight to the knee with a strap across the instep to ensure a perfect fit. Captain Palmer
appears to have preferred pantaloons to breeches and had several orders for them made of stockinette, a knitted fabric.[36]
Further changes to be seen in coats of the period are the rolled notched collar and, in terms of the male body shape, a
very full chest was now favoured. This could be gained by padding the breast of the coat, which can be seen in extant
uniforms of the period. This is also caricatured in a drawing of a 'Dandy Midshipman' of 1819 (see Figure 48), who
is nearly bent in half from the great weight of his padding. Both the styles favoured in the early part of the nineteenth
century and their relationship to dandyism owes much to the taste of Beau Brummell. George Bryan Brummell, or
'the Beau' as he was known, favoured the informal 'country styles' of male dress, but was not, according to costume

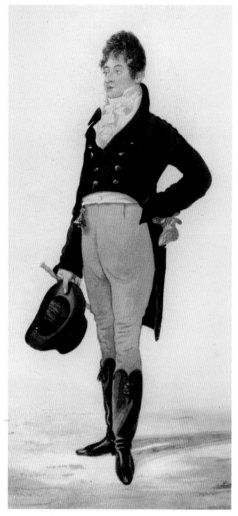

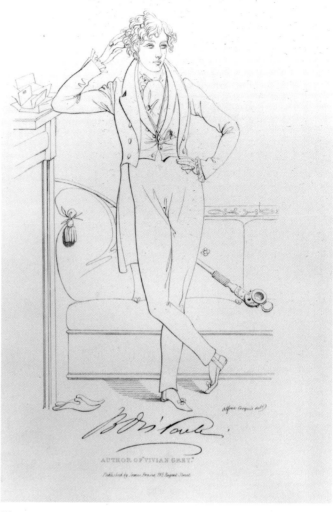

49
George 'Beau' Brummell, Robert Dighton, Caricatures of Notable Englishmen, 1805. Private collection.
This image of dandy Beau Brummell illustrates all the elements of elegant masculine dress in the early nineteenth century.

50
Benjamin Disraeli, Daniel Maclise, circa 1833. National Portrait Gallery, NPG D1032.
Instead of the restrained elegance advocated by Brumell, Disraeli favoured a more flamboyant style of dandified dress.

historian Nora Waugh, 'an innovator, but a perfectionist'. He 'set the seal on the new fashion by removing the odour of the stables. He had the floppy cravat starched, the muddy boots polished and, above all, he demanded perfect cut and fit'.[37] (See Figure 49.) Yet, while Brummell may have set the standard of male dress in Britain, and in a sense, contributed to its standardization, dandyism itself was against uniformity. Although Brummell favoured an understated and elegant style, some of his followers, like the young Benjamin Disraeli could be flamboyant (see Figure 50).

Dandyism was not solely about dress; it encompassed an attitude. The dandy did not work, he was not married and above all he was a social snob, although he himself did not necessarily come from an aristocratic background. Further, the lifestyle of the dandy was an expensive one; Brummell himself spent his inheritance of over £40,000 by the time he was 38. Forced to flee to France to escape his debtors in 1819, Brummell died in a sanatorium in 1840, in abject poverty and mentally unstable. In Britain, in his absence, a backlash against the dandies steadily

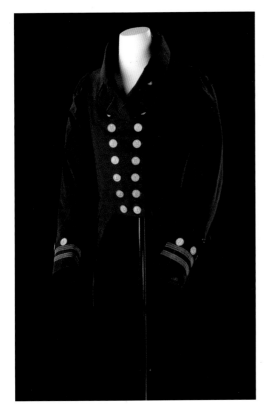

51
Undress coat of Vice-Admiral Sir Edward Codrington, pattern
1825 7. UNI0122 / F4835-001.
This coat, which was worn at the Battle of Navarino in
1827, clearly shows the influences of Brummel, with its
rolled, notched collar and very high standard of tailoring.

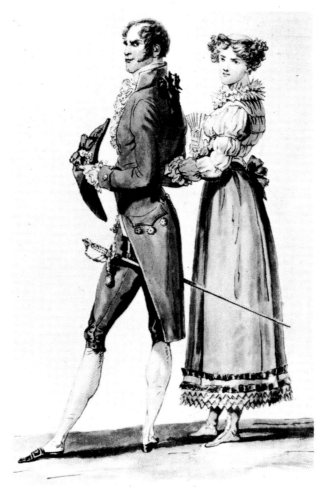

52
Englishman in Court Dress, Carle Vernet, 1817.
Bibliothèque nationale de France, Paris.

gained ground; among its advocates were writers like Thackeray and Carlyle, whose commentary focused on the uselessness of the dandy and 'puffery' of his appearance. However, there was another element to the dandy which, when paired with his seemingly useless lifestyle, was at odds with the increasingly pervasive evangelicalism: this was his inherent effeminacy which carried with it an undertone of homosexuality. Despite these connotations, Brummell's influence was felt in naval uniform, but not until the regulations of 1825, as can be seen in an undress coat worn by Admiral Codrington (see Figure 51) which, when compared with Dighton's caricature of Brummell, contains all the elements advocated as necessary for a truly stylish figure, including the cut-away front and roll collar. Yet, by this time Brummell had ceased to be a fashion leader and was living in increasing decline in Caen.

The lag between uniform in the 1820s (even undress) and fashionable clothing is not unique to naval dress, but can be seen in the court dress of this period as well. While formal evening wear for the stylish consisted of a dark frock coat, dark pantaloons buttoned at the ankles, and a waistcoat of a contrasting colour and fabric, court dress owed much to the eighteenth century and in some cases still featured a vestigial wig-bag sewn firmly to the back of the collar – despite the fact that cropped hairstyles were now worn (see Figure 52). Full dress uniform, like court dress, also recalled outmoded fashions. The coat of a rear-admiral from this period has a cut-away front and the old-fashioned elements

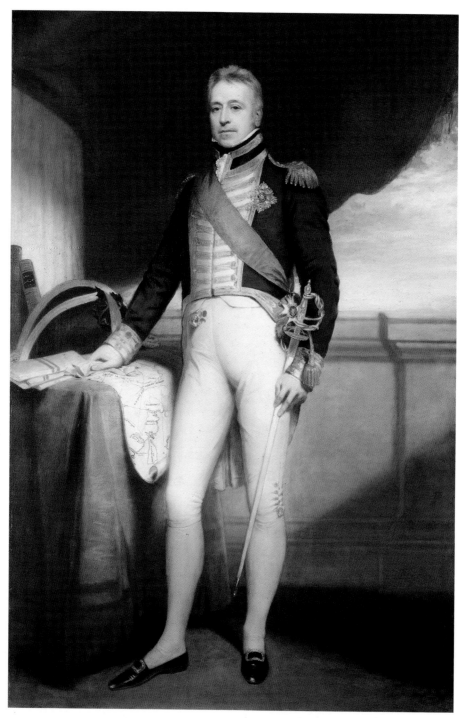

53

Vice-Admiral Sir George Cockburn, Sir William Beechey, 1820. BHC2618 / BHC2618.

Cockburn is shown in full dress, which has clearly diverged from civilian fashion. The full dress uniform of the 1820s was neither practical nor fashionable, but instead, with its exaggerated lapels, recalled the clothing of Nelson's navy.

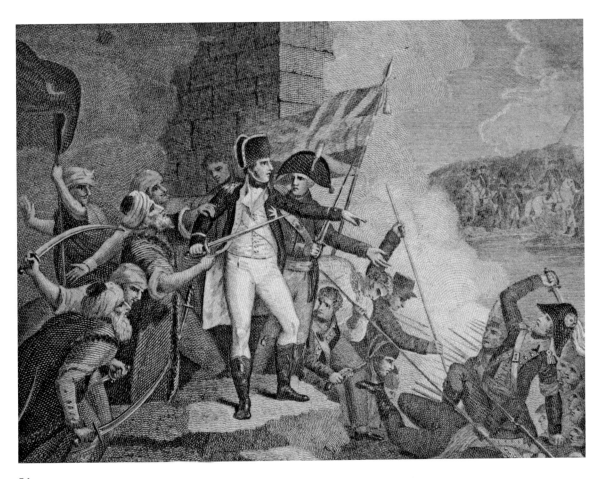

54
Sir S. Smith Defending the Breach of d' Acre, against Bonaparte, Laffert (artist), A Smith (engraver),
Richard Evans (publisher), 12 March 1815. PAD5622 / PU5622.
Sir Sidney Smith is the central figure in this print. His image as a dashing and heroic officer is completed by
his tasselled hessian boots, against which the Admiralty fought so hard.

of buttonholes on the skirts, three-point pocket flaps and a standing collar. The lapels have become much wider but are firmly stitched to the coat, creating the visual effect of a breastplate as can be seen in a portrait of Sir George Cockburn painted in 1820 (see Figure 53). Like court dress, the full dress uniform retains breeches and a waistcoat that is not cut straight across, as had been done in popular fashions since the late eighteenth century, but instead ends in two points, recalling a style that was popular in the 1770s and had in fact been worn by the Royal Navy since that time. By this point, uniform had become something that was, visually, completely separate from contemporary fashions.

In 1814, Prince William, Duke of Clarence and Admiral of the Fleet, sought to add more changes to the naval uniform, which included white pantaloons and gold-topped boots. However, the Admiralty was firmly against this and one of the board members wrote to Vice-Admiral Thomas Foley, noting:

> Bickerton [Admiral Sir Richard Bickerton] has very properly transmitted to us a letter he has received from the Duke of Clarence enclosing a Memorandum intended to be issued by him, relative to alterations in the uniform, or perhaps *amendments*, as some may call them.

We have given directions to Bickerton not to permit anything of the sort without a regular order from this board. I think it right to mention it to you that in case anything of the sort should come to you, you should not encourage the officers expending their money on things which will not be permitted to be worn.[38]

The Duke of Clarence had actually attempted to drag the navy forward in terms of updating some of the clothing worn to keep in step with contemporary fashion. It appears that the main point of contention with these proposals was the gold-topped Hessian boots that he recommended. Certainly they were the height of fashion in this period, and George August Sala, writing in the mid-nineteenth century, paid tribute to them as 'mirror-polished, gracefully-outlined, silken tasselled Hessians'.[39] (See Figure 54.) They were also recommended by Beau Brummell, who claimed to have spent hours having his polished to attain a mirror-like surface. Perhaps they were deemed to require too much maintenance, or their associations were with the wrong type of élite society: both the dandies and the high-living coterie of the Prince of Wales.

The old navy versus the new navy

By the 1820s, due in part to the lasting public memory of the Battle of Trafalgar as well as to changes in society, the naval officer had become a socially desirable figure. While the officers of *The Post-Captain* were portrayed as honest and manly yet still rough, those officers depicted in the novels of Jane Austen have become sought-after figures. This is clearest in *Mansfield Park*, which contrasts the less savoury aspects of the 'old navy' with the social desirability of the 'new navy.' Austen began writing *Mansfield Park* in 1809, and it was published in two editions in her lifetime, in 1814 and 1816. In the novel the character of the Admiral is an officer who rose through the navy in the eighteenth century and, although he is never seen, accounts of him lead to the conclusion that his behaviour owes more to Chesterfield than to the moral and religious tracts of Hannah More, a writer and philanthropist, popular in the late eighteenth and early nineteenth centuries. The Admiral is credited with having ruined the characters of his wards Mary and Henry Crawford, as Mary herself makes clear when she comments on the company he keeps:

> Post-captains may be very good sort of men, but they do not belong to *us*. Of various admirals I could tell you a great deal: of them and their flags, and the gradations of their pay, and their bickerings and jealousies. But, in general, I can assure you that they are all passed over, and all very ill used. Certainly, my home at my uncle's brought me acquainted with a circle of admirals. Of *Rears* and *Vices* I saw enough.[40]

In contrast to the Admiral and the 'old navy' is William Price, a 'young man of an open, pleasant countenance, and frank, unstudied, but feeling and respectful manners…'[41] which allow him to move within polite society. Yet his behaviour and stories of his profession also contrast him not only with the Admiral, but also with the vain and wealthy Henry Crawford:

> To Henry Crawford they gave a different feeling. He longed to have been at sea, and seen and done and suffered as much. His heart was warmed, his fancy fired, and he felt the highest respect for a lad who, before he was twenty, had gone through such bodily hardships and given such proofs of mind. The glory of heroism, of usefulness, of exertion, of endurance, made his own habits of selfish indulgence appear in shameful contrast; and he wished he had been a William Price, distinguishing himself and working his way to fortune and consequence with so much self-respect and happy ardour, instead of what he was![42]

The character of the naval officer is still a foil, but it is no longer the bluff Captain Mirvan tormenting the foppish Lovel as seen in *Evelina* (see Chapter 1, page 29) or the rough manliness of Captain Brilliant against the effeminate

Lord Fiddlefaddle in *The Post-Captain*; instead it is the correct behaviour of William Price compared to the devious vanity of Henry Crawford. The naval officer has evolved to illustrate the qualities of refined sentiment, hard work and high principles. Naval officers have been refined, but not feminized and are suitable examples not only of national heroes, but also of models of masculinity.

Austen's final novel, *Persuasion*, written in 1816 and published posthumously in 1818, is set at the end of the Napoleonic Wars when the officers of the navy, rich with prize money, are being paid off and returning to British society. In the early chapters of the novel, the foolish and spendthrift baronet, Sir Walter Elliot, an echo of the Chesterfieldian aristocrat, decries the organization that allows those without birth to attain rank. Although his daughter, Anne, notes that they 'have done so much for us'[43], he persists:

> ... it [the Navy] is in two points offensive to me; I have two strong grounds of objection to it. First, as being the means of bringing persons of obscure birth into undue distinction, and raising men to honours which their fathers and grandfathers never dreamt of; and, secondly, as it cuts up a man's youth and vigour most horribly: a sailor grows old sooner than any other man. I have observed it all my life. A man is in greater danger in the navy of being insulted by the rise of one whose father his father might have disdained to speak to, and of becoming prematurely an object of disgust himself, than in any other line. One day last spring, in town, I was in company with two men, striking instances of what I am talking of: Lord St Ives whose father we all know to have been a country curate, without bread to eat: I was to give place to Lord St Ives, and a certain Admiral Baldwin, the most deplorable looking personage you can imagine; his face the

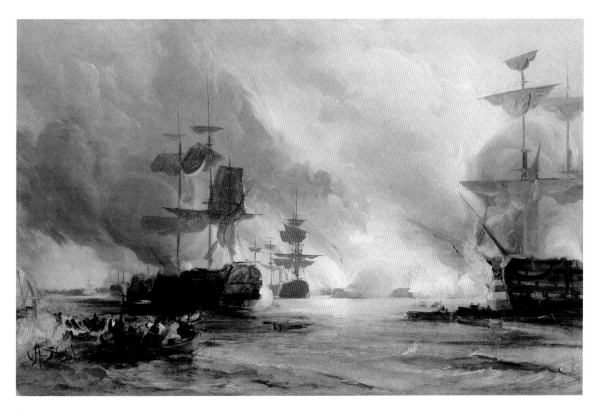

55
The Bombardment of Algiers, 27 August 1816, George Chambers, Senior, circa 1836. BHC0615 / BHC0615.

colour of mahogany, rough and rugged to the last degree, all lines and wrinkles, nine grey hairs of a side, and nothing but a dab of powder at top.[44]

Captain Wentworth, in contrast to the weak and vacillating Sir Walter, is an exemplar of early nineteenth-century manliness. However, while naval officers are seen as desirable, particularly as husbands for the daughters of the landed gentry, Austen's representations are not to be seen as blind hero worship. Wentworth and his friends have their shortcomings – particularly inconstancy of feeling, as Captain Benwick demonstrates by rapidly forgetting the heartbreak of the premature death of his fiancée and quickly becoming engaged to another. This example stands out in stark contrast to Wentworth's prolonged attachment to Anne Elliot, but also brings to mind the character of Factor from *The Post Captain*, who was often and quickly moved to tears, which made the depth of his feeling suspect. During the early decades of the nineteenth century, the officers of the navy were often seen as ideal men, yet they are not completely unblemished. While Wentworth is ultimately shown to possess all the desired masculine qualities, he has also proven his merit within the navy, rising in his profession and becoming moderately wealthy as a result of his successes – the very type Sir Walter Elliot denigrates. Yet, while the lure of prize money and potential elevation in social status were two of the incentives for joining the navy during the period of 1792–1815, this degree of mobility was already curtailed, due in part to a prolonged period of peace, but also to an increasing stratification of society that was tied closely to issues of morality and evangelicalism.

The conflicts of the early decades of the nineteenth century impacted on the images of the navy, particularly as seen in the lasting legacy of Trafalgar. However, events such as the War of 1812 did not enhance the reputation of the navy. As John Mitford, a former naval officer and one-time associate of Lord Byron, commented, 'The war with America certainly terminated very badly for this country … the Americans boast that they were our Conquerors by their physical strength, courage, and seamanship, allowing not anything of their superior forces.'[45] While this may have damaged the reputation of the Royal Navy as a military power, the idea of the officer as moral exemplar can be seen in the role of the navy in the period after the Napoleonic Wars: an increasing role in anti-slavery activities following the abolition of the slave trade in 1807, and anti-piracy activities such as the Bombardment of Algiers in 1816 (see Figure 55), which saw the release of over 1,000 'Christian captives', all helped elevate them to the level of Britain's moral guardians. Yet, as a visual representation of this transformation, the uniform was synonymous with two conflicting identities: that of Nelson, whose legacy would prove difficult to live up to, and that of the period of immoderation and moral laxity epitomized by the Prince Regent. While public perceptions of the naval officer may have become more positive, that visual construction of their identity – the uniform – had stagnated.

1 *Gentleman's Magazine*, 1801, p. 34.

2 *Morning Post and Gazetteer*, 16 October 1798.

3 Mary Wollstonecraft, *A Vindication of the Rights of Women*, vol. I, 2nd edition (London: J. Johnson, 1792), p. 27.

4 Ribeiro, *Dress in Eighteenth-Century Europe*, p. 211.

5 Giuseppe Marc'Antonio Baretti, *Easy Phraseology, for the use of young ladies who intend to learn the colloquial part of the Italian language* (London: G. Robinson, T. Cadell, 1775), p. 39.

6 *The Times*, London: Thursday, 12 June 1788; p. 3; issue 1096; col. B.

7 Sir Thomas Byam Martin, *Letters and papers of Admiral of the Fleet Sir Thomas Byam Martin, GCB*, ed. Sir Richard Vesey Hamilton, 3 vols. (Greenwich Navy Records Society 1898–1903), pp. 120–21.

8 *Ibid*.

9 *Ibid*.

10 National Maritime Museum, Perceval papers, PER/1/46.

11 C. P. Moritz, *Travels of Carl Philipp Moritz in England in 1782* (London: 1924), p. 83 quoted in Ribeiro, *Dress in Eighteenth-Century Europe*, p. 213.

12 Quoted in May, *The Uniform of Naval Officers*, vol. I, p. 29.

13 Caleb Hillier Parry, *Facts and observations tending to shew the practicability and advantage of producing British Isles clothing wool equal to that of Spain, together with some hints towards the management of fine-woolled sheep* (Bath: 1800), p. 52.

14 *Ibid.*, pp. 53–4.

15 *Ibid.*

16 Shawn L. Maurer, *Proposing Men: Dialectics of Gender and Class in the Eighteenth-Century English Periodical* (Stanford: Stanford University Press, 1998), p. 75.

17 Rodger, *Command of the Ocean.*

18 Office for Sick and Wounded Seamen, 13 May 1805, quoted in May, *The Uniform of Naval Officers*, vol. 1, p. 50.

19 Extract of a letter from the Physicians and Surgeons of the Royal Hospital at Haslar to the Commissioners for Sick and Wounded Seaman, 28 April 1805, quoted in May, *The Uniform of Naval Officers*, vol. 1, p. 51.

20 *Ibid.*

21 *The Lady's Monthly Museum* (January 1802), NMM typescript, p. 69.

22 John Davis, *The Post-Captain: or the wooden walls well manned: comprehending a view of naval society and manners*, 3 vols., 3rd ed. (London: T. Tegg, 1808), pp. 173–4.

23 For a full discussion of the reception of Chesterfield's *Letters*, see Davidson, *Hypocrisy and the Politics of Politeness*, pp. 65–73.

24 'Lord Chesterfield's Creed', *Gentleman's Magazine of Fashions* (March 1775) p. 131, quoted in Davidson, *Hypocrisy and the Politics of Politeness*, p. 70.

25 Davis, vol. 2, p. 144.

26 Davidson, p. 76.

27 Davis, vol. 3, p. 199.

28 *Ibid.*, vol. 2, p. 136–37.

29 *Ibid.*, vol. 3, p. 209.

30 Charles Blanc, *Art and Ornament in Dress* (London: Chapman and Hall, 1877) pp. 66–67 quoted in Alison Matthews David, 'Decorated Men: Fashioning the French Soldier, 1852–1914', *Fashion Theory*, (Oxford: Berg 2003), vol. 7, issue 1, p. 7.

31 Mary Julia Young, *A Summer at Brighton*, 3 vols. (London: J. F. Hughes, 1807), vol. 1, pp. 60–61.

32 *Naval Chronicle*, vol. xxvii, (1812), p. 334 quoted in May, *The Uniform of Naval Officers*, vol. 1, p. 63.

33 *Ibid.*, p. 65.

34 John Harvey Boteler, *Recollections of my Sea Life from 1808-1830* (Naval Record Society, 1924), p. 34 quoted in May, *The Uniform of Naval Officers*, vol. 1, p. 69.

35 All prices and entries from ledger that are quoted are in the collection of the tailoring firm Meyer & Mortimer, Saville Row, London.

36 Meyer & Mortimer.

37 Nora Waugh, *The Cut of Men's Clothes 1600–1900* (London: Faber & Faber, 1964), p. 112 quoted in Jane Ashelford, *The Art of Dress: Clothes and Society 1500–1914* (London: National Trust Enterprises, Ltd., 1996), p. 185.

38 National Maritime Museum, XX (62750.1) papers of Sir Thomas Foley, quoted in May, *The Uniform of Naval Officers*, vol. 1, p. 77.

39 George Augustus Sala, *Gaslight and Daylight* (London: Chapman and Hall, 1859), p. 63 quoted in Ashelford, *The Art of Dress*, p. 186.

40 Jane Austen, *Mansfield Park*, 3 vols. (London: T. Egerton, 1814), vol. 1, p. 124.

41 *Ibid.*, vol. 2, p. 128.

42 *Ibid.*, p. 135.

43 Jane Austen, *Northanger Abbey* and *Persuasion*, 4 vols. (London: John Murray, 1818), vol. 3, p. 41.

44 *Ibid.* pp. 42–43.

45 John Mitford, *The Adventures of Johnny Newcome in the Navy* (London: Sherwood, Neely & Jones; J. Johnston, 1819), p. 282.

56

A Mid on Half Pay, C. Hunt (engraver and publisher), 1 June 1825. PAF3722 / PW3722.

The Navy's New Clothes

The years following the end of the Napoleonic Wars saw the navy down-sizing as ships were paid off and relatively young officers found themselves with a reduced income, as in the 1825 caricature *A Mid on Half-Pay* (see Figure 56), which shows a gaunt and threadbare midshipman reduced to polishing shoes to eke out a living. The instruments of his profession have been pawned and his empty sextant box holds the new tools of his trade: boot polish and brushes. Certainly in this period of relative peace, public perceptions of the navy were linked, with growing nostalgia, to the period of Nelson. Popular novels such as *The Navy 'at Home'* and *The Sailor Boy* (both published in 1830) are set in the time of Nelson's navy – in fact, the heroes of *The Sailor Boy* are present at the two great Nelsonic victories: the Nile and Trafalgar. In the late 1830s, *The Commodore and his Daughter* (1838) placed the title character at the Battle of Camperdown, admittedly a victory won by Admiral Adam Duncan; however, both the sailor and officer of the late Georgian navy were lionized in popular literature, their courage, skill and seamanship becoming legendary.

This legacy proved to be a mixed blessing, as both the War of 1812 and the Battle of Navarino (1827) did not measure well against the yardstick of Trafalgar. The Battle of Navarino, an action between the combined French, Russian and British fleets under the British Commander Edward Codrington, against the Turkish-Egyptian fleet, was conducted by European allies on behalf of Greece in her struggle for independence from the Ottoman Empire, and was an inadvertent victory (see Figure 57). Codrington had been sent to engage in diplomatic negotiations and, it was felt that, by entering Navarino Bay where the Turkish-Egyptian fleet was anchored, he deliberately provoked hostilities. He was court-martialled after the battle and reluctantly cleared of charges; however, the victory was not enthusiastically reported by the British press, particularly *The Times*. What this does illustrate is that the Royal Navy of 1827 was, in popular public opinion, not as strong as Nelson's navy. This perceived decline was discussed at length in pamphlets and tracts throughout the first half of the nineteenth century.

As part of what could be construed as an attempt to create a new look for the navy, a radical change was made to the uniform regulations of 1827 when the uniform so long associated with the great naval victories won by hallowed names like Nelson, Rodney and Hood was abolished. In its place was a streamlined, modern costume, drawn directly from contemporary fashions, that served to dress all commissioned officers in more or less the same costume, with the exception of midshipmen, who still retained the style worn in the early part of the nineteenth century. Rank was differentiated by epaulettes and by the width of gold lace worn on the collar, cuffs and trousers. It is difficult to fully analyse the uniform change of 1827, as no Admiralty records survive to indicate why the decision was taken, or who, in fact, was behind it. However, an examination of period texts such as pamphlets, novels, and memoirs reveals issues and attitudes such as moral laxity and evangelicalism that make it possible to contextualize the change. Within the navy, the new uniform and the various amendments that were made to the patterns through the first half of the nineteenth century impacted on long-running institutional issues, especially pay and promotion. One interpretation of the new uniform is that it provided a way to break with a past that

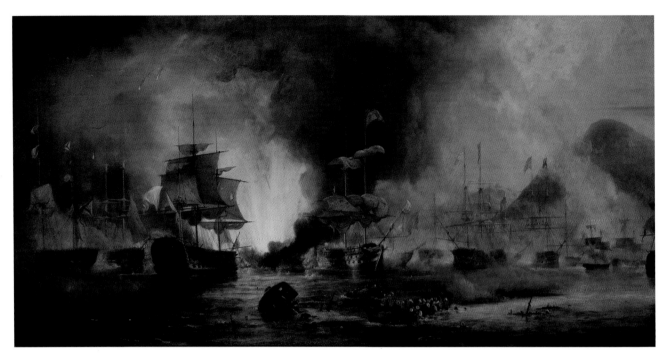

57

The Battle of Navarino, 20 October 1827, George Philip Reinagle, 1828. BHC0623 / BHC0623.

was increasingly mythologized. It can also be seen as a way of presenting an image of a new force, which the navy increasingly became as it underwent the transition from sail to steam.

The new uniform

In late December 1827, the Lord High Admiral, the future William IV, introduced uniform regulations that drastically altered the existing patterns of 1825 (see Figure 58). These new regulations both updated the uniform and drew it more in line with contemporary fashions. Unfortunately, as mentioned earlier, Admiralty records do not survive to elucidate the motives or decision behind this change. In the Admiralty records at the National Archive, there is a copy of the 1825–27 regulations that has been partially amended. The notations suggest that this was started as a cursory update of regulations, and that only small changes, similar to those of 1812–25 and 1825[1] were being considered. However, the notations are only present in the first third of the regulations, and further alterations appear to have been abandoned as more extensive changes were introduced. These regulations were circulated detailing the new dress, including a coat of 'blue cloth, with a white stand-up collar … a slashed sleeve with blue three-pointed flap and three buttons and holes; a white cuff … pocket flaps with three points, not buttons; the body of the coat lined with white[,] the same cloth and the skirts lined with white kerseymere'.[2] For those whose clothing was relatively new, there was a brief reprieve at the end of the circular:

> Patterns of drawings of each of the before-mentioned articles of dress are to be seen at this Office, and at the Office of each Port Admiral; and His Royal Highness directs, that no article shall after this date, be made of any other pattern. Articles which have been already made of a

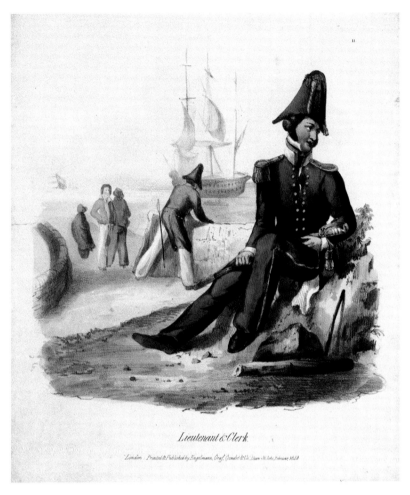

58
Lieutenant & Clerk, Engelmann, Graf, Coindet, & Co, February 1829. PAF4204 / PW4204.
The uniforms of 1825–7 were the first illustrated regulations. However, they were more in keeping with tailors' patterns than these which are quite similar to the fashion plates of publications such as *The Gentleman's Magazine of Fashion*.

different pattern from the foregoing, may, however be worn till the 1st of January 1829, after which no deviation whatsoever will be permitted.[3]

These new, double-breasted coats were worn with a waistcoat and trousers instead of breeches. While it drew directly from contemporary styles in that it followed the lines of that staple of the male wardrobe, the morning coat, it also incorporated styles specific to uniform, such as the stand-up collar. It also retained elements of the 1748 uniform such as the mariner's cuff and three-point pocket flaps; the latter were by this point solely ornamental, as the pocket bag was accessed through the skirts of the coat. Although undress uniform was technically abolished, officers could wear a short blue single-breasted greatcoat (see Figure 59). Like the uniforms of 1748, the uniform changes of 1827 only affected commissioned officers while mates, midshipmen and warrant officers continued to wear the uniforms of 1825. The new patterns of 1827 were not universally well received; Sir Thomas Byam Martin confronted the Duke of Clarence over the new uniform, noting in his memoirs that 'When the alterations took place

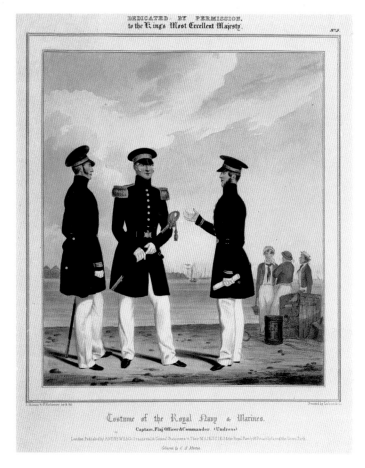

59

Costume of the Royal Navy & Marines. Captain, Flag Officer & Commander (Undress), **L Mansion (artist), St Eschauzier (artist), C H Martin (artist), Lefevre & Co (printers), Andrews & Co (publishers). PAF4262 / PW4262.**

While technically undress uniform was abolished, this great coat was presented as an option for undress.

I was too sulky to keep my opinion to myself, and told the Lord High Admiral I thought it would be distasteful to the whole service. He assured me he had nothing to do with the change! I said he had the credit of being the author of it.'4

Visually it was a definitive break from the old dress uniform. As there was a long-standing link between dress and morality – that appropriate and to a certain extent sober dress was indicative of moral goodness – it is interesting to note that, throughout the 1820s (the years immediately preceding the change), the overwhelming concern expressed in popular tracts and pamphlets in regard to the navy was the moral condition of its officers. The writers dwell specifically on issues of prostitution, at one point naming it as one of the root causes of the mutiny of the Nore in 1797. Yet as one pamphleteer, known as 'An Old Naval Surgeon,' wrote in 1824:

> Having heard of the publication of a Pamphlet addressed to the Lords Commissioners of the Admiralty on certain immoralities tolerated in the Navy, I was induced to read it; and discovered, that it rated of a very great existent evil, which I freely confess, from its general prevalence in the Service since I embarked in it, never before struck my mind with the full force it has now done; and I cannot but feel it a duty I owe to the Service as well as to the Country in general, to make some observations upon the present System, which I shall address to the Naval Profession, in the hope that this subject may engage the attention of those officers who are zealously bent upon the improvement of the navy, so that they may give it due and unprejudiced consideration, and be

Sailors Carousing, *or a peep in the Long room*

60

Sailors Carousing, or a peep in the Long Room, George Cruikshank, 1 October 1825. **PAD0158 / PU0158.**

This image of sailors carousing with prostitutes is a common one throughout the late eighteenth and early nineteenth centuries. It is also a theme that is shown not only on shore, but in the context of the cockpit as well. In the 1820s it was stressed that this atmosphere was increasingly unwholesome for the boys who were midshipmen.

> led to use their exertions, in order to remedy the evil … It is not my intention to approach the Admiralty on the subject, or to presume to inquire why their Lordships have not, at a time like the present, turned their attention to the moral improvement of the Navy, while they have done, and are doing, so much for the material part of it.[5]

The writer refers to the new technological innovations that are beginning to take place in the navy, yet notes that these strides forward on one front are increasingly at odds with what was popularly viewed as an outmoded moral laxity. This concern regarding the moral corruption of future officers at a young age is also seen in the novels of Frederick Marryat, particularly in his first novel, *Frank Mildmay*, which he wrote during the 1820s and published in 1829. A naval officer, Mildmay refers to the ruin of his character as taking place while he was still a young midshipman through his 'sensual education in the cockpit.'[6] The worry that young and impressionable midshipmen were being raised and trained in an unsuitable environment was not a new one; it was voiced in the mid-eighteenth century and throughout the period of Nelson's navy. However, by the 1820s, evangelicalism, which had been steadily rising since the late eighteenth century, was now firmly in the mainstream of British society (see Figure 60). Given that pamphleteers and writers like Marryat were voicing concerns about the moral atmosphere of the navy,

it is possible that many believed that the way in which to visually demonstrate improvement in this area was by altering the exterior appearance. Correct dress, pared of the excesses of the previous century, denoted not only the moral uprightness and forward-looking vision of the wearer, but of the organization he represented.

The reaction to the change, both public and private, was mixed. Admiral of the Fleet Sir Thomas Byam Martin raged against it in his memoirs:

> The coat we had before this late ridiculous change without exceptions was known and respected throughout the world; particularly the undress which was neat and unpretending and therefore appropriate to the profession. It was the uniform which Nelson wore when he was killed, and we were proud to think that what he wore, we wore too.[7]

The loss of Nelson's uniform is at the heart of the matter, as no other name has such a resonance with the both the navy and the nation at this period. However, an examination of the 1795–1812 pattern worn by Nelson (cat. 17) in comparison to that of the 1825–27 version worn by Codrington (cat. 40) reveals that the latter is merely a sartorial echo of the former, as mentioned previously; Codrington's uniform owes more to the styles popularized by Beau Brummell than to the fashions of the late-eighteenth century worn by Nelson. In addition, although Byam Martin may have spoken to the Duke of Clarence about his dislike of the new uniform, both the correspondence of the Admiralty and the Duke of Clarence appears to indicate that it was generally accepted, as there are (Byam Martin's comments aside) no other complaints registered. Within the navy the change seems to have been accepted positively, as George Gillott, Secretary to the Admiralty, remembered in 1842, when further changes were planned: 'The uniform with the white collar and cuffs ... which was similar to that now proposed ... was considered very sensible and the only objection I heard made to it was the difficulty of cleaning the white Collar & Cuffs.'[8] The most outspoken criticisms of the new uniform came not from the navy but from the *Gentleman's Magazine of Fashions*, which derided the change in July 1828:

> ... to *whose* or to *what influence* are we to attribute the cashiering of the consistent, appropriate, neat, simple and becoming uniform of the Navy, and the adoption, by authority, of flimsy, and to the *sailor's eye*, unsightly finery instead? When we delineate a sailor, we naturally look for his dress of TRUE BLUE; the dress in which he had fought, bled, and conquered for us under HOWE, JERVIS, RODNEY, DUNCAN, PELLEW, COLLINGWOOD, NELSON, and in a thousand victories; and when we see him, for no reason worth a pruin; and for fantastic notions deprived of this honourable, and by our TARS beloved uniform; and behold him dressed up, instead, in a costume made only for court days and drawing rooms ...[9]

As with Byam Martin's comments, the writer invokes the hallowed names of naval victors, particularly Nelson.

The 1795–1812 pattern was, at the time of its introduction, already beginning to diverge from contemporary fashions. The new uniform marks a link to contemporary dress rather than remaining a relic of the past. This change was made during a period when the navy had to redefine its role, as it was no longer a force needed for warfare. However, there was a deeper issue that the *Gentleman's Magazine of Fashions* touches on briefly, and that was the idea of refining military men. It was a concern that this new dress would have an almost feminizing effect on them, rendering them unfit for active service and leaving the British navy manned by a crew of ineffectual dandies. This fear, that fashionable dress when, in some cases, it is linked with effeminate or homosexual elements of society becomes representational of those qualities, was one that emerged cyclically, as can be seen in previous examples such as the macaronies, which were similar to the 1820s associations with dandies like Disraeli.

This concern in regard to effeminacy was one voiced by Byam Martin which had to do with shifting trends in the education of midshipmen and, by 1843, cadets, which was also linked in caricature to the new uniform. In the period immediately following the Napoleonic Wars, there was a change in the way in which midshipmen and cadets were trained. Previously they went to sea at a young age, like Byam Martin, to learn practical skills in

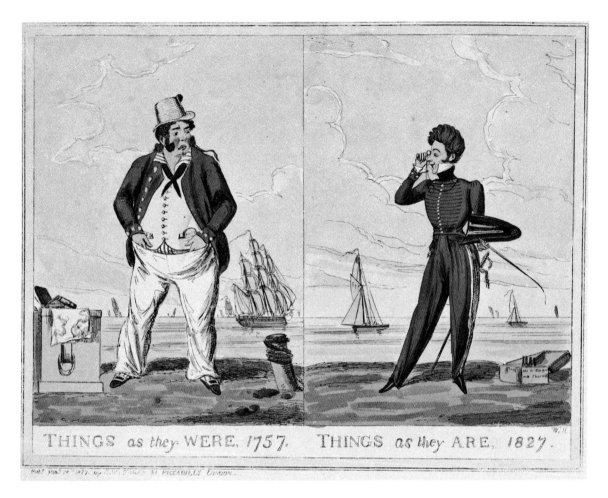

61
Things as they were, 1757. Things as they are, 1827. H W (engraver), S W Fores (publisher), 1827.
PAF3724 / PW3724.

an environment where the public was warned in 1827, in words similar to those used in *Frank Mildmay*, that 'If you know what a Man of War is, and that cock-pit of a Man of War is, then you know how fearfully at times it resembles, what by some has been occasionally denominated – "A little hell".'[10] Instead, midshipmen, and later cadets, were increasingly sent to the Royal Naval College at Portsmouth or, after 1837, to training ships. These arrangements created more of a boarding-school atmosphere instead of the morally dangerous environment of the ship. This change in training practices led to complaints that midshipmen went to sea with a good education but no practical skills. Byam Martin saw this as part of the general decline of the British officer and was damning in his view of the 'new' navy:

> The rivalry with midshipmen is no longer [in] smartness of professional duties, but in frivolous effeminacy, incompatible with what we wish and expect in the character of seamen. If we do not, above every other consideration, train young men so as to make them real, practical seamen, the consequences may be truly awful to the country.[11]

This idea of 'frivolous effeminacy' is linked visually to the new uniform, as can be seen in the 1827 caricature *Things as they were 1757. Things as they are 1827* (see Figure 61), which illustrates what is meant to be a lieutenant wearing the dress of Nelson's navy, his sea chest bursting with charts, maps and navigational equipment, showing that he is ready for action. By contrast, an effeminate lieutenant is shown in the new uniform of 1827; with the wasp waist and exaggerated shoulders of a dandy, he peers affectedly through a monocle and his small sea chest is filled with hair oil and perfumes. The new uniform was a visual reinforcement of Byam Martin's assertions.

When paired with peacetime down-sizing, this reform and refinement actually contained the implications that the navy would now be a smaller force manned with inferior officers that made Britain itself vulnerable. In the 1830s, with unrest in France and Wellington as Prime Minister, there were renewed fears of a possible invasion. A privately published pamphlet of 1838, *The Navy: Letter to his Grace the Duke of Wellington K.G. upon the Actual Crises of the Country in respect to the state of the Navy*, highlighted growing public concern:

> Do the nations on the Continent disband their armies, because of their mutual protestations of amity towards each other? We see the contrary all over the Continent; notwithstanding each power has its strong fortresses and positions on its frontiers, its standing Army is still kept up, and each nation closely watches the other. England, too, has her frontier – THE SEA; and,

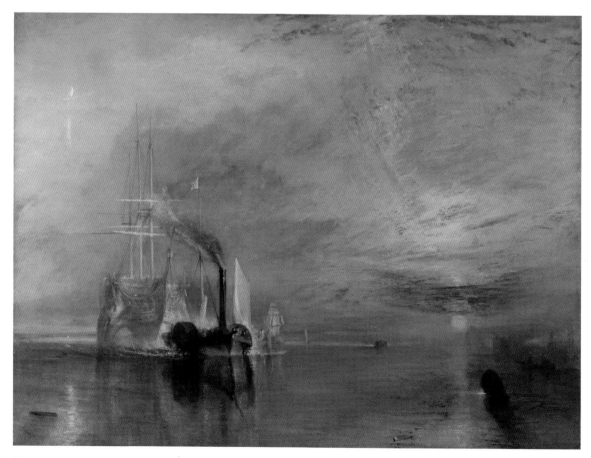

62
The Fighting Temeraire *tugged to her Last Berth to be broken up, 1838*, Joseph Mallord William Turner, 1839. National Gallery NG524. Turner Bequest, 1856.

formerly, she had her strong fortresses – HER SHIPS – her 'WOODEN WALLS,' and therefore she did not fortify her shores; and while these were in existence, she could defy any attack, no French Army (the only one she had then to fear) could venture across the Channel. These defences, however, no longer exist: the wooden walls are thrown down; the country is laid open; an Army may land without meeting any resistance whatever; and defenceless must England remain unless her walls are set up again.[12]

The writer than goes on to list the superior forces that are amassing against Britain, including the French and Americans as well as the Russian Fleet, which was seen exercising in the Baltic. In addition, he points out that this neglect of the navy may be seen in the highest levels of government, as the Queen herself set a poor example by not going to sea at all in the first year of her reign; she is compared unfavourably with the French king who '… visited the sea coast last summer, and a squadron attended upon him … His majesty went on board his ships and … even handsomely rewarded the seamen.'[13] It should be noted that in this same year, the artist J. M. W. Turner painted *The Fighting Temeraire tugged to her last berth to be broken up* (see Figure 62) showing the famous ship of the line that had come to the aid of the *Victory* at the battle of Trafalgar. The painting was felt, at the time, to show the decline of British naval power, as the obsolete ship of the line is towed away by a steam-powered tug; it also illustrated the advance of the new technology: steam power. Further, a rebuttal to these accusations appeared in 1839, in a pamphlet authored by Lord Minto, then First Lord Commissioner of the Admiralty. Minto sweeps aside what he sees as the misplaced faith in the 'wooden walls' and boldly outlines the future of the navy with the advent of steam power:

> … with respect to COMMERCE, convoys were never so efficiently protected as they will be by steamers. No sailing cruiser or privateer can venture to approach them. From these views it appears that our EMPIRE has far more cause for hope than apprehension from the ascendancy of Steam in naval affairs. We may expect however that some time will elapse before this truth is generally admitted. Men's minds will be loath to receive so momentous a conversion, as that of the comparative inutility of ships of the line.[14]

Minto outlines quite clearly the need for modernization within the navy and the role that steam will play as a new technology – as well as highlighting how outmoded the old wooden sailing ship has become.

It is interesting to note the juxtaposition between popular novels of the period, which propagate the image of Nelson's navy as the supreme force, while the political pamphlets outline the pressing need to discard the old sailing navy and embrace the future: that of a modern-looking navy with new technologies. The Battle of Navarino was the last action fought entirely by sailing ships; after 1827, steamships were used by the navy, initially for short journeys; and they were, in general, small boats like tugs. This was in part because coal was very expensive and a great deal was needed to fuel steamships. Yet this did not deter the navy and, after 1832, both iron and steam were a feature of shipbuilding at the naval dockyards. Sails were retained for use on steamships, as they provided extra power when the weather was right.

In 1830, the uniform underwent another change, as the white collar and cuffs were, at the instigation of William IV, altered to scarlet, which meant that the navy

63
Detail of cuff, full dress coat belonging to Commander J. Robertson Walker, pattern 1830–3. UNI0159 / F4841-003.

64
Vice Admiral, Engelmann, Graf, Coindet, & Co,
February 1829. PAF4208 / PW4208.

was now dressed in scarlet and blue, the colours of the Windsor uniform worn during the reign of George III (see Figure 63). This uniform was now worn by both commissioned and warrant officers, with the exception of mates, gunners, boatswains, carpenters, midshipmen, masters and volunteers, who still wore the 1825 uniform. The use of steam also meant the introduction of a new naval warrant officer, the engineer, who was first appointed in 1837. Engineers were given the same uniform as that worn by gunners: that of 1825, indicating that they were warrant officers. This new position of engineer would have far-reaching effects on the social structure of the navy, as their movement from the position of warrant officer to commissioned officer in 1846 sparked a debate in *The Times* about the appropriateness of this decision. A letter to the editor signed 'Wardroom' was published in November, which stated that to elevate the engineers would be to put them in the company of 'a superior class of people altogether, and by whom, generally speaking, they would be looked down upon as out of their station in society'.[15] A rebuttal to the snobbish attitudes expressed in 'Wardroom's' letter appeared a few days later from 'A Civil Officer of the Navy', who sought to remind the public of the original purpose of the navy: 'The navy estimates are not voted for the purpose of keeping up exclusive cliques, but for the support of an efficient and working force.'[16]

In terms of the appearance of the uniform, by 1825, the Admiralty was issuing illustrated regulations in the form of a pattern book which ensured a degree of standardization as tailors were no longer reliant on printed descriptions or required to view the sealed patterns lodged at the dockyards. In 1827 prints illustrating the new

uniform and accessories as worn by various ranks were issued, which were very similar in format to fashion plates of the period. Several of the interpretations of the new uniform owe more to the styles shown in the *Gentleman's Magazine of Fashions* than to the pattern books favoured by the Admiralty in 1825. One such example, for the 1830 uniform of a vice-admiral (see Figure 64), shows the double-breasted coat worn unbuttoned at the top, against Admiralty regulations, but in keeping with the *Gentleman's Magazine of Fashions* which advised reader in May 1828, that coats '… should be left, as if carelessly open in the front, so as to *discover* a pale silk under-waistcoat with gold buttons, which *en passant*, should be buttoned up to the coloured cravat, which may be so disposed, or arranged, as to clasp about the throat like the cordon of Field Marshall Wellington on a Court day.'[17]

The new navy

The new heroes of the navy were not the old military men; they were instead the polar explorers. These naval expeditions were not new; those of Cook in the 1770s were celebrated, and even Nelson as a young midshipman took part in the Phipps's Arctic expedition, where he famously attempted to capture a polar bear for its skin, an event mythologized in an early biography of Nelson and reproduced as a series of popular prints showing scenes from the Nelson's life (see Figure 65). However, these eighteenth-century voyages were eclipsed by the Royal Navy's achievements in the Arctic and Antarctic throughout the 1820s–40s. Exploration meant the expansion of empire, but it also contributed to Britain's intellectual and cultural cachet abroad. An Admiralty proposal of 1828

65
Nelson and the Bear, Richard Westall, circa 1806. BHC2907 / BHC2907.

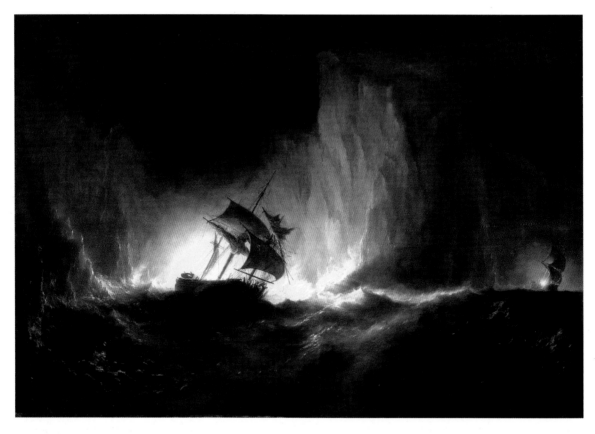

66
HMS Erebus *passing through the chain of bergs, 1842*, Admiral Richard Brydges Beechey.
BHC3654 / BHC3654.

outlines the goals of the expedition which would 'sustain the high esteem which England at present occupies among the civilized nations of the world' through the advancement of scientific and geographical knowledge.[18] Further, this acquisition of knowledge and creation of taxonomies were also tied to religion, as seen in Thomas Bewick's phenomenally popular *Birds of Britain* (originally published in 1790), which was informed by knowledge gained on various expeditions. In the introduction to the sixth edition, Bewick wrote, 'When I first undertook my labours in Natural History, my strongest motive was to lead the minds of youth to the study of that delightful pursuit, the surest foundation on which Religion and Morality can efficiently be implanted in the heart.'[19] The advancement of science, and in fact a fascination with polar exploration, caught the public imagination in a more romantic way as well. The plot device of Mary Shelley's 1818 novel *Frankenstein* features a Captain Walton who is impatient to embark on his Arctic expedition that the might '... satiate my ardent curiosity with the sight of a part of the world never before visited, and may tread a land never before imprinted by the foot of man'.[20] In terms of science, Walton longs to discover 'the secret of the magnet'[21] – a reference to the interest in and experiments on the Earth's magnetic field, and the search for the magnetic north pole.

With regard to religion, and particularly evangelicalism, the personal qualities that were deemed necessary for a successful expedition fulfil all the desired masculine criteria of the period: perseverance and endurance, humane treatment of indigenous people, and impeccable seamanship and navigational skills in frozen waters and difficult climates (see Figure 66). It is worth noting that the celebrated Arctic explorer William Edward Parry (1790–1855) was both an evangelical and an ardent advocate of moral reform in the navy. During this period, the portraits of

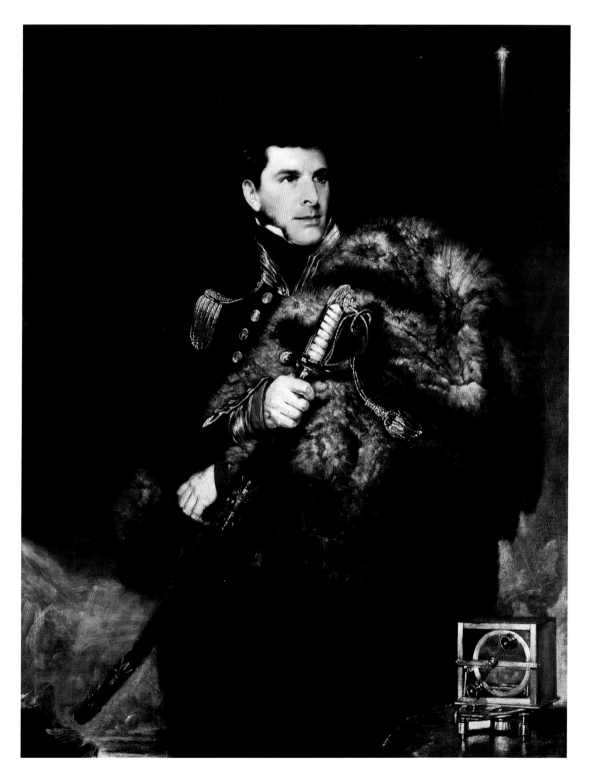

67
Commander James Clark Ross, John R. Wildman, 1834. BHC2981 / BHC2981.

polar explorers such as Parry were added to those of the existing naval pantheon of Nelson, Collingwood, Hawke and others, which were widely available as popular prints and would have been images with which the public was familiar. One example of the new naval hero was James Clark Ross, who discovered the magnetic north pole in June 1831. An 1834 portrait of Ross shows him resplendent in his dress uniform swathed in bearskin and surrounded by the attributes of his discovery, which both confirm him as a man of science but also embody popular romantic ideals fostered by fictional characters such as the noble but lonely Walton in *Frankenstein*. (See Figure 67.) This reference would still be fresh in the public conscience as Mary Shelley's novel was reprinted in 1831. It is interesting that the refinement of his immaculate full dress uniform is tempered by the bearskin, possibly implying that the masculinity of the arctic explorer is an antidote to the perception of overly refined dandies in the navy. Further, a comparison might also be made with the image of *Nelson and the Bear*; where Nelson failed, Ross has succeeded and got his bearskin. The polar explorers of the first half of the nineteenth century were one way in which the navy was able to surpass the legacy of Nelson.

The uniform of 1843

In 1843, the scarlet cuffs and collar were permanently abolished, and the uniform returned to a version of the 1827 regulations. Gold lacing was also added to the skirts, and stripes were worn paired with the mariner's cuff to denote rank (see Figure 68). These changes did not come without some debate in the Admiralty itself, as George Gillott, Secretary to the Admiralty, voiced his concerns regarding not only the extra cost to the wearer that the addition of gold lace would entail, but that what was meant to be a relatively practical uniform was becoming increasingly less useful:

> The other alteration which would enhance the expense will be the additional gold lace on the skirts of the Coats which will have the inconvenience of inducing the Superior Officers who wear it to put them on as rarely as the regulations will permit as the lace tarnishes fast when unfortunately on or near the sea, and the dress uniform will therefore be likely to become a mere <u>gala</u> coat instead of being what you mentioned the Duke of Wellington considered indispensable as any dress that uniform could be one adopted to all occasions.[22]

Nearly twenty years after the *Gentleman's Magazine of Fashions* decried the new uniform as 'fit only for drawing rooms and court days', Gillott voiced a similar concern. Not that the new uniform was necessarily dandified but, that by embellishing it with additional distinction lace, it would become impractical and expensive. In effect, making the uniform coat a garment where 'the appearance of increased splendour was an object'[23] meant that it would be rendered useless, as it was now something that could be worn only rarely and was no longer the serviceable suit of clothing that the Duke of Wellington had promoted.

It was not only the lace that Gillott felt was an issue in terms of added expense. Proposed changes to the 1843 regulations extended epaulettes to the ranks of mates and second masters as well as implementing additional insignia for existing epaulette patterns. The new designs for the rank of master would have 'two Gold Epaulettes same as Lieutenants, but with bullions [the] same size as Subalterns in the Army and [a] Reef Knot within the crescent'.[24] Those worn by second mates would include 'Two Gold Epaulettes same as

68
Detail of a cuff, full dress coat belonging to Commander Henry Bolton, pattern 1843. UNI2851 / F4836-003.

69

Embroiders' bill for Lonsdale & Tyler. ADM 7/620. The National Archives, Kew.

Mates, but [with] a Ring of an Anchor.'[25] Preliminary designs for epaulettes were also provided for other junior ranks, including midshipmen. Gillott's concerns were that these new additions would significantly affect the cost of the uniform. He provided embroiderers' bills[26] as well as a comparative list of the price of the old uniform against the added costs of the proposed changes.[27] (See Figure 69.) In it, he notes that the lieutenant's uniform would increase by £3 while the changes for mates and second masters would increase the cost of the uniform by £5 for their new distinctions. Ultimately the proposed uniform changes went before a committee of senior officers, who voted against some of them, specifically the addition of full epaulettes for junior ranks. Some on the board were sensitive to the financial implications; for example, Admiral Sir Charles Ogle felt that 'Many of the Inferior Officers have been ruined in paying for their Epaulettes.'[28] However, Vice-Admiral Sir E. D. King felt that the 'value of Epaulettes diminished in Upper Ranks & created too much self importance in the younger'.[29]

The primary concern about the proposed uniform changes for 1843 was their expense. In 1842, when these changes were first put forward, the chief point of dissatisfaction expressed by officers of the navy in popular tracts and pamphlets was the lack of pay and the few chances of promotion. In the 1845 publication *The Present*

Condition and Prospects of many Captains of her Majesty's Navy, the author compares the plight of the captain in the Royal Navy with that of the French:

> In the French Navy, stationary is furnished; the British officer supplies himself. The French Government issues linen, and table services, such as crockery, glass, etc.; in our Navy 7 percent per annum is deducted from the Captain's pay for the use of these articles; and, till yesterday, the almost necessary number of three chronometers for the safe navigation of the ship was withheld, unless the Captain paid for one of them; and many a Commander, when chronometers were dearer than they now are emerged from a half-pay of £155 a year to commence a full-pay career of £302.2s.6d. by providing an eighty-guineas watch for the public service, which remained on his hands when paid off, even if as fit as ever for another ship.[30]

While the claims may have been exaggerated, through publications like these the public perception soon saw the naval officer as underpaid and ill-used. While pay was an important issue, the greater concern seems to be that of promotion. Throughout the latter part of the eighteenth century, there was a surfeit of senior commissioned officers, a situation which did not change throughout the French Revolutionary and Napoleonic wars and one which continued into the nineteenth century.[31] The concerns engendered by this situation, particularly the long-standing impact it had on the opportunities for promotion, were voiced by Captain Rous RN and MP, who addressed the House of Commons in March 1842, noting that without the hope of advancement and recognition of talent of those young officers in the navy, there would ultimately be a breakdown in discipline and in the organization itself: 'We are all governed by rewards and punishment, but to them no rewards are held out, and consequently to them punishment has no sting.'[32] The idea that the navy, and in fact the military at large, was no longer a career in which to make one's fortune was also seen in popular fiction, specifically in Charlotte Yonge's 1853 novel *The Heir of Redclyffe*, where the character Philip, who has given up a place at Oxford to join the army in order to restore family fortunes, pines for 'the late war'[33] (the Napoleonic Wars), because his regiment is inactive. In light of the poor prospects of promotion and pay, one interpretation of the proposed uniform changes of 1843, particularly the addition of epaulettes, was that if advancement was not forthcoming, than at least its appearance could be obtained. However, as Gillott pointed out, the changes were financially excessive for junior officers who were not seeing an increase in pay.

As can be seen from the 1843 regulations, the issue of an impractical uniform with costly distinction lace was not resolved in the 1840s, but continued as a bitter subtext of the 1850s navy. Dissatisfaction was expressed in the fictional account of a master, *The Navy as it is; or the Memoirs of a Midshipman* (1854) by Augustus Broadhead, which notes that, despite the dress uniform with its gold lace, the rank of master is still not given the same respect as that of a lieutenant. The author combines the concerns voiced by Gillott – that the uniform would be impractical and more useful as court dress – with the warnings of Rous, that without the hope of promotion the master has become disillusioned:

> Oh, wise in their own opinion, but a very erring department in reality, the Admiralty – how long will you be ruled by tailors and haberdashers, and make good uniforms into bad ones, take away sling belts and give things that make a man look as if a sword was lashed to him to please these connoisseurs in dress, and also fill their pockets, alter uniforms, and give expensive dress to those who can ill afford to purchase them, have nowhere to keep them and moreover do not want them?[34]

The uniform had become the focus and the means of his disappointed hopes of promotion as well as a constant reminder of low pay, as he had no means of maintaining so expensive a costume. The uniform of the 1840s had become a visual construct of dissatisfaction.

The public image of the naval officer

Throughout the first half of the nineteenth century there was a duality in the public image of the navy. In pamphlets, tracts and newspaper reports it was seen as an organization that was working toward the advancement of scientific knowledge and new technologies like steam power, as well as addressing long-standing issues of morality. However, in popular fiction, the navy's identity seemed firmly tied to the Georgian navy, one of sailing ships, and constructs of honour and duty. It is this latter identity that Elizabeth Gaskell used in her 1854 novel *North and South*, written during the build-up to the Crimean War. In her novel of industrialization, Gaskell contrasted the aristocratic, almost feudal south of England with the industrialized north, particularly Manchester, with its mills that helped to secure for Britain the title 'workshop of the world'. In the book, the Hale family move from the idyllic New Forest to the manufacturing city of Milton, or Manchester, and are forced to reassess their attitudes towards class and labour issues. A shadowy presence throughout the novel is Frederick Hale; once a lieutenant in the navy, Frederick was involved in a mutiny which bears a strong resemblance to the mutiny of the *Hermione* in 1797. As Elizabeth Gaskell's father's family, the Stevensons, were a navy family, and all her uncles served in the Royal Navy during the 1790s, it is likely that this would have been an incident familiar to them. In his book, *The Command of the Ocean*, Nicholas Rodger outlines the importance of the mutiny in that

> [It] was a spectacular and unique event, and one of the very few which apparently conforms to the popular stereotype of a brutal captain driving his men to extremities. In fact the conduct of Captain Hugh Pigot was not simple brutality, but inconsistent and irrational brutality ... worse, he directly attacked the moral foundations of shipboard society. In the final incident which triggered the mutiny, he threatened to flog the last men down from aloft. They would necessarily be the yard-arm men, the most skilful topmen, with the dangerous and critical job of passing the reef-earrings. Pigot was punishing men for being the best, and when three men fell to their deaths in their haste to get down, he called to 'throw the lubbers overboard'. It was the worst insult in the seaman's vocabulary, and this final degradation drove the men mad. They seized the ship and murdered most of the officers.[35]

These events are very similar to those in Frederick Hale's account in *North and South*, which he writes to his mother from his refuge in Spain, where in reality, Pigot's crew took the *Hermione*. Frederick, however, writes that his captain's brutality so outraged his sense of honour that the had no other moral choice but to become part of the mutiny, yet instead of murdering the officers as happened in the case of the *Hermione*, Frederick's crew set them adrift in a boat. This was the story originally put out by the crew of the *Hermione*. If Frederick were to return to Britain, he would be tried and executed as a mutineer, despite the passage of time, as his father notes sorrowfully: 'The lapse of years does not wash out the memory of the offence – it is a fresh and vivid crime on the Admiralty books till it is blotted out by blood.'[36] The navy is shown as a throw-back, an almost feudal organization where even a rebellion long since past and brought about by cruelty is still an offence for which Frederick must pay with his life. His role in the 'rebellion is the stuff of romance ... [and] stands for the way of the past'.[37] The navy that Gaskell portrays is very much linked to the past, as it was in popular perception. Despite the changes going on in the first half of the nineteenth century, both in terms of technology and appearance, the treasured public persona is again linked to the navy of the 1790s. While the Arctic explorers may have become modern heroes, the navy itself was still tied nostalgically, in the collective public mind, to Nelson.

The Crimean War presented the Royal Navy with what was hoped to be an opportunity to return to military glory, as *The Times* noted on 6 January 1854:

> The Admiralty has constructed a fleet of magnificent ships, armed with all that modern science has done for navigation. We trust that young, able, and energetic officers will be selected to command them; and we venture to affirm that, with good ships, good officers, and good treatment, the blue jackets will not fail to do their part in their country's battles.[38]

70

Sailors' encampment before Sebastopol, The Bellerophon Doves, **Read & Co, 11 November 1854. PAF3820 / PW3820.**
"Jack appeared highly delighted at the prospect of serving ashore during the siege, and girded with his revolver and cutlass took up his quarters in the tent on land with as much sang-froid as if it was his natural sphere of action." This affectionate caricature highlights the way in which the sailors of the navy were publicly perceived to be more resourceful and better lead by their officers than their counterparts in the army.

Both the army and the navy were criticised by the public for inefficiency in the Crimea, but in the ensuing official enquiries, the navy emerged as better organized, better supplied and more humane than the Army (see Figure 70). In addition, although it was not entirely the case, the navy was seen as being more the egalitarian. The enquiries made a great point that an admiral in the navy had risen from the rank of able bodied seaman and was respected among his peers.[39] In popular literature, the novel *The Pride of the Mess* (1855) was the first naval novel in the fifty years since the battle of Trafalgar not to be set in the time of Nelson. It was a novel of the Crimea, and its hero, a young lieutenant called Herbert, who was promoted to captain for bravery at Sebastopol, is everything that a masculine hero should be: his moral uprightness is expressed through his refusal to consume sugar, smoke

tobacco or wear cotton that may have been produced by slaves. In short, he considers the moral consequences of his actions, a characteristic which would, in terms of both religion and morality, tie in closely with evangelicalism. In addition, Herbert's upbringing is such that his father, the son of a minor aristocrat, eschews the fashionable life to lead a quiet, solid, middle-class existence in Devon. This is contrasted with Herbert's uncle, whose life is dedicated to making money and using his influence to fulfil his own avaricious designs.

As a young officer, Herbert's innate goodness and lack of pretence recommend him to his commanding officers, while his navigational skills and seamanship are impeccable as he manoeuvres a small craft through the dangerous tangles of the sunken fleet at the entrance to the harbour at Sebastopol. He is the ideal naval officer: one who is refined but not effeminate, humane, moral, brave, well trained and increasingly professional. When he is invalided home to Britain after suffering a shoulder wound at Inkerman, he is immediately recognized by his uniform as a naval hero of the late war, and is celebrated as such, although he himself is too modest to accept it as his due.

Uniform regulations 1856

The style of naval uniform had not really been updated from 1827, while contemporary fashions had altered again. The previous year, Alexander Cochrane petitioned for changes to the uniform, arguing that 'Our uniforms are too numerous: they at present consist of Round Jacket, Frock Coat, Evening Plain Coat, and Full Dress. I think they ought to be reduced to two, namely, the Frock Coat with the skirts not too long to go aloft, and an Evening Coat

71
Frock coat, Royal Marines, belonging to E.W. Pritchard, pattern 1856–67. UNI0433 / F4853-001.
This coat includes medal ribbons of Crimea, Turkish Crimea and Midjidie.

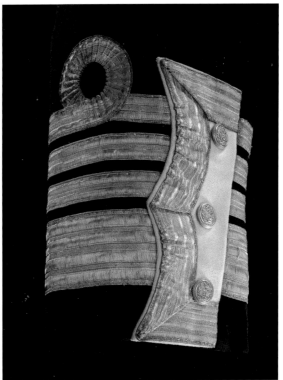

72
Detail of a cuff, admiral's full dress coat, pattern 1856. UNI0320 / F4870-003.

which shall be sufficiently ornamented to constitute a full dress Coat.'[40] It should be noted that the frock coat of the mid-nineteenth century was a very different garment to that worn in the eighteenth century. It had knee-length skirts in both the front and back and featured a much looser sleeve and cuff. Although by mid-century the cut of the coat was no longer as tight as it had been fifty years earlier, the waist was still defined and the chest still meant to be quite full. An example of this type of frock and the way it translated into military fashions can be seen in the uniform worn by E. F. Pritchard of the Royal Marines (see Figure 71).

Cochrane's proposals, as well as suggestions by several others, were initially accepted by the Admiralty and a committee was convened in the spring of 1856 to advise on the new uniform. Its major proposals were that the present full dress coat should be abolished, and the undress coat, with the appropriate laces to indicate rank, should be retained in place of the full dress. In addition, the committee members felt that no officer below the rank of master should wear epaulettes. However, among the comments from the Admiralty Board on these recommendations was one made by Captain Alexander Milne, who felt that the abolition of the dress uniform and its replacement with something more practical and fashionable was a suggestion with which he could not agree:

> [I am] … of the opinion that the undress coat without epaulettes is by no means an appropriate uniform for an Admiral or Captain; It is nothing more nor less than a Civilian Blue Coat with the stripes on the sleeve. I consider there is a certain amount of display required by officers in command and unless the display is maintained by having a proper uniform for state occasions I believe it will prove detrimental to the Naval Service and to the position of the Service in Foreign Countries. I would rather retain the present uniform.[41]

Ultimately, the proposed changes were discarded, and full dress, undress and frock coats were retained, as were epaulettes. However, the width of the gold distinction lace was cut down and the upper row of lace on the sleeve featured the distinctive 'curl' or circle that came to be one of the hallmarks of naval uniform (see Figure 72). The dress uniform changed little from this point to the present, with the exception of epaulettes which were no longer worn after 1939, and were finally abolished in 1959.[42] However, the undress and frock would continued to keep pace with contemporary fashions.

Ratings' uniforms

The new regulations for 'Uniform Dress for Petty Officers, Seamen, and Boys'[43] were issued on 30 January 1857. They included a blue cloth jacket and trousers, a duck or white drill frock with 'collar and wristbands of blue Jean,'[44] duck trousers, blue serge frock, pea jacket, black silk handkerchief, hat 'black or white according to climate,'[45] cap, woollen comforter and the appropriate petty officers' badges (see Figure 73). This uniform would change little throughout the nineteenth century, with the exception of the addition of non-substantive badges, which reflected changing technologies.

Due to the supply systems, ratings already had an almost uniform appearance. Although they were not given a uniform until 1857, as early as 1827 a badge of distinction was issued for petty officers, which was an attempt at 'improving the situation of Petty Officers,'[46] (see Figure 74) that they might be held in greater respect by their colleagues. This badge consisted of an anchor surmounted by a crown embroidered in blue on a white ground. Jane Austen's brother, Charles, a future admiral of the fleet, commented in his journal on the addition to the uniforms in 1828: '… mustered at Divisions the Men in White Frocks the Crown and Anchor worked in Blue on the Petty Officers'.[47] This idea of improving the lot of ratings, or in fact taking interest in what could be construed as the 'working classes' of the ship, again ties in strongly to the ideals of evangelicalism. From the end of the eighteenth century, the tracts of Hannah More advocated the moral improvement of the poor and working classes. We have seen how strongly evangelical tracts concerned with the moral state of the navy circulated throughout the fleet in the 1820s, and certainly influenced the popular fiction of Captain Marryat. However, while moral improvement was imperative, evangelicalism did not equate it with a move in social station. In evangelical thought, ratings might be

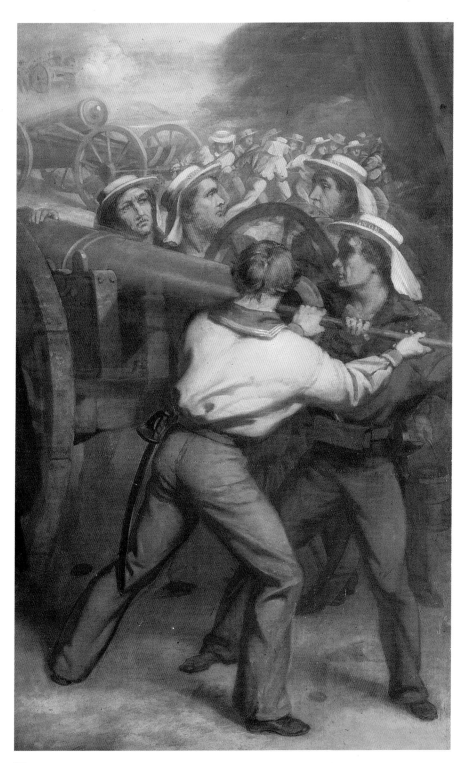

73
Detail of portrait of *Captain William Peel (1824–1858)*, **John Lucas. BHC2943 / BHC2943.**
This detail shows ratings in their newly regulated uniform.

74
First Class of Petty Officers. Master at Arms, or Quarter Master, M Gauci (artist),
Engelmann, Graf, Coindet, & Co (printers), 1828. PAF4195 / PW4195.
Print of a First Class Petty Officer shows the new badge.

given greater respect, yet they were not to aspire to move socially upwards. Those who espoused evangelicalism strongly believed that social stations were meant to be preserved, as everyone belonged in his or her correct place. While a uniform might improve appearance and help instil respect, it also very clearly marked social standing and served to reinforce one's position within the navy. Other contributing factors to the new uniform for ratings stemmed from the change to continuous service in 1853, as well as the practice of captains and flag officers, dating from the early nineteenth century, who often dressed their crews in a uniform that would be unique to the ship

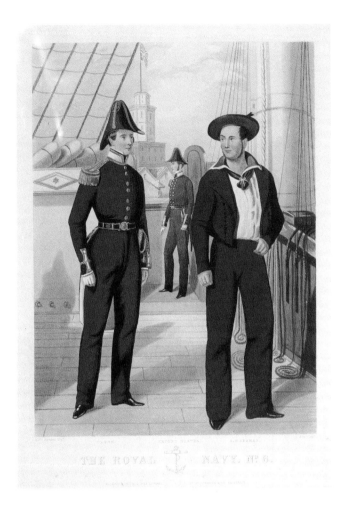

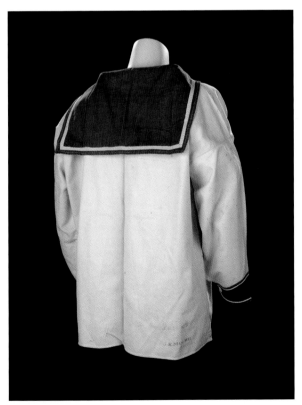

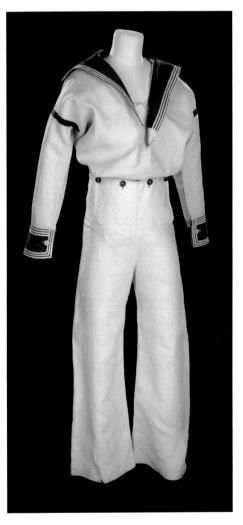

75

The Royal Navy. No 6. Clerk. Second Master. A B Seaman,
R H C Ubsdell (artist), J Harris (engraver), Ackermann &
Co, 1849. PAF4236 / PW4236.

This print illustrates new regulation for officers, but also
indicates the appropriate dress for seamen, even though
they would not have regulated dress until 1857.

76

Sailor suit worn by the Prince of Wales on the Royal
Yacht in 1846. UNI0293 and UNI0294 / F4848-001.

77

Detail of frock collar worn by Joseph Edwin Moore.
UNI3962 / F4850-002.

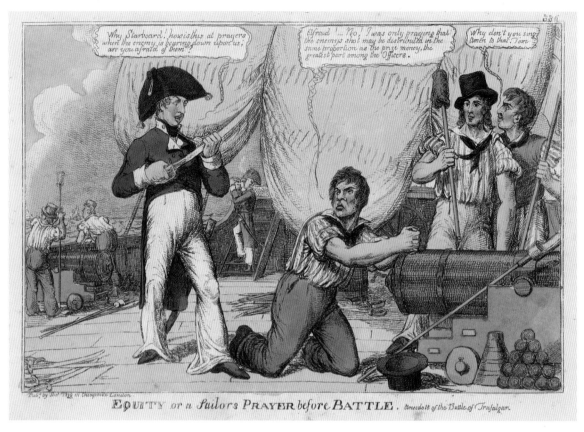

78

Equity or a Sailor's Prayer before Battle. Anecdote of the Battle of Trafalgar, Thomas Tegg.
PAF3761 / PW3761.

The shirt worn by the sailor is simply another version of that worn by the officer. However, the collar is not
starched, nor is it worn upright with a stock. Instead, it is worn loosely over the shoulder with a black silk tie.

in which they served.[48] In addition, plates illustrating officers' uniform in 1849 also show the suggested dress for
seamen (see Figure 75). It is likely that it was these factors, together with the wish to elevate the status of seamen,
that led to the introduction of a badge for petty officers.

The patterns for the first ratings' uniforms were taken from those worn on the Royal Yacht, which featured
white duck frocks with blue jean cuffs and collars, an example of which can be seen in the uniform worn by the
young Prince of Wales in 1846 (see Figure 76), which Queen Victoria recorded in her diary: 'Bertie put on his sailor's
dress, a new one, beautifully made by the man who makes for our men. When Bertie appeared the Officers and Men
(who had asked permission to do so) were all assembled on deck, and cheered him, seeming quite delighted.'[49] The
young Prince of Wales's uniform featured three stripes of white tape on the blue collar and cuffs, as well as watch
stripes on both arms. It was this costume that launched the style of sailor suits for children.

Many stories have grown up around the sailor's uniform, and particularly about the collar. Its distinctive,
elongated shape is said to have developed in order to keep pig-tail grease from staining the back of the jacket (see
Figure 77). However, this does not appear to be the case, as the evolution of the collar can be traced through images
of the sailor from the late eighteenth through the first half of the nineteenth centuries. Initially it was simply the
collar of the shirt cut in a style worn by almost all men in the late eighteenth century, and was not worn starched as
an officer would have nor was it worn with a cravat. Instead, it was worn loosely with a black silk tie underneath

79
Joseph Edwin Moore (1841–1920), Seaman, 1854– circa 1865. Historic Photographs Collection at the
National Maritime Museum, C8418 (HP. 1983/26)

it, and a blue jacket on top (see Figure 78). In the early years of the nineteenth century, the prototype of the frock, as it came to be known, was worn. It was in essence a smock with the elongated, stylized blue jean collar. This style crystallized by the mid-1840s, and was formalized in the 1857 regulations for ratings' uniform (see Figure 79). The blue jacket was retained and worn over the frock. The second story about the collar says that the three rows of white tape represent Nelson's three great battles: the Nile, Copenhagen and Trafalgar. Again, this is romantic, but wrong. In 1856, another committee was formed to report on the need for a uniform for sailors, and it recommended that white frocks be worn with blue jean collars with two rows of tape. However, the choice was taken instead to follow the aesthetics of the style worn by sailors on the Royal Yacht, and three rows of tape were chosen.

1 With the exception of the change in colour of lapels from blue to white and the addition of epaulettes there were no major changes to the cut or style of uniform between 1812 and 1827. Smaller changes that took place were the addition of the crown above the anchor to the button of officers, with the exception of Gunners, Boatswains and Carpenters in 1812. In 1825, embroidered badges were added to the collar of officer's uniforms of the Navigating, Medical, Secretarial and Accountant branches of the navy.

2 Admiralty Regulations, 18 December 1827, quoted in May, *The Uniform of Naval Officers*, vol. 1, p. 91.

3 *Ibid.*, p. 95.

4 Byam Martin, *Letters and papers of Admiral of the Fleet Sir Thomas Byam Martin, GCB*, vol. 1, p. 117.

5 Anon., *An Address to the Officers of his Majesty's Navy, by an Old Naval Surgeon* (London: Hatchard and Son, 1824), pp. 1–4.

6 Frederick Marryat, *The Naval Officer; or, Scenes and Adventures in the Life of Frank Mildmay*, 3 vols. (London: Henry Colburn, 1829), vol. 3, p. 256.

7 Byam Martin, vol. 1, p. 117.

8 National Archives, ADM7/620/3662 Uniforms.

9 *Gentleman's Magazine of Fashion*, July 1828, p. 43.

10 Thomas Robson, *St. Helena Memoirs, Part the First; Being the Memoir of a Young Officer of the Royal Navy who died at St. Helena, 17th December 1820, Aged Twenty-One Years*, second edition (London: James Nisbet, 1827), p. 20.

11 Byam Martin, vol. 1, p. 24.

12 Edward Hawker, *The Navy. Letter to his grace the Duke of Wellington, K.G., upon the Actual crisis of the country in respect to the state of the navy.* (London: A. Spottiswoode, 1838), p. 2.

13 *Ibid.* pp. 29–30.

14 Gilbert Elliot Murray, 2nd Earl Minto, *The Navy: A Letter to the Early Minto, G.C.B., First Lord Commissioner of the Admiralty, By one of the People*, second edition, (London: Ridgway, 1839). p. 36.

15 *The Times*, 24 November 1846, p. 7.

16 *The Times*, 28 November 1846, p. 5.

17 *Gentleman's Magazine of Fashion*, May 1828, p. 5.

18 National Archives, ADM1/3467.

19 Thomas Bewick, *History of British Birds*, 2 vols. (Newcastle: T. Bewick, 1797) quoted in Francis Spufford, *I May Be Some Time: Ice and the English Imagination* (London: Faber & Faber, 1996), p. 14.

20 Mary Shelley, *Frankenstein* (London: Colburn & Bentley, 1831), p. 4.

21 *Ibid.*

22 National Archives, ADM7/620/3662 Uniforms.

23 *Ibid.*

24 *Ibid.*

25 *Ibid.*

26 *Ibid.*, bill from Londsdale & Tyler giving epaulette prices for the ranks of admiral, vice-admiral, rear-admiral, post-captain, captain under three years' seniority, commanders and lieutenants.

27 National Archives, ADM7/620/3662 Uniforms.

28 *Ibid.*

29 *Ibid.*

30 Anon. *Present Condition and Prospects of many Captains of her Majesty's Navy* (London: 1845), pp. 12 13.

31 Rodger, *Command of the Ocean*, pp. 507–27.

32 Henry John Rous, *Navy Estimates: Speech (verbatim) of the Hon. Captain Rous, R.N., M.P. in the House of Commons, March 4th, 1842* (London: R. Logsdon, 1842), p. 5.

33 Charlotte Yonge, *The Heir of Redclyffe*, 2 vols. (London: John W. Parker and Son, 1853), vol. 1, p 175.

34 Augustus G. Broadhead, *The Navy as it is; or the Memoirs of a Midshipman*, 2 vols. (Portsea: T. Hinton, 1854), vol. 2, p. 154.

35 Rodger, *The Command of the Ocean*, p. 452.

36 Elizabeth Gaskell, *North and South*, (Leipzig: Bernhard Tauchnitz, 1854), p. 202.

37 Stefanie Markovitz, 'North and South, East and West: Elizabeth Gaskell, the Crimean War, and the Condition of England,' *Nineteenth Century Literature*, (Berkeley: University of California Press, 2005), vol. 59, p. 480.

38 *The Times*, 6 January 1854.

39 *The Times*, 1 May 1855, 'State of the Army before Sebastopol', p. 12.

40 Memorandum from Vice-Admiral Sir Thomas John Cochrane, Commander-in-Chief Portsmouth, written to Sir Charles Wood, one of the Lords Commissioners of the Admiralty, 4 June 1855 quoted in May, *The Uniform of Naval Officers*, vol. 1, p. 161.

41 National Archives, ADM1/565 comments of Alexander Milne quoted in May, *The Uniform of Naval Officers*, vol. 1, p. 172.

42 W. E. May, W. Y. Carmen and John Tanner, *Badges and Insignia of the British Armed Services* (London: Adam & Charles Black, 1974) p. 12.

43 National Archive, ADM224/5, Circular No 283, Admiralty, 30 January 1857.

44 *Ibid.*

45 *Ibid.*

46 1827 Admiralty Circular quoted in Jarrett, *British Naval Dress*, p. 76.

47 National Maritime Museum, Charles Austen diaries, AUS/125 6 January 1828.

48 Jarrett, *British Naval Dress*, p. 92.

49 Queen Victoria, ed. Arthur Helps, *Leaves from the Journal of Our Life in the Highlands, 1848–1861* (Smith Elder & Co., 1868), p. 182.

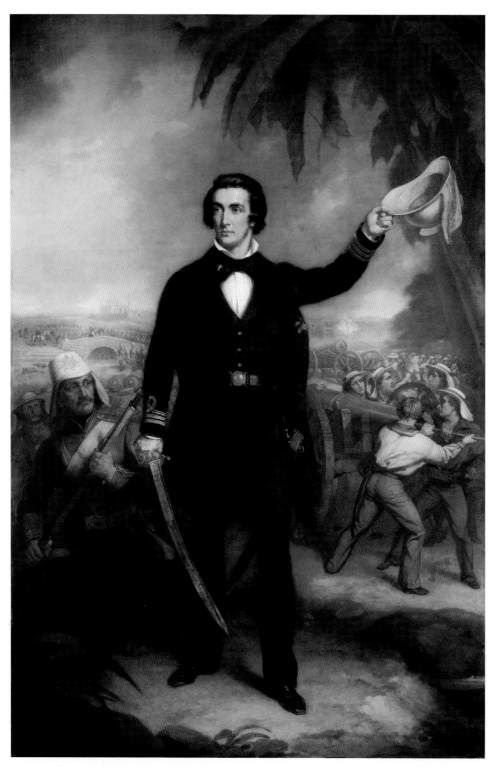

80
Captain William Peel (1824–1858), John Lucas. BHC2943 / BHC2943.

Conclusion

While the character of Herbert in William Johnson Neale's *The Pride of the Mess* was a fictional idealization of the naval officer, his moral superiority and bravery were mirrored in the real-life figure of Captain Sir William Peel (1824–58), the third son of politician Sir Robert Peel (see Figure 80). Peel, like Herbert, was at Inkerman in the Crimea and showed particular bravery at Sebastopol. He was awarded the Victoria Cross, the highest honour for gallantry, for saving his ship by picking up a bomb with a lit fuse and flinging it overboard. Again, like Herbert, he was wounded and invalided home. However, there their similarities end. Peel was sent to China as the commander of the newly commissioned steamer *Shannon*. Shortly after his arrival in Hong Kong he was diverted to India, where he commanded the British naval brigades in the relief of Lucknow during the Indian Mutiny (1857–58). He was severely wounded in the thigh and, during his recovery it was decided to transport Peel and others to Cawnpoor, in part due to an outbreak of smallpox in the hospital. Peel chose to ride in a cart along with his men, and it was either through this decision or because he had already been infected in hospital that he contracted smallpox and died at Cawnpoor on 27 April 1858, aged thirty-three.

Peel's posthumous portrait, painted by John Lucas at the request of Robert Peel in 1858 depicts him in the midst of battle at Lucknow, urging his men forward, showing apparent unconcern for his own safety. His uniform is spotless and he appears oblivious of the dangers of war, unlike the lesser men who crouch below him. It is worth noting that Graves & Company was advertising prints taken from the portrait by July 1858[1], making it an image familiar to the public. However there are two jarring elements present in Peel's uniform: the curl on his sleeves and the rose in his buttonhole. When it was first introduced in 1856, the curl was often – sometimes mistakenly – interpreted as an oval instead of a circle, as in this painting of Peel. In a 1918 lecture given by Admiral the Marquess of Milford Haven, he wryly noted that 'In my first ship one of the lieutenants, who was a dandy, wore on his London-made uniforms an oval instead of a the round curl.'[2] This comment is doubly condemning, because not only was the interpretation of the curl indicative of a dandy, but the idea that a uniform should be London-made had, since the early nineteenth century, provoked derisive comments from officers such as Edward Codrington, who noted in 1805 that London tailors, while fashionable, knew nothing of what was properly required in garments worn at sea.[3] The curl, when paired with the rose, is enough to raise the spectre of the dandy over one of Britain's celebrated naval heroes.

However, Peel was an exemplar of the prevailing Christian ideals, particularly those espoused by the Tractarians, a group predominately made up of Oxford academics who came to prominence in the 1830s with a series of tracts concerning, among other theological points, the need for the Anglican Church to celebrate communion every Sunday. They had evangelical antecedents, and Tractarian writers like Charlotte Yonge advocated a certain type of manliness, exemplified by the central character of Sir Guy Morville in her novel *The Heir of Redclyffe*. Sir Guy is impulsive yet courageous, generous and gentle, aware of his shortcomings, modest of his attributes and desirous to conquer his temper, which is the curse of his family. His capacity for self-sacrifice, which he regularly practises by

forgoing the pleasures of hunting and riding in order to labour over his books, is such that he saves his self-righteous cousin Philip's life at the cost of his own. His kindness and concern touch and influence the lives of those around him for the better. This ideal was not dissimilar to the masculinity celebrated in Hannah More's tracts fifty years earlier. Peel's memorial in *The Times* illustrates this type of manliness, as it almost echoes that of Guy Morville, who also dies young: 'The loss of his daring but thoughtful courage, joined with eminent abilities, is a very heavy one to the country; but it is not more to be deplored than the loss of that influence which his earnest character, admirable temper, and gentle kindly bearing exercised on all within his reach'.[4] While Peel was representative of this type of masculinity, it was an ideal that was soon to be eclipsed by 'muscular Christianity' – the idea that physical exertion, particularly sport, contributed to the development of both a manly character and Christian morality – which would come to dominate the second half of the nineteenth century.

One of the most well-known proponents of this idea was Charles Kingsley, who felt that 'godliness was compatible with manliness' and viewed manliness as an 'antidote to the poison of effeminacy – the most insidious weapon of the Tractarians – which was sapping the vitality of the Anglican Church'.[5] Kingsley believed that manly pastimes, particularly outdoor sports such as hunting and fishing, offset the potentially harmful effects of 'education and bookishness'[6] . The hero of one of Kingsley's early novels, *Westward Ho!* (1855), which is set in the late sixteenth century, epitomizes the ideals of muscular Christianity:

> Amyas Leigh ... was not, saving for his good looks, by any means what would be called now-a-days an 'interesting' youth, still less a 'highly educated' one; for, with the exception of a little Latin, ... he knew no books whatsoever, save his Bible, his Prayer-book, the old 'Mort d'Arthur'

81
Admiral Sir Frederick Richards 1833–1912, Sir Arthur Stockdale Cope. BHC2964 / BHC2964.

of Caxton's edition, ... and the translation of 'Las Casas' History of the West Indies,' ... lately done into English under the title of 'The Cruelties of the Spaniards'.... [He] talked, like Raleigh, Grenville, and other low persons, with a broad Devonshire accent; and was in many other respects so very ignorant a youth, that any pert monitor in a national school might have had a hearty laugh at him. Nevertheless, ... [he] had learnt certain things which he would hardly have been taught just now in any school in England; for his training had been that of the old Persians, 'to speak the truth and to draw the bow', both of which savage virtues he had acquired to perfection, as well as the equally savage ones of enduring pain cheerfully, and of believing it to be the finest thing in the world to be a gentleman; ... and of taking pride in giving up his own pleasure for the sake of those who were weaker than himself.[7]

Amyas Leigh became a popular literary hero; as critic and novelist Justin McCarthy noted in an 1872 essay on Kingsley's work, this masculine ideal was a success: 'In a moment our literature became flooded with pious athletes who knocked their enemies down with texts from the Scriptures and left-handers from the shoulder.'[8]

In addition, *Westward Ho!* is set in the romanticized past and focuses on England's role on the sea, holding Drake and Raleigh up as the quintessential English heroes. Amyas Leigh becomes a sailor in the military service, which Kingsley sees as an integral part of England's heritage. However, Kingsley not only equates the military with this new manliness, he also, in the very first page of the novel, ties it to the British Empire of the nineteenth century. He explicitly binds England's naval heroes to Britain's present state in the world writing that it was 'the Drakes and Hawkinses, Gilberts and Raleighs, Grenvilles and Oxenhams, and a host more of "forgotten worthies", whom we shall learn one day to honour as they deserve, to whom she owes her commerce, her colonies, her very existence'.[9] It is these two themes set out in *Westward Ho!* that would come to define much of the popular image of the Royal Navy in the second half of the nineteenth century: the role of guardian of Empire and exemplar of muscular Christianity.

The changes in the uniform throughout the second half of the nineteenth century reinforce this last point. The body shape that we see is no longer that of languid, sloping shoulders and wasp-waists gained only with the aid of corset. Instead, the silhouette of uniform begins to adopt the square shoulders that we associate with today's masculine shape. This can be seen in a portrait of Admiral Sir Frederick Richards, painted in 1900 (see Figure 81). His dress uniform is clearly still based on that of the mid-nineteenth century, but his shoulders are both broad and square, an effect that is enhanced by his very heavy, stiff epaulettes. However, the changing masculine identity of both the officer and sailor, as well as its visual representation, is one that is yet to be fully explored.

1 *The Times*, Thursday, 22 July 1858, issue 23052, p. 1.

2 May, *Officer's Uniform*, vol. 2, p. 195.

3 National Maritime Museum, Perceval papers, PER/1/45.

4 *The Times*, Thursday, 10 June, 1858, issue 23016, p. 7.

5 David Newsome, *Godliness and Good Learning: Four Studies on a Victorian Ideal* (London: Cassell, 1961), p. 207, quoted in Nick Watson, Stuart Weir and Stephen Friend, 'The Development of Muscular Christianity in Victorian Britain and Beyond', *Journal of Religion & Society*, vol. 7, (Omaha: Creighton University, 2005), p. 2.

6 Anne Bloomfield, 'Muscular Christian or Mystic? Charles Kingsley Reappraised', *The International Journal of the History of Sport* 11 2:172–90, quoted in Watson, Weir and Friend, p. 2.

7 Charles Kingsley, *Westward Ho! or, the Voyages and Adventures of Sir Amyas Leigh, Knight, of Burrough, in the County of Devon, in the reign of her most glorious majesty Queen Elizabeth*, 2 vols. (Leipzig: Bernhard Tauchnitz, 1855), vol. 1, pp. 9–10.

8 Justin McCarthy, *Modern Leaders: Beings in a Series of Biographical Sketches* (New York: Sheldon & Company, 1872) p. 6.

9 Kingsley, vol. 1, p. 2.

Dressed to Kill

Catalogue

▯ This symbol next to a catalogue entry indicates an
accompanying pattern line drawing in the Patterns
section at the back of the book, pp. 165–180.

Pattern 1748

1
Button, flag officer
Brass, bone or ivory
UNI6139

This button is an example of that worn on a flag officer's undress uniform between 1748–67, on general-purpose dress 1767–83 and on full and undress uniform 1783–87. The buttons are made of bone or ivory, faced with brass and would have been attached by means of a catgut shank. The design features an indented edge that surrounds a rope-twist border, which in turn supports a raised octagon. Along the edge of the octagon is a stamped border of repeating circle motifs. In the central reserve is a stamped, stylized Tudor rose motif.

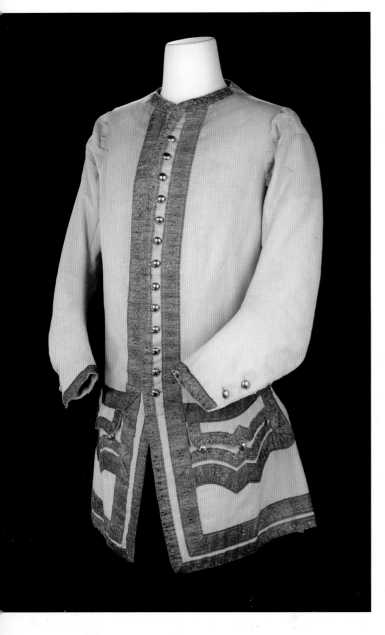

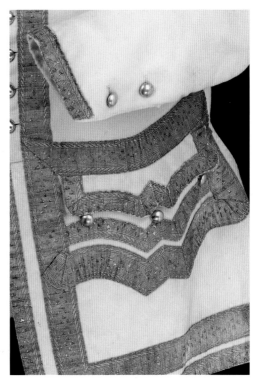

2
Waistcoat, captain with over three years' seniority
Wool, gold alloy, brass, wood
UNI0001 📄

This long-sleeved dress waistcoat of a captain with over three years' seniority, is an example of the first uniforms that were produced in 1748. The rank of the wearer is indicated by the double row of gold lace along the front and skirt, and by the elaborate arrangement of gold lace around both of the pockets. The three-pointed pocket flaps follow the fashions of the day, with the decorative split on the centre point. This waistcoat was altered at a much later date, possibly for fancy or theatrical dress. The slope of the shoulders has been changed and the back and side seams have been opened.

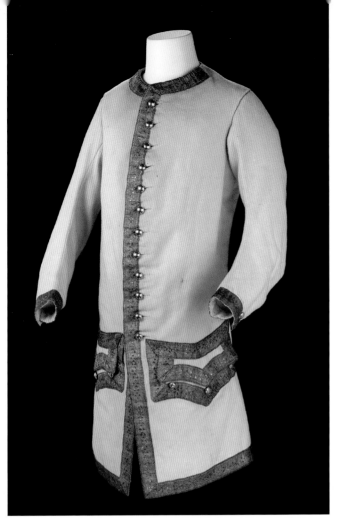

3
Waistcoat, captain with under three years' seniority
Wool, gold alloy, brass, wood
UNI0002

This dress waistcoat of a captain with under three years' seniority features long sleeves, which at the time were considered to be old fashioned. The front and front skirts of the waistcoat are edged with gold lace, as are the cuffs. The three-pointed pocket flap is both edged and outlined with gold lace. Under each of the three points is a domed button made of wood faced with brass.

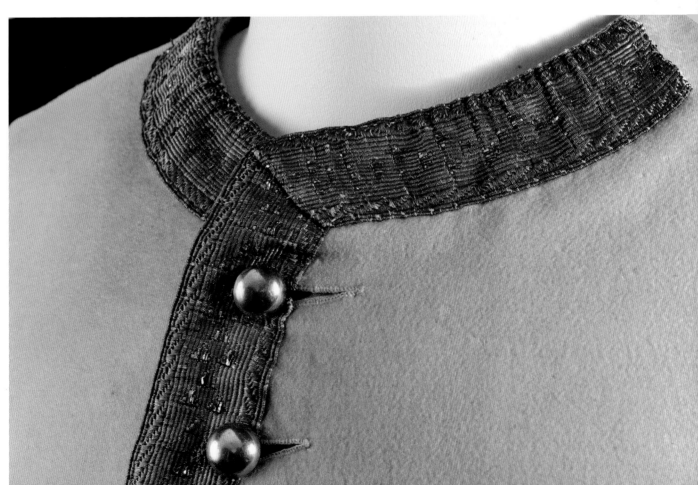

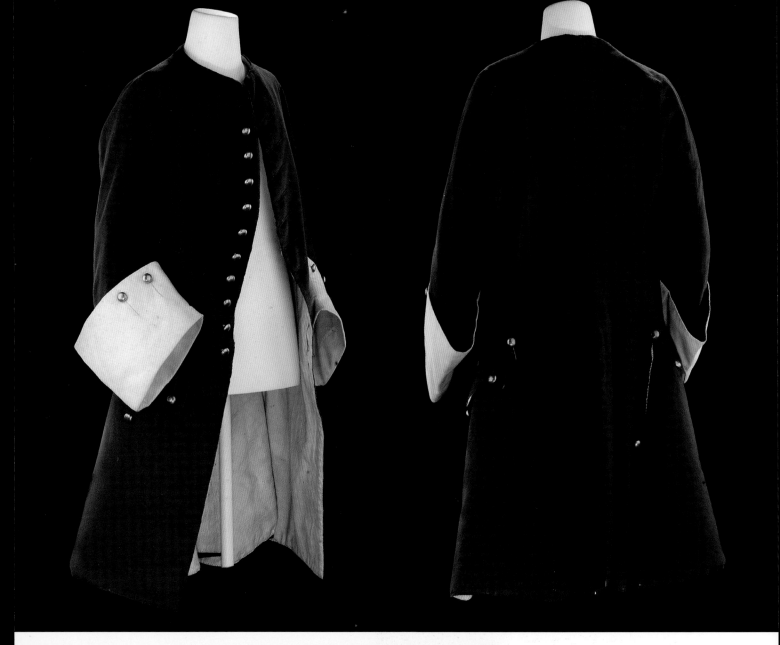

4

Dress coat, lieutenant
Wool, linen/wool twill, brass, wood
UNI0003

This dress coat of a lieutenant has much in common with the formal suits of the mid-18th century. It is full-skirted with no collar and very deep boot-cuffs. However, instead of the silks, velvets or extremely fine wools that were used for formal civilian clothing, this coat is of an extremely hard-wearing wool. The dress uniform of the Royal Navy was really a hybrid between fashionable and occupational dress. This garment is an example of the first patterns of naval uniform.

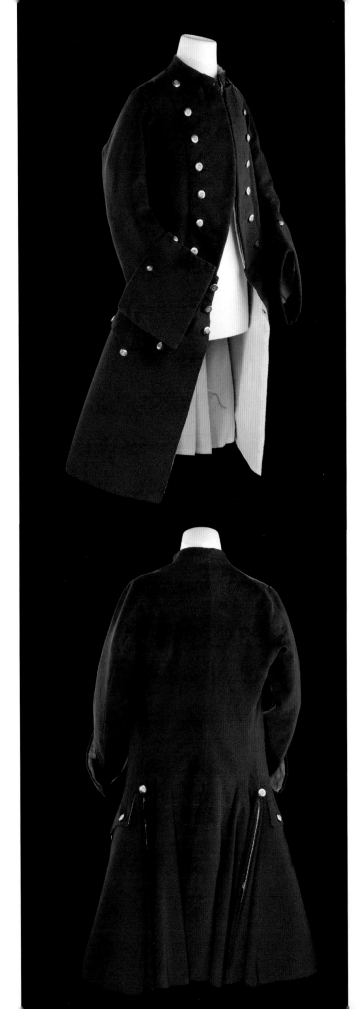

5
Undress coat, lieutenant
Wool, linen/wool twill, velvet, horn, brass
UNI0004

The undress frock of a lieutenant was a working garment. It is of blue wool and has a very low stand-up collar lined with white velvet. The frock features wide lapels buttoned back with horn buttons faced with brass that has been die-stamped with a Tudor rose motif. Just inside and running the length of both lapels is a second set of buttons and buttonholes worked on white linen/wool twill. In this way the coat could be closed without unbuttoning the lapels.

In keeping with the styles of the mid-18th century, the coat has extremely full skirts, three-point pocket flaps and faux buttonholes on either side of the central back vent. The sleeves have boot-cuffs that are fixed with buttons and lined with white shaloon, a linen/wool blend.

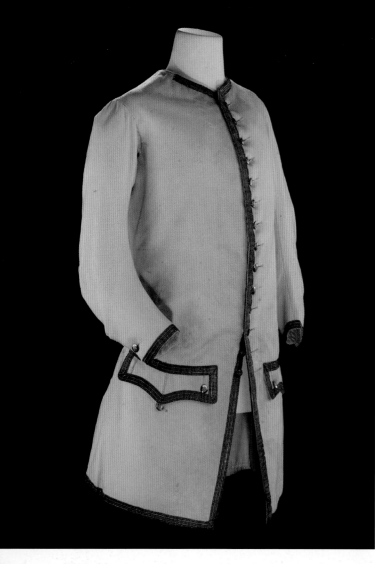

6
Waistcoat, lieutenant
Wool, linen, wood, brass, gold alloy
UNI0005 🔒

This long-sleeved dress waistcoat of a lieutenant is an example of the first uniforms that were produced in 1748. The gold lace features the *mousquetier* pattern and the buttons are of a wood core, faced with brass and stamped with a quatrefoil rose motif. It is interesting to note that although in general Royal Naval uniform followed the fashion of the mid-18th century, the long sleeves would have been considered old-fashioned by 1748.

7 (facing page)
Frock, midshipman
Wool, linen, brass, wood
UNI0006 🔒

This midshipman's frock is quite similar to the lieutenant's undress frock. However, the sleeves feature a white boot-cuff divided by a three-pointed flap of blue wool. This was known as the 'mariner's cuff' and came directly from the occupational dress of sailors. By the mid-18th century it was also incorporated into fashionable dress, featuring on both men's suit coats and women's riding habits.

The midshipman's frock also has a turn-down collar of white velvet backed with blue wool. In cold or inclement weather this would have been worn turned up with a button on the underside.

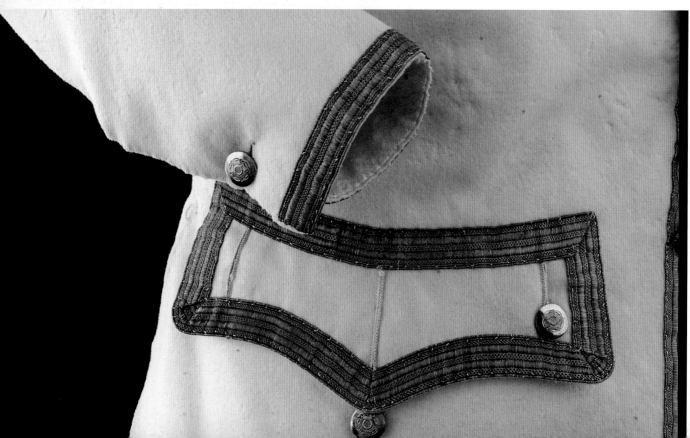

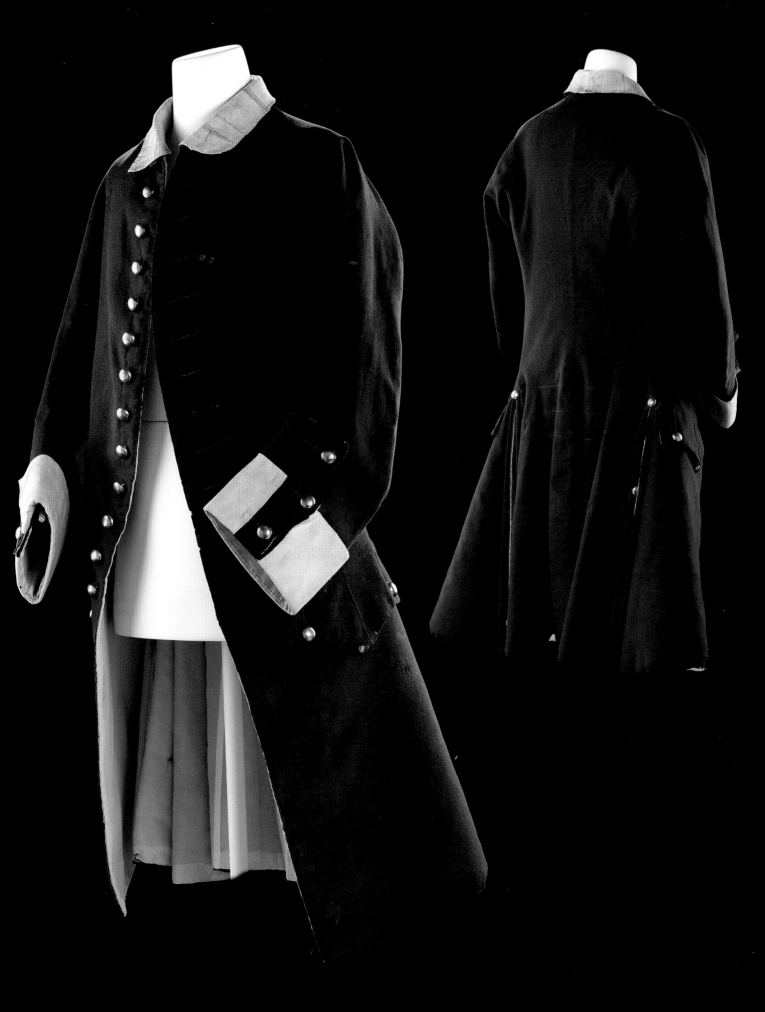

Pattern 1774

8
Breeches, captain
Wool, linen, silk, horn, brass
UNI0010

These breeches for a captain's uniform are a rare survival. In 1774, the uniform regulations were changed and the blue breeches that were stipulated in the 1748 regulations were replaced with white breeches. These have a linen gusset in the back of the waist. The eyelets on either side were for linen tapes that would have been used to adjust the fit. The four buttons on each of the knees are of horn, faced with brass that has been die-stamped with the fouled-anchor motif.

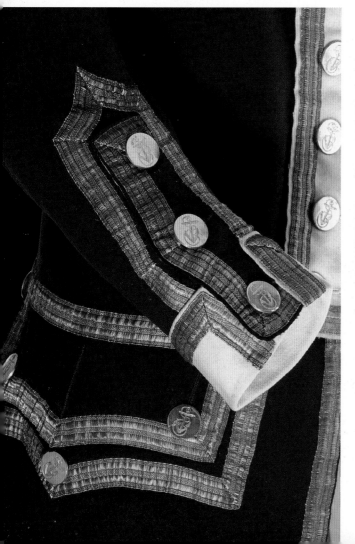

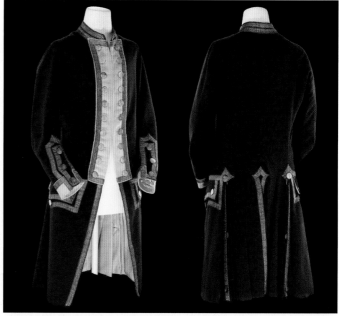

9
Dress coat, captain
Wool, linen, horn, brass, gold alloy
UNI0011

Full dress frock of a captain. The frock is of blue wool with button-back lapels faced with white and edged with gold lace. Although it is possible to wear the coat with the lapels partially buttoned across the chest, there are also three hook-and-eye fastenings so that the coat can be closed without unbuttoning the lapels. The neckband, which would later become the standing collar, is also edged with gold lace. The skirts are not as full as those of the late 1740s. The back vent is still edged with gold lace, as is the pocket, and the three decorative faux buttonholes on either side of the back vent have been retained.

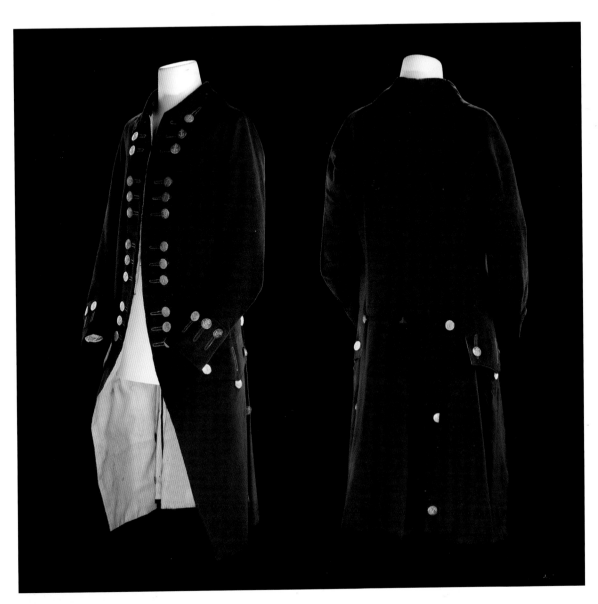

10
Undress coat, captain with over three years' seniority
Wool, linen, horn, brass, metal alloy
UNI0012

This frock is made of blue wool fabric with a felted finish and features button-back lapels. The rank of the wearer is indicated by the groupings of the buttons on the lapels. In this case, the 12 buttons on each lapel are arranged in groups of three, which indicates the rank of a captain with over three years' seniority. The buttonholes are outlined with metal thread, and the buttons themselves are of horn or bone faced with brass that has been die-stamped with an anchor fouled with a chain instead of a cable. The coat also has a turn-down collar that fastens to the top button of each lapel. As with the dress coat of this period, the skirts are not as full as earlier in the century.

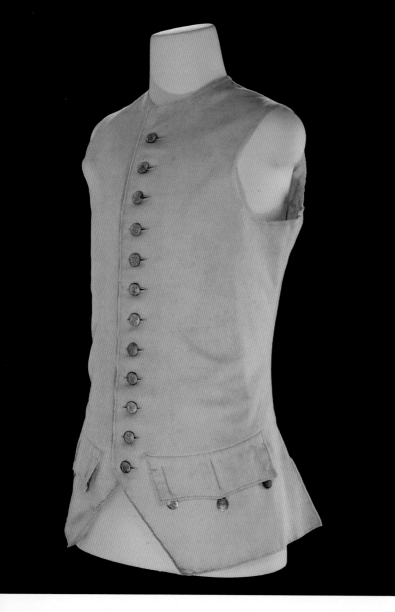

11
Waistcoat, captain
Wool, brass
UNI0013

This waistcoat for a captain would have been worn with both dress and undress uniform, as would white breeches. It is of white wool with a felted finish and fastens with 12 brass buttons which are die-stamped with the fouled-anchor motif. In common with the coats of the period, the waistcoat also features three-point pocket flaps with three buttons. The waistcoat is lined with white flannel, which would certainly have provided extra warmth.

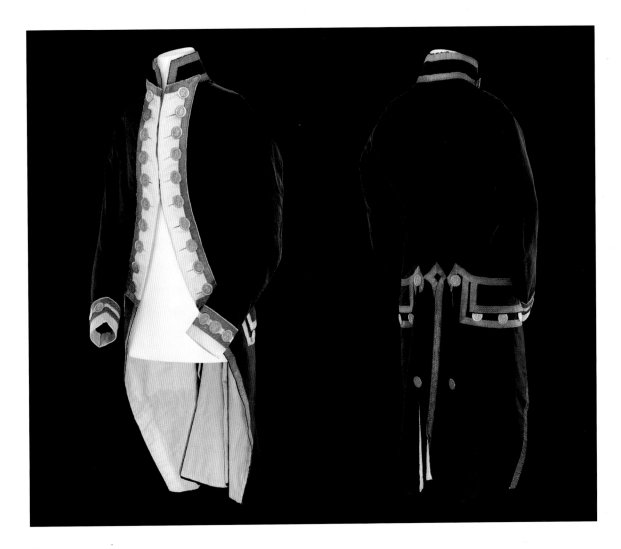

12
Dress coat, captain with over three years' seniority
Wool, silk, linen, brass, gold alloy
UNI0018

In November 1787, the Admiralty issued the most comprehensive uniform regulations to date. These included modifications to dress and undress uniforms for captains of both over and under three years' seniority. This uniform worn by Alexander Hood (1758–98), was for a captain with over three years' seniority. A particular feature is the double row of lace on the cuff. The influence of contemporary fashion is also seen with the narrow lapels, high stand-up collar, narrow skirts and large buttons.
Reproduced with kind permission of Lieutenant Colonel I. K. MacKinnon of MacKinnon.

13
Button, warrant officer
Gilt brass
UNI6858

Large, flat brass button, engraved with the fouled-anchor motif, worn by warrant officers between 1787 and 1860. Although uniform regulations were introduced in 1748, it was not until 1787 that the warrant officer was given an official uniform. The rank of warrant officer included the master, surgeon and purser as well as the gunner, boatswain and carpenter.

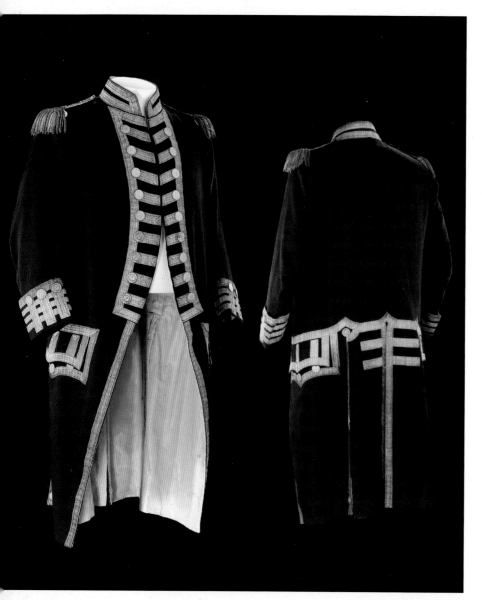

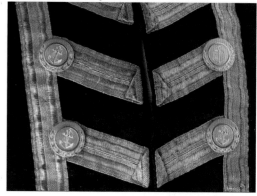

14
Dress coat, admiral
Wool, silk, linen, brass, gold alloy
UNI0027

This uniform, which belonged to Admiral Sir William Cornwallis (1744–1819) illustrates the principal changes to uniform regulations for the year 1795. These include the change in colour of the lapels and cuffs from white to blue and the inclusion of epaulettes. Epaulettes were a military fashion that came from France and although they were not mentioned in uniform regulations until 1795, some officers wore them anyway. In terms of contemporary fashion, this uniform reflects popular styles with its narrow sleeves, cuffs and lapels, and illustrates the leaner silhouette that was popular in male dress towards the end of the 18th century.
Reproduced with kind permission of Miss J. Wykeham-Martin.

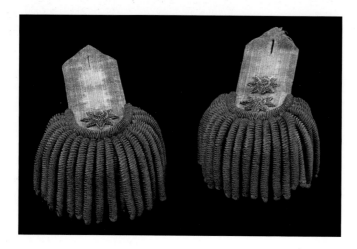

15
Epaulettes, admiral
Gold thread, silver, metal or card
UNI0034 and UNI0035

This pair of epaulettes belonged to Admiral Sir William Cornwallis (1744–1819). It originally featured the three silver stars that indicated the rank of Admiral. Each epaulette is edged with 16 bullions, 76 mm in length. It should be noted that the third star on each does not match; it is possible that these epaulettes were originally purchased by Cornwallis in 1795 and altered when he was promoted in 1799.
Reproduced with kind permission of Miss J. Wykeham-Martin.

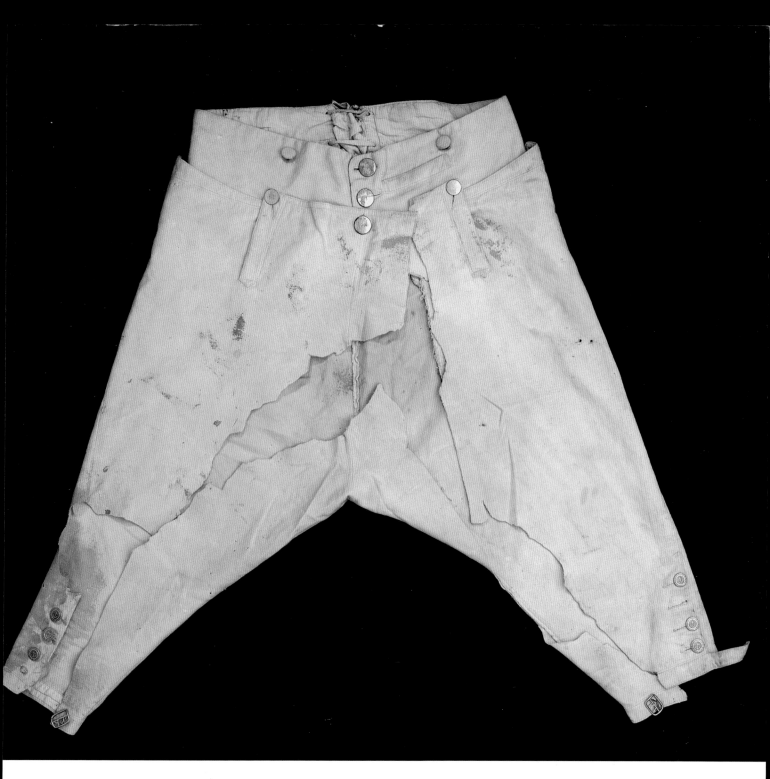

16
Breeches, flag officer
Wool, brass, linen
UNI0021

These breeches were worn by Admiral Lord Nelson (1758–1805) when he was mortally wounded at the Battle of Trafalgar. There are bloodstains to the knees and seat that probably belong to Mr John Scott, Nelson's secretary, who was killed earlier in the battle. The breeches were cut by surgeon's scissors so they could be easily removed.

The breeches are of white twill woven wool with a napped finish and feature a flap front. At the back of the breeches is a white linen gusset that was used to adjust the fit. This was done with linen tapes that were passed through eyelets on either side of the gusset. They were secured at the knee with four small gilt-brass flag officer's buttons and small brass buckles.
Greenwich Hospital Collection.

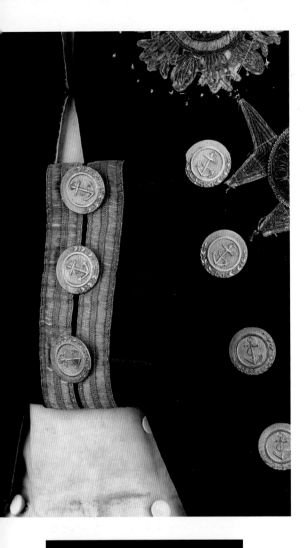

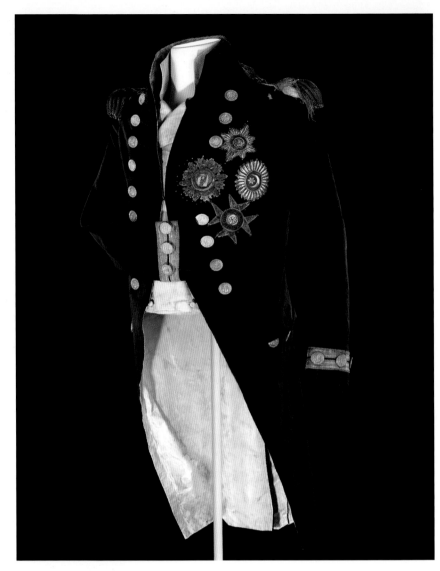

17
Undress coat, vice-admiral
Wool, silk, brass, metal thread, gold alloy
UNI0024 📖

Vice-admiral's undress coat worn by Nelson (1758-1805) at the Battle of Trafalgar. There is a bullet hole on the left shoulder, close to the epaulette. The damage to the epaulette itself is also apparent. There are bloodstains on tails and left sleeve, which are probably those of Nelson's secretary, John Scott, killed earlier in the action. The coat is of blue wool cloth with a stand-up collar and button-back lapels. On the left side, Nelson's four orders of chivalry – Knight of the Bath, Order of the Crescent, Order of Ferdinand & Merit and Order of St Joachim – are sewn to the front of the coat and over the edge of the lapel so that it could not be unbuttoned.

The sleeves terminate in an extremely narrow round cuff with two rows of gold distinction lace and three flag-officer's buttons. The left sleeve is completely lined with black silk twill but the right is lined with the same fabric only as far as the elbow. At the end of the right sleeve is a small black silk loop which secured the unused sleeve to a lapel button. The tails and breast are lined with white silk twill and the shoulders are quilted with running stitch.
Greenwich Hospital Collection.

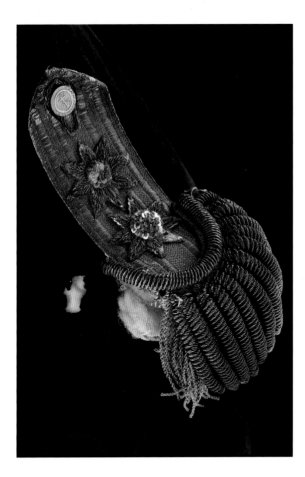

18
Epaulettes, vice-admiral
Gold alloy, silver, silk, card or sheet metal, cotton wadding
UNI0031 and UNI0032

Epaulette of a vice-admiral worn by Nelson (1758–1805) at the Battle of Trafalgar. The epaulette is of wide gold lace mounted over card or sheet metal. There are two stars, indicating the rank of vice-admiral, worked in metal thread and silver spangles. The underside of the epaulette is partially padded and covered with yellow silk. The top and side of the epaulette has been partially damaged by the bullet that killed Nelson. This caused the loss of several gold bullions as well as revealing the cotton wadding used to pad the underside of the epaulette. This item is displayed on uniform UNI0024 (cat. 17).
Greenwich Hospital Collection.

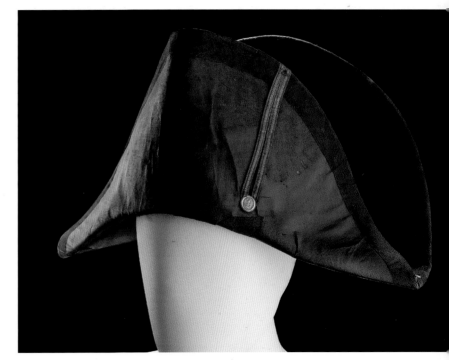

19
Hat
Beaver felt, glazed linen, gold alloy, silk, brass
UNI0038

Three-cornered hat that was probably a captain's undress foul-weather hat. The hat is made of beaver felt which has been covered with a black glazed linen, or holland. This would have made the hat waterproof to a certain degree. The edges are bound in black silk and there is a gold lace loop (vellum and check pattern) secured by a gilt-brass button indicating the rank of captain. The cockade is now missing.

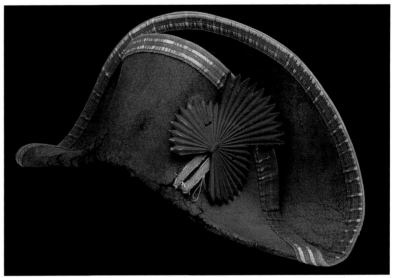

20
Hat, flag officer
Beaver felt, gold alloy, leather
UNI0058

This hat, worn by Nelson at the Battle of Copenhagen (1801), was given by him to his sword-cutler, Mr Salter of 73 The Strand, London, and displayed in the shop window with a black card cut-out which indicated where the *chelengk*, or turban badge, a gift from the Ottoman sultan, was worn.

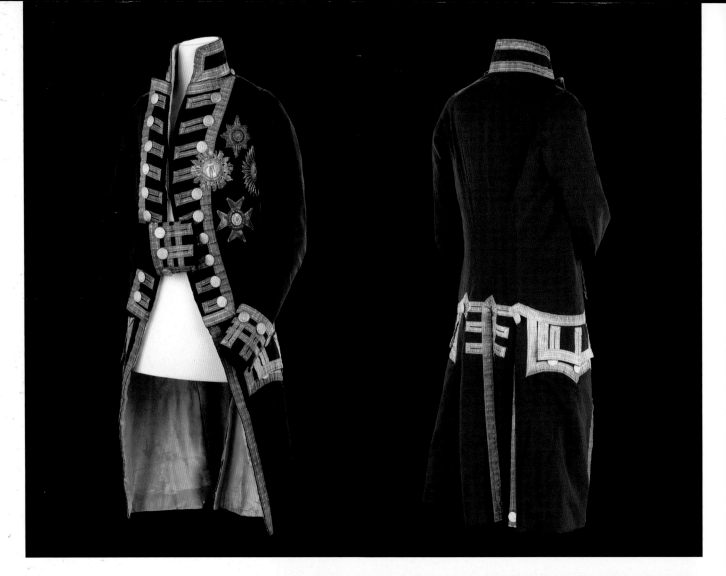

21
Dress coat, vice-admiral
Wool, silk, linen, gold alloy, brass
UNI0023

Vice-admiral's full dress coat belonging to Nelson.
The coat is of blue wool cloth with blue stand-up
collar, lapels and cuffs. The collar, lapels and skirts
are edged with gold lace. The buttonholes on the
lapels, cuffs and pockets are also edged in gold
lace. The pocket flaps and pockets themselves are
edged in gold lace, as are each of the skirts. There
are three faux buttonholes on either side of the
central back vent that are also outlined with gold
lace. The front, tail and collar of the coat are lined
with twill-woven cream silk. The left sleeve is lined
with white linen, while the unused right sleeve is
unlined. The left sleeve, which would have been
quite tight, has a small slit in the cuff. Conversely,
there is no slit in the right sleeve and there are
the remnants of a black silk loop at the end of
the right sleeve. On the shoulders of both sleeves

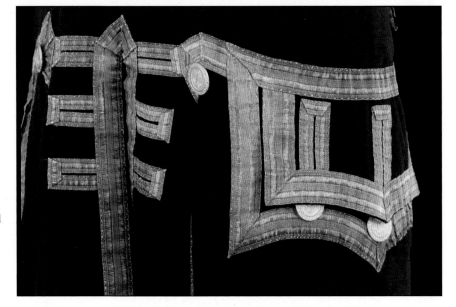

are narrow braids made of overstitched blue thread, and closer to the
collar, on each side, are two small brass buttons: these were the means for
attaching epaulettes which had been introduced in 1795. The coat has two
hook-and-eye fastenings in the front. Nelson's orders of chivalry are sewn
to the left-hand front of the coat.

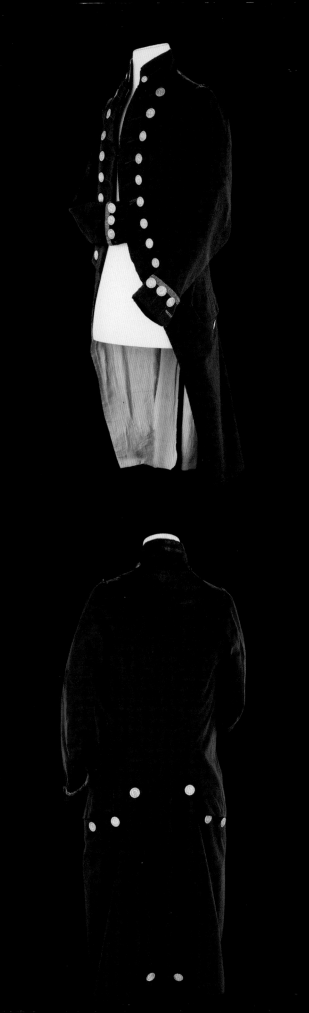

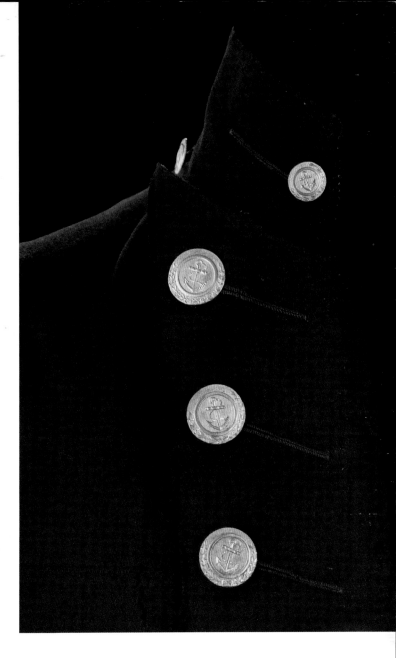

22
Undress coat, rear-admiral
Wool, linen, brass, gold alloy
UNI0022

Rear-admiral's undress coat worn by Nelson (1758–
1805) at the Battle of the Nile in 1798. The coat is of
blue wool and features a stand-up collar with non-
working buttonholes and two small gilt-brass flag-
officer's buttons. The entire coat is lined with white
linen, with the exception of the collar (which is lined
with silk twill) and the unused right sleeve. The cuff of
the right sleeve features a small black silk loop which
was used to secure it to the front buttons of the lapels.
The back of the collar and shoulders are stained with
pomatum (pig-tail grease).

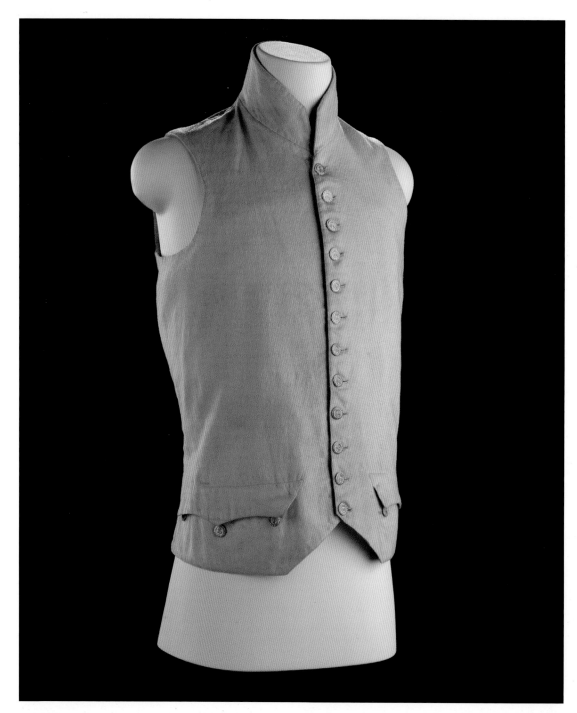

23
Waistcoat, flag officer
Wool, cotton, gilt brass
UNI0028

This white wool waistcoat is of the 1795 pattern. The rank and status of the wearer were indicated by the pattern of the buttons – in this case that of a flag officer. It is interesting to note that the waistcoat retains the three-point pocket flap, which would have been considered old-fashioned by 1795.
Trafalgar House Collection.

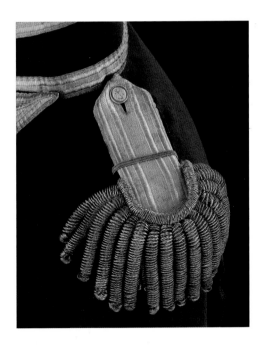

24
Dress coat, captain with over three years' seniority
Wool, brass, gold alloy, silk, velvet, linen
UNI0043 ▯

Full dress coat belonging to Alexander Hood (1758–98).
The coat is of blue wool and features a stand-up collar edged
with gold lace, as are the button-back lapels and front edge of the
skirts. The sleeves feature the distinctive 'mariner's cuff', which
has been edged in gold lace, and there are a further two rows of
lace on the sleeve to indicate rank. Clearly Hood could afford
a more lavish coat, as the collar is lined in white velvet and the
breast and tails are lined in white silk twill, as are the interiors of
the pocket flaps.
*Reproduced with kind permission of Lieutenant Colonel I. K.
MacKinnon of MacKinnon.*

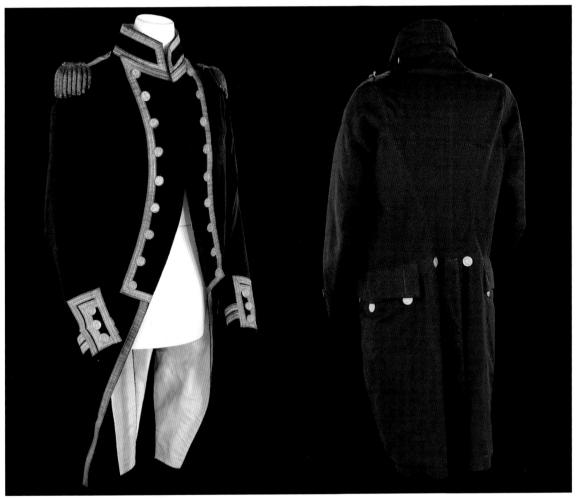

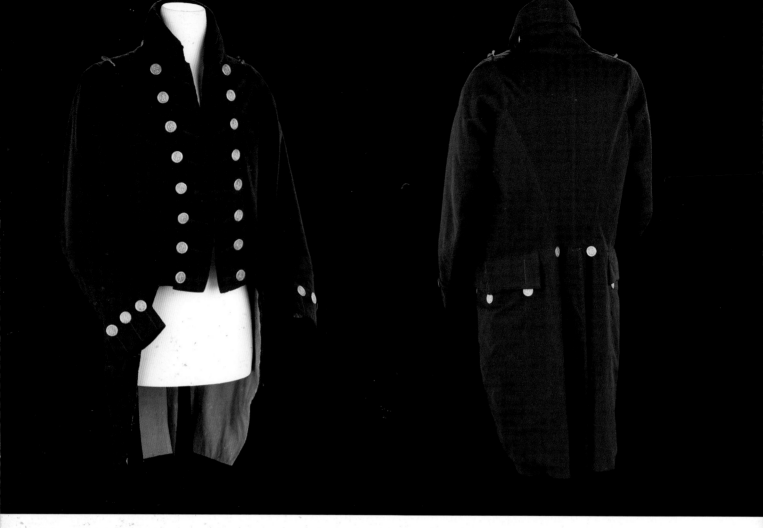

25
Undress coat, captain with over three years' seniority
Wool, linen, brass
UNI0042

This coat, with its straight waist, is of a more fashionable cut than Captain Hood's full dress coat (cat. 24). This may be because there was more latitude in undress to include fashionable elements, or it may be because the coat was made later during this period of regulations. The coat has a heavy tweed interlining, which would have provided added warmth. Although it is a fashionable cut, it should be noted that the uniform coats retain the three-pointed pocket flaps of the mid-18th century.

26
Epaulette, commander
Gold thread, silk, card
UNI0044

This is an example of a commander's epaulette. The strap is of card covered on one side with wide gold lace in the vellum and check pattern. The reverse is covered with blue silk. The epaulette has two rows of hanging bullions: the outer row features 17 large bullions and the inner row features 17 small bullions.

27 (facing page)
Boat Cloak
Wool, brass, linen
UNI0078

This boat cloak, although quite faded, is an extremely rare survival of protective or outdoor clothing from the early part of the 19th century. It is made of a hard-wearing, coarse-weave green wool and lined with a similar brown wool. The cloak, which is quite voluminous, gathers into a stand or fall collar and fastens with a small Royal Naval button at the neck. With its deep hood, it would have provided excellent protection against the elements. Its length would have also served to protect stockings and shoes in addition to clothing, all of which would have been expensive to replace.

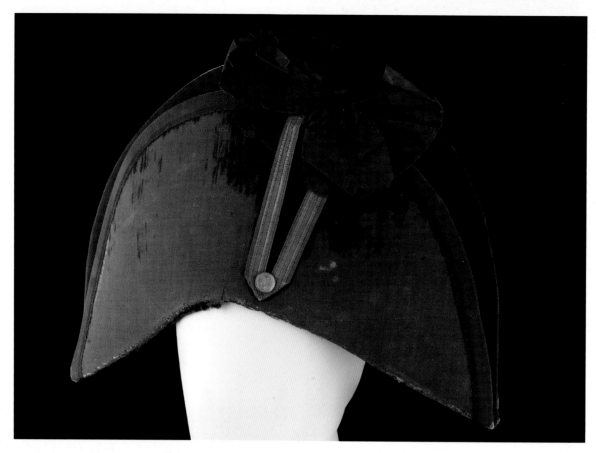

28
Hat, surgeon
Silk plush, buckram, base metal
UNI0074

Surgeons and physicians were not given a uniform until 1805. This is representative of one of the early patterns for that rank. The cocked hat belonged to surgeon Joshua Horwood (d. 1850). Made of a silk plush that resembled the beaver felt usually used for hats, this hat would have been quite expensive. On the front is a loop of gold lace fastening to a small gilt-brass button, which is an example of the warrant officer's pattern and features an anchor within an oval order. Horwood served as surgeon's mate in HMS *Prince* at Trafalgar. He was promoted to surgeon in 1807. *Lent by P. E. Postgate.*

29
Breeches, surgeon
Wool, linen, brass, base metal
UNI0075

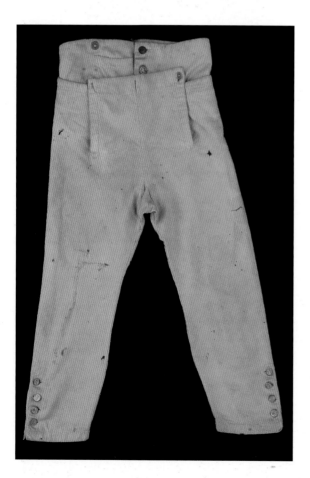

This pair of breeches are part of the uniform of surgeon Joshua Horwood (d. 1850), who served as surgeon's mate in HMS Prince at Trafalgar, and was promoted to surgeon in 1807. This uniform was passed down through the family and at some point was altered for children's dress. The breeches are typical of the regulations uniform of the period in that they are made of white face-cloth, a plain weave wool with a napped pile, and feature a button-and-flap front with a deep waistband lined with white linen. They still retain regulation buttons for the rank of surgeon. However, the shape has been altered, specifically the legs, which have been taken in and shortened. *Lent by P. E. Postgate.*

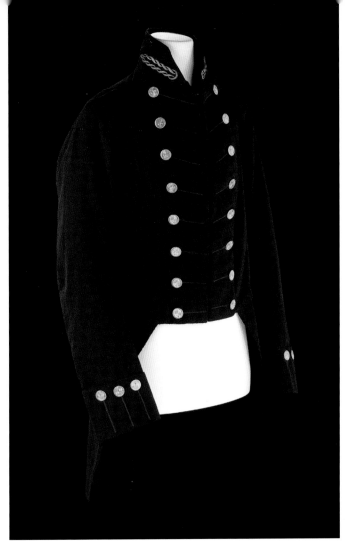

30
Dress coat, surgeon
Wool, brass, metal alloy
UNI0076 📷

Full dress coat of naval surgeon Joshua Horwood (d. 1850), who served as surgeon's mate in HMS *Prince* at Trafalgar, and was promoted to surgeon in 1807. Since officers were required to provide their uniforms at their own expense, there is often a varying quality to the tailoring of the garments. This coat, of blue wool with a felted finish, is not of a very high quality and the collar is awkwardly cut and turned. It is completely unlined, except for the sleeves which are lined with white cotton. The coat features a stand-up collar, and rank is indicated by the embroidered twist motifs in metal thread on both sides of the collar, and by the buttons, which are those of a warrant officer.
Lent by P. E. Postgate.

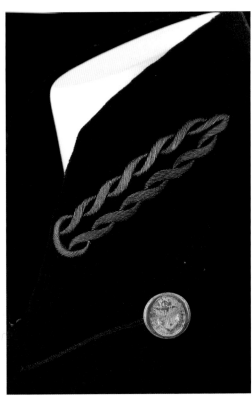

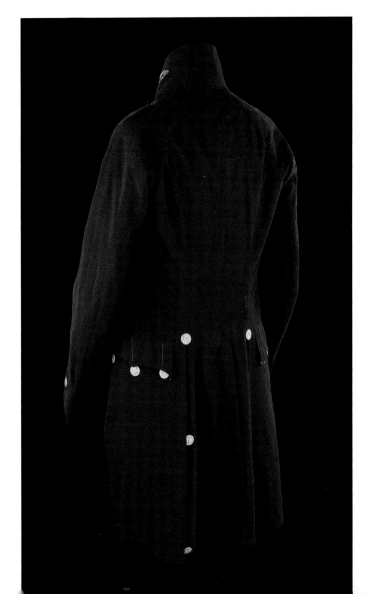

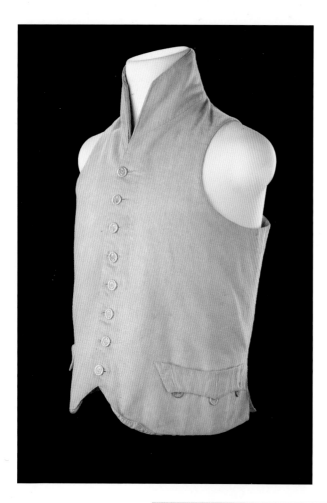

31
Waistcoat, surgeon
Wool, cotton, brass
UNI0077

Waistcoat of naval surgeon Joshua Horwood (d. 1850), who served as surgeon's mate in HMS *Prince* at Trafalgar, and was promoted to surgeon in 1807. Made of white wool with a felted finish, it is lined and backed with cotton. The inside facings are of white wool and the stand-up collar is also lined with the same fabric. There are four linen tapes at the back to adjust the fit. The waistcoat fastens with eight small cast-brass buttons with a fouled-anchor motif. The front pockets feature a faux flap which is turned and lined with cotton. Below it are three cast-brass buttons. Written in brown ink, on the lining just below the collar, is the name 'Mr. Howard', possibly a misspelling on the part of a servant.
Lent by P. E. Postgate.

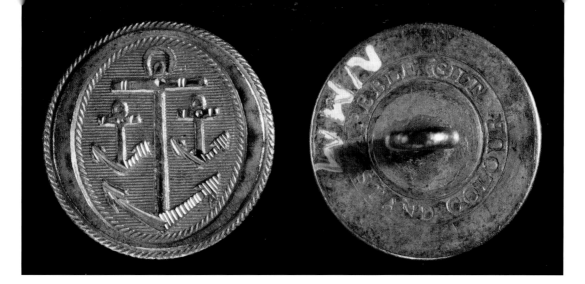

32
Button, master
Gilt brass
UNI7108

Gilt-brass master's button with a rope-twist outer border and oval inner border. In the centre, on lined ground, is a large anchor flanked by two small ones. On the reverse is the inscription 'TREBLE GILT/STAND. COLOUR.' Reference to this pattern appears in the regulations of 1807: 'Buttons worn by the masters to bear the arms of the Navy Office.'

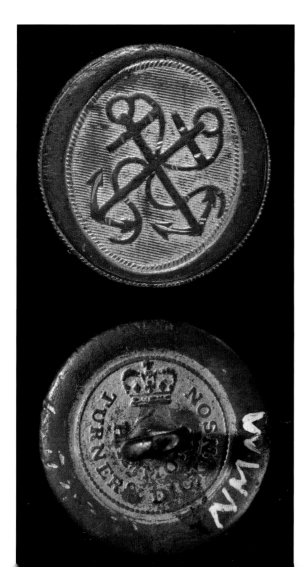

33
Button, purser
Gilt brass
UNI7154

Purser's gilt-brass button with rope-twist outer border and raised oval border with a flat top. In the centre, on lined ground, are two crossed fouled anchors. On the reverse is a crown with the maker's inscription 'TURNER & DICKINSON'. This button is first referred to in the 1807 regulations, which note that the buttons worn by pursers are to bear the arms of the Victualling Office.

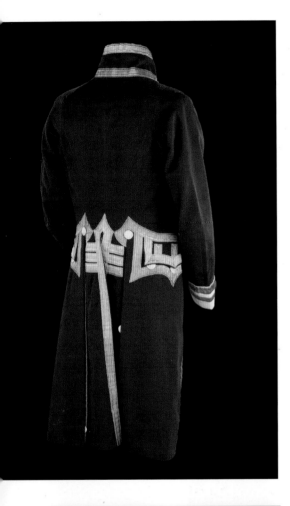

34
Dress coat, rear-admiral
Wool, silk, gold alloy, brass
UNI0094

This 1812 pattern dress coat, belonging to a rear-admiral, reflects the influence of contemporary fashions on uniform. The lapels have been stitched down, the buttonholes are non-working and have been edged with bands of gold lace. The front of the coat fastens with 14 heavy brass hooks and eyes to create a very solid effect. This is further enhanced by additional padding in the lining of the chest and shoulders. The front is cut straight across and the skirts slant back in the style of the cut-away coat. The crown over the anchor on the buttons was introduced in the 1812 regulations.
Rowand Collection.

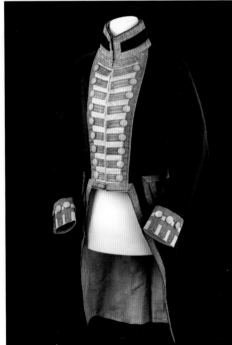

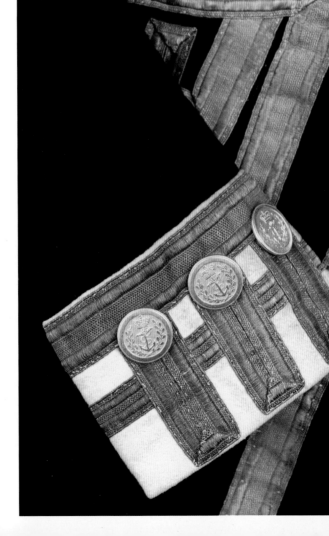

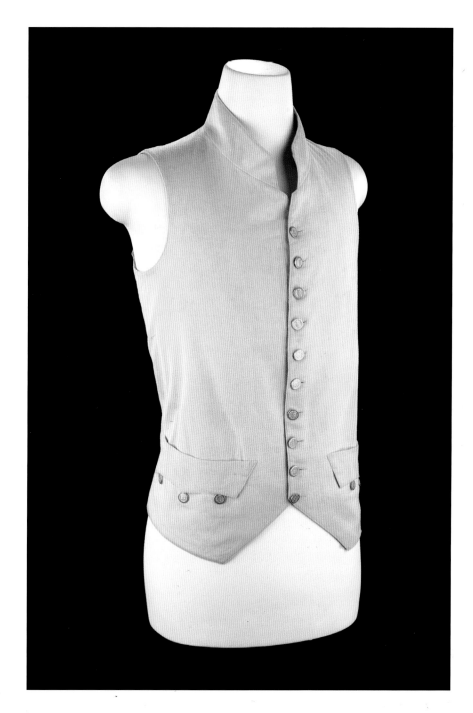

35
Waistcoat, flag officer
Wool, cotton, silk, brass, linen
UNI0095

Single-breasted waistcoat of white wool twill belonging to a flag
officer. The garment is lined with white silk twill and backed
with calico. It is interesting to note that it still retains the three-
pointed pocket flaps, introduced with the 1748 patterns.

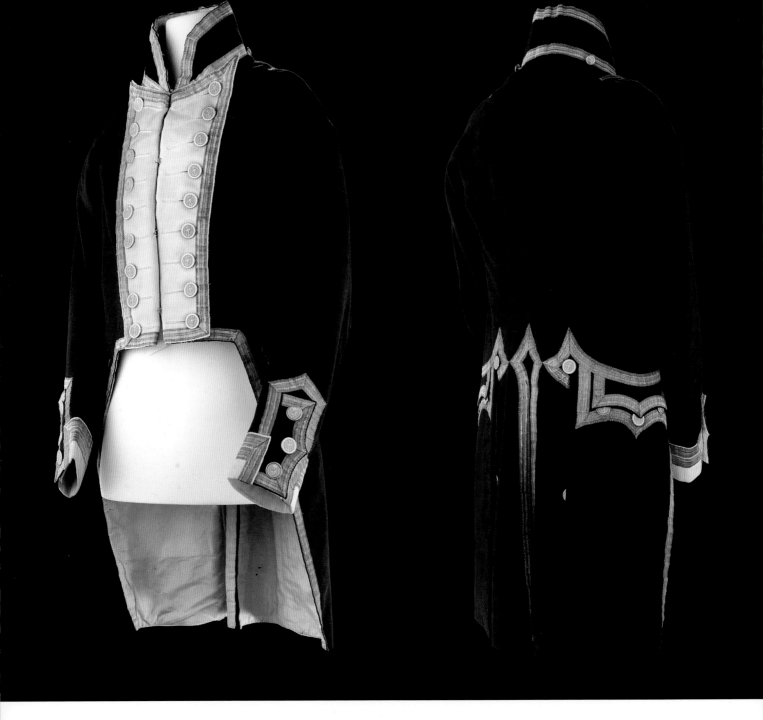

36
Dress coat, captain or commander
Wool, silk, cotton, linen, gilt brass, gold alloy
UNI0096

This dress coat of a captain or commander clearly shows the impact of contemporary fashions on naval uniform. The front is cut straight across in the cut-away style. The lapels are still working, but by this period it was the fashion to stitch them down so they could no longer be unbuttoned. The buttons feature the crown over the fouled anchor which was introduced with the 1812 regulations. Finally, the pocket flaps are non-functional and completely decorative as the pockets are now located in the tails of the coat, concealed by the sword pleats.

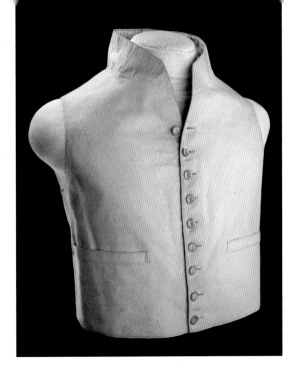

37
Waistcoat, captain or commander
Wool, silk, linen, gilt brass
UNI0104

This single-breasted waistcoat of white wool with a stand-up collar was worn by a captain or commander. It is lined with white silk, and the nine gilt-brass buttons on the front feature the fouled anchor surmounted by a crown which was introduced with the 1812 regulations.

38
Hat, captain or commander
Beaver felt, base metal, gold alloy, brass, linen
UNI0102

An army hat, said to be that of the Royal Horse Guards 1793–1812, but with a naval button. The cocked hat is of beaver felt and the edges are bound in gold lace. The cockade is of black grosgrain ribbon with a picot edge. Instead of the gold-lace loop, there is a band of overlapping metal plates running across the cockade. There are two tassels of gold and blue bullion on the outside corners. It is likely that, since regulations concerning hats were not clear in this period, this is a non-regulation hat with a naval button.

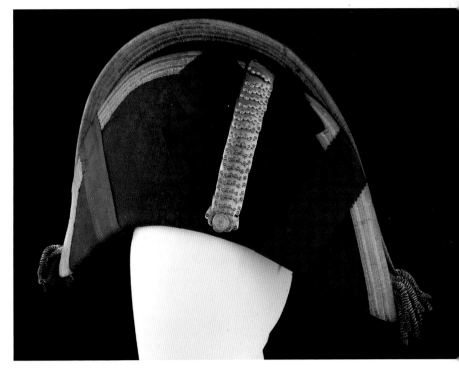

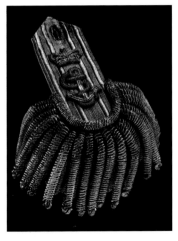
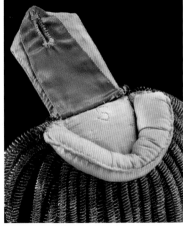

39
Epaulettes, captain
Gold thread, silk thread, sheet metal
UNI0098

Pair of captain's epaulettes belonging to J. Stockham (d. 1814). The regulations of 1812 stipulated that captains should now wear two epaulettes with insignia that indicated their rank: the fouled anchor and a crown. The epaulettes have 20 large bullions and 17 small ones. On the shoulder-pad of each is an embroidered 'S'.

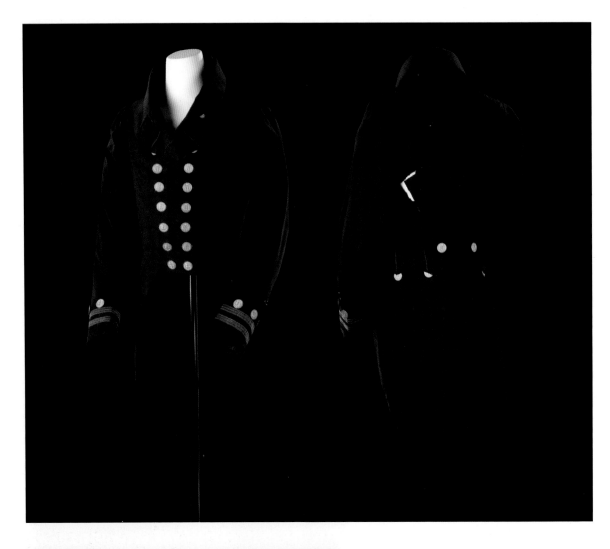

40

Undress coat, vice-admiral
Wool, silk, linen, cotton, gilt brass, gold alloy
UNI0122

Undress coat of Vice-Admiral Sir Edward Codrington (1770–1851), worn at the Battle of Navarino on 20 October 1827. There is a rent under the arm, traditionally said to have been caused by a splinter which smashed his watch. However, the position of the rent would make this unlikely.

By 1825, the style of the full dress uniform had become increasingly fossilized, owing more to the ceremonial garments worn at court. Undress, which tended to keep more in step with contemporary fashions, had also fallen behind, and the style of Codrington's coat clearly echoes the fashions popular in the early years of the 19th century. However, there are fashionable elements such as the full gathered shoulders and extremely fitted waist. Rank is indicated by the two rows of distinction lace on the cuffs.

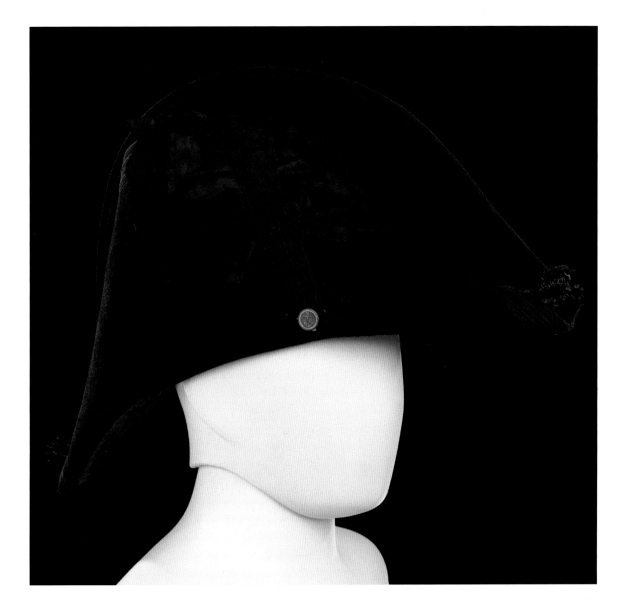

41
Cocked hat, warrant officer
Beaver felt, silk, leather, gilt brass
UNI0137

Beaver felt cocked hat of a warrant officer's pattern belonging to Surgeon James Black. The new uniform regulations of 1825 included the innovation that warrant officers were to have specific insignia on their buttons and embroidered on their collars. The device for a surgeon featured a snake twined around an anchor, which was that of the old Sick and Hurt Office. Unlike the uniform, the button on the hat did not have specific insignia, but featured the fouled anchor on lined ground.

James Black saw very brief active service: he was appointed surgeon in the Royal Navy on 10 September 1810 and served on HMS *Raven* from 26 June 1812 until sometime before December 1815. In 1824, it was noted in the 'Navy List' that he was now a medical doctor and it was during this time that he would have worn this uniform. He retired in 1839 and died in 1868. With the exception of his time on the *Raven*, he spent the whole of his career inactive. It is probable that he had his own private medical practice.

42
Full dress coat, surgeon
Wool, linen, brass, silver alloy, gold alloy
UNI0138

Full dress coat of Surgeon James Black (d. 1868). In 1825, uniform regulations were illustrated for the first time. Other innovations to the patterns included various devices for warrant officers on the collar – as can be seen here with the surgeon's device of an anchor with a snake twined around the stock, which was previously used by the Sick and Hurt Office. The buttons also had the same motif. Officers had to supply their own uniforms and, as a result there are varying degrees of quality, depending on what they could afford. This uniform is very finely tailored and features a quilted vitruvian scroll pattern in running stitch around the inside of the collar.

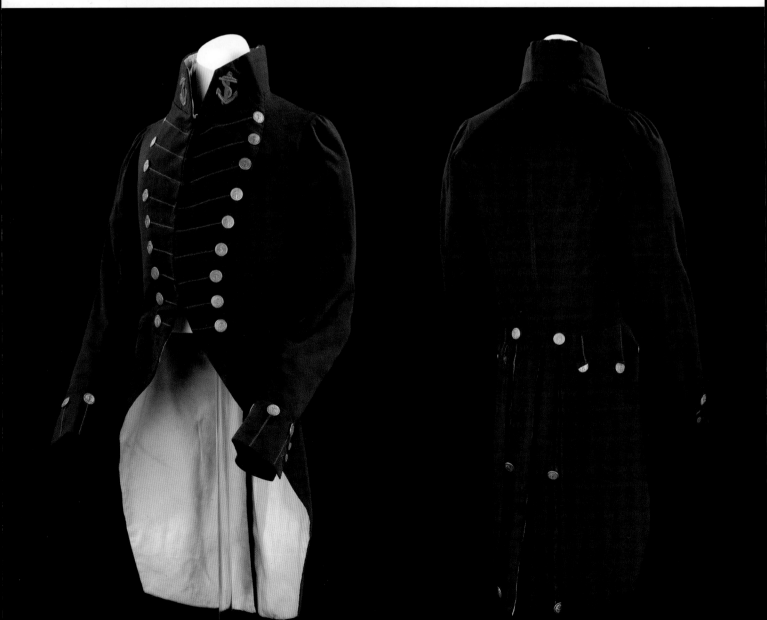

43
Full dress coat, commander
Wool, gold alloy, gilt brass, linen, silk
UNI2851

This uniform was originally made in 1829 by Clancy of Dublin, the sleeves were altered for the 1843 uniform regulations. The primary difference between the patterns of 1827 and those of 1843 is the white slash and blue cuff which feature in the latter. The breast and shoulders of this coat are interlined with a very heavy-gauge felt. The garment is further shaped by a series of lines of running stitch which serve to hold the interlining in place and create the effect of a very rounded chest. Commander Henry Bolton, to whom this uniform belonged, became a commander in 1829 and ended his career in charge of a district in the Irish Coastguard.

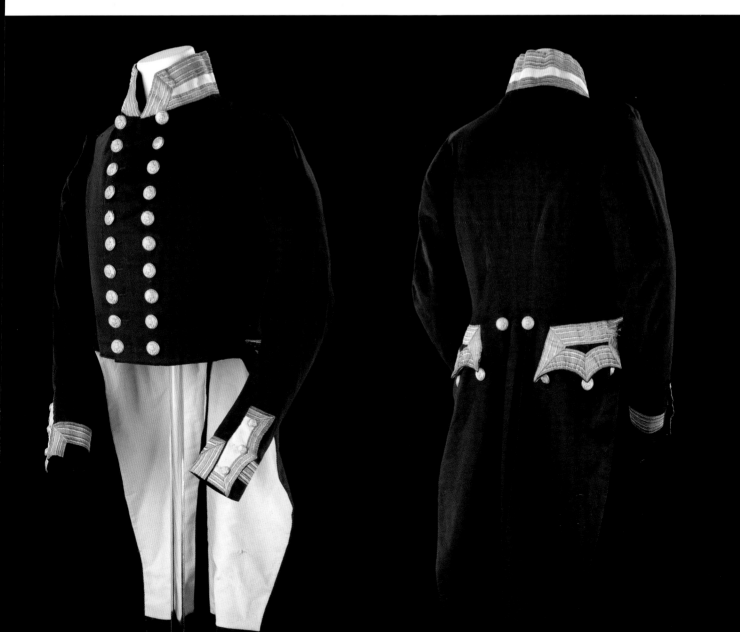

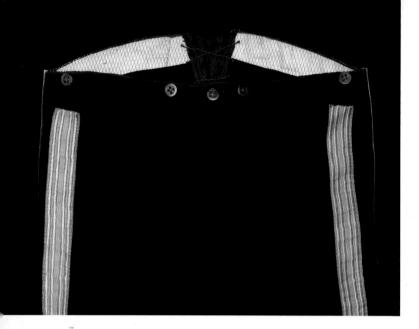

44
Dress trousers, commander
Wool, silk, cotton, wood, gold alloy
UNI2852

Full dress trousers of blue wool. The waistband is lined with glazed, printed cotton and the back has a gusset of black silk. The front has wooden button fastenings with additional wooden buttons to secure braces. On the legs, to the front of both the outside seams are 1½-inch wide stripes of gold lace. There is also a strap of blue wool which secures across the instep to ensure the fit of the trousers.

45
Epaulettes, commander
Gold thread, sheet metal, velvet, wool, linen, gilt brass
UNI3164 and UNI3163

These epaulettes, which have no device, indicate the rank of commander. Introduced into Royal Naval uniform regulations in 1795, the epaulette was, until 1827, a relatively flexible strap of gold lace over very thin sheet metal with loose bullions. The regulations of 1827 introduced the extremely stiff and formal bonnet and crescent, and an additional border of gold purl added to the strap. When binders were originally in use in the late 18th and early 19th centuries, they were sewn onto the shoulder of the coat and the strap of the epaulette was slipped through them. However, the binders on these epaulettes are merely for show, as they are a band of gold lace, backed by blue wool, sewn around the epaulette. Epaulettes were instead secured to the coat by tapes, which ran through corresponding eyelets on the shoulder of the coat.

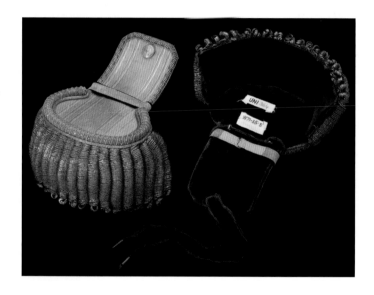

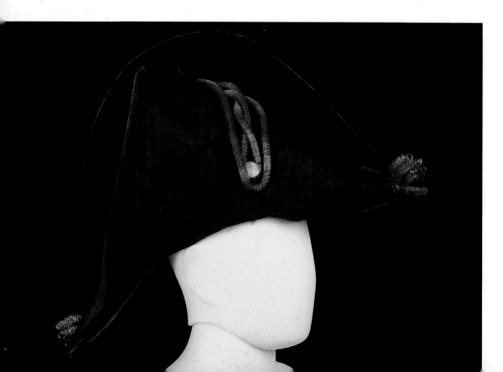

46
Hat, commander
Beaver felt, gold bullion, gilt brass, silk, wood, paper
UNI3162

Large cocked hat of beaver felt, which retains a great deal of the original fur nap. The hat is bound in black silk ribbon which has an oak leaf and acorn pattern. On the front is a large cockade of ribbed black silk ribbon. There are two loops of gold bullion, the central loop twisted. They are secured by a gilt-brass button (a domed button with indented edge with rope-twist border encircling a raised border with a flat top encircling a fouled anchor surmounted by a crown on a lined ground). At the outer edges of the hat on each side are blue silk and bullion knots with five outer gold bullions and five smaller inner ones of blue purl. The crown is lined with cherry-red silk backed with paper and stamped with the following maker's inscription: I. B. & W. Wilson/Manufacturers/London.

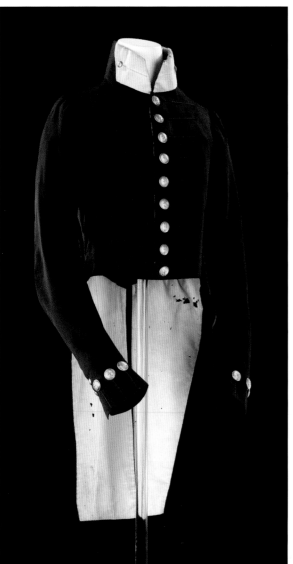

47
Coat, midshipman
Wool, gilt brass, silk, linen
UNI0150

Single-breasted coat with nine gilt-brass buttons. Both the yoke and breast of the coat are interlined with extremely heavy-gauge red wool, which is secured by means of several diagonal lines of running stitch. This serves both to secure the interlining and create the fashionable body shape of a very full chest. This coat also features other fashionable elements such as the gathered sleeves at the shoulders. The way in which the coat is constructed creates the effect of having broad shoulders, a broad, slightly rounded chest and an extremely narrow waist. Further, with such short, slight tails, it also gives the effect of the wearer having very long legs.

This coat belonged to Edward Augustus Down (1818–36) Midshipman, RN. The son of Rear-Admiral Edward Augustus Down, his first ship appears to have been the *Ringdove* and he served in her from 11 December 1833 to 12 May 1836. Shortly afterwards he joined the *Vanguard*, in which he died at Malta towards the end of 1836.

Pattern 1830–1843

48
Undress coat, lieutenant
Wool, linen, velvet, brass
UNI0216

There are two large pockets located in each of the tails; the pocket bag is made of brown silk twill. On the interior of the coat, the under arms and chest have been interlined with fine brown wadding. The yoke across the back shoulders is interlined with squares of blue and white tweed. The tails are lined with blue face-cloth, a plain weave wool with a napped pile, but only over the pocket area. Inside the yoke, sewn over the tweed is a maker's label of printed cotton. It features a large oval with a central reserve cartouche and a deep *guilloche* border. At the small of the back is a rectangular insert of glazed linen which served to reinforce a weak point at the top back vent in the tails. The two front panels of the bodice are also interlined with white buckram.

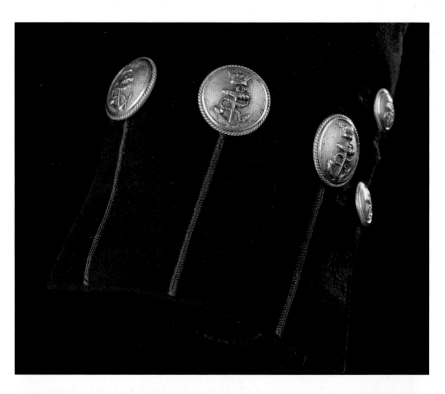

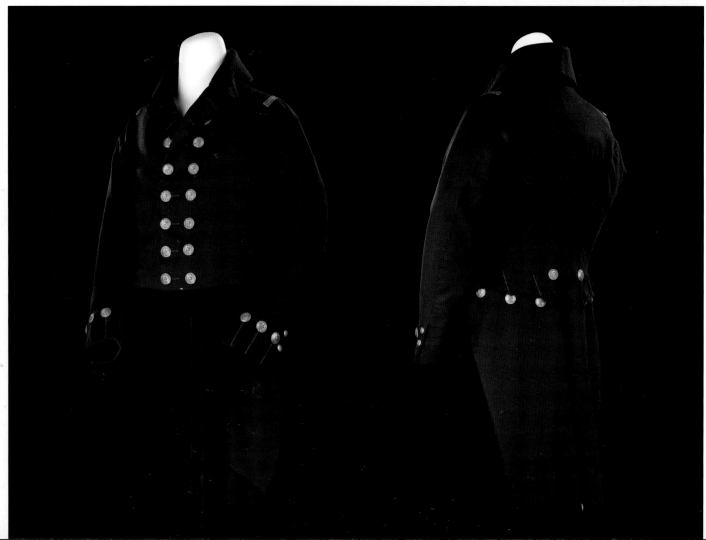

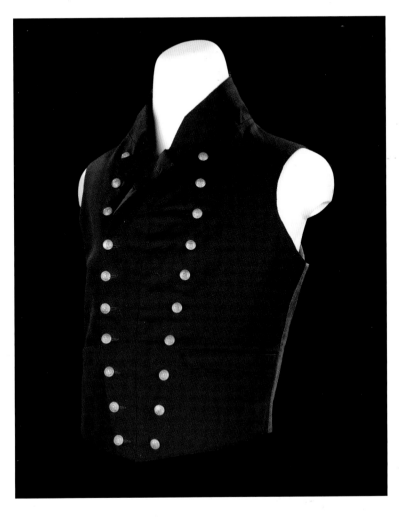

49
Waistcoat, lieutenant
Wool, cotton, brass
UNI0220

Double-breasted blue wool waistcoat of a
lieutenant with stand-up collar. The waistcoat
fastens with two rows of 10 small gilt-brass
buttons. It was meant to be worn with all
buttons fastened, as is evident since the
buttonholes are finished on one side only. There
are two long, shallow pockets in the front lined
with brown linen. The inside of the waistcoat
is lined with a beige cotton twill fabric.
The stand-up collar is lined with blue wool
and bears traces of dirt. At the back of the
waistcoat are four linen tapes for adjustment.

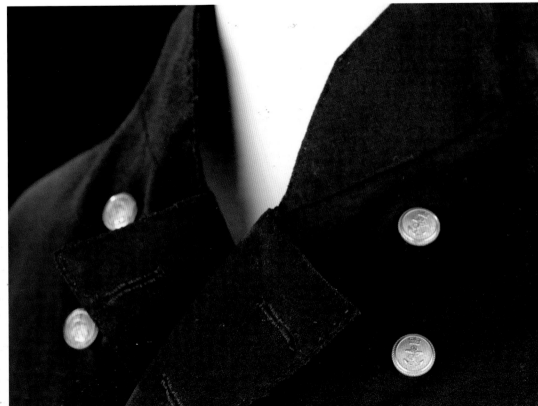

50
Trousers, lieutenant
Cotton, base metal, elastic, linen
UNI0228

Trousers of white cotton twill with a satin finish and a fall front with four metal button fastenings. The flap fastens with two additional buttons. There is a fob pocket in the waistband. There are four buttons along the top for braces. At the back there is one button on either side of the gusset to secure braces. The central back gusset also has two eyelets on either side with cotton tape to adjust the fit. The trousers have tapered legs, with a small vent on the outer seam at the ankle. On the legs, just inside the bottom hems, are four metal buttons (two on each side of the ankle) to which are fixed a black elastic bootstrap. The pocket bags are of heavy white cotton. The front of the trousers are lined with the same material. The back of the waistband is inscribed in ink on either side of the gusset with the laundry mark 'H. James'.

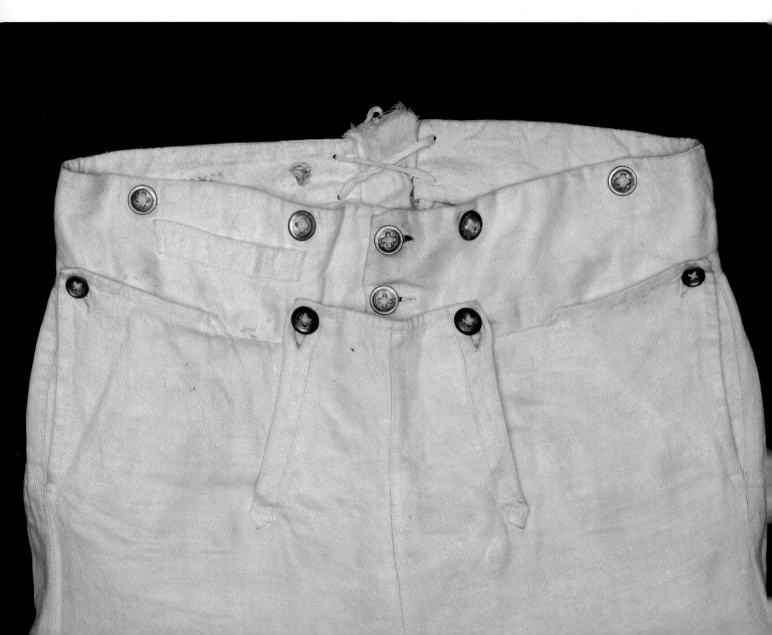

51
Boat cloak, lieutenant
Wool, silk, cotton, base metal
UNI0232

Boat cloak of navy wool, lined in the front with black twill silk. The cloak is gathered at the shoulders into a high standing collar. The collar is reinforced and stiffened with rows of running stitch on the exterior and has a plush lining. The cloak originally fastened at the base of the collar with an eye and tape. There are two cast gilt-base metal bosses on either side of the collar.

52
Full dress coat, purser
Wool, silk, gilt brass, gold alloy, leather
UNI0217

Full dress coat belonging to purser John Lord (joined RN in 1823; d. 1860). Lord became a purser in 1832, after the uniform was changed by William IV from one with white cuffs and collar to scarlet cuffs and collar: the Windsor colours. While commissioned officers and warrant officers were meant to wear what was essentially the same uniform, rank could be discerned by whether the coat was double- or single-breasted, the arrangement of buttons and the width of gold lace on the collar and cuffs, as well as epaulettes. That this is a uniform for a warrant officer is indicated by the single-breasted coat with its grouping of eight buttons in pairs. In addition, the purser would have worn only one full epaulette and one scale (epaulette without bullions). The coat is of blue wool and the skirts are lined in white. The stand-up collar is reinforced with leather, faced with scarlet wool and edged with gold lace. The cuffs are lined in black twill silk, as is the small of the back.

53
Buttons, engineer
Gilt brass
UNI6910

Four buttons showing the design worn by engineers in the Royal Navy between 1841–56. The button, of gilt brass, features a beam engine under a crown on a lined ground. The edge is an outer rope-twist border with an inner border with a flat top. The three smaller buttons were made by R. E. Hayward, while the largest button was made by Firmin.

Pattern 1843

54
Cocked hat, admiral
Beaver felt, gold alloy, silk, gold bullion, gilt brass, wood
UNI0245

Heavily restored cocked hat presented to Charles Napier. Beaver felt bound with gold lace. On each end is a blue and gold tassel. The hat has a ribbed silk cockade and three loops of gold bullion, the central one twisted, over a domed gilt-brass button. The interior of the hat features a blue silk hatband embroidered with running stitch and chain stitch in a *guilloche* pattern with three anchors. The hat is lined with white silk and has a stamped inscription in the crown: 'Presented/To/ Admiral Sir C.Napier/By The/Workpeople/In the Employ of/Messrs. Christys'/Bermondsey Street, Southwark/November 9, 1855'.

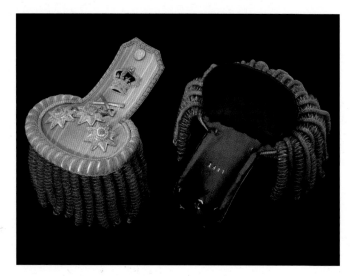

55
Epaulettes, admiral
Gold thread, silver thread, sheet metal, gold bullion, velvet, leather, base metal, wood
UNI0285

These epaulettes are the 1846 pattern worn by Admiral Sir Thomas Cochrane (1775–1860), 10th Earl of Dundonald. They feature a crown worked in velvet, metal and silk thread above a crossed sword and baton in base metal over three stars that have been worked in silver thread, purl and spangles. The crescent is a wood core with gold braid and purl twisted around it to create the alternating dull and bright pattern. The underside features a rigid bonnet covered with blue velvet; the strap is lined with leather and has a gilt stamp to indicate whether it is to be worn on the left or right shoulder. These epaulettes were originally purchased by Cochrane in 1848 when he was appointed Commander-in-Chief of the West Indies. They were altered with the addition of the third star when he was promoted to admiral in 1851.

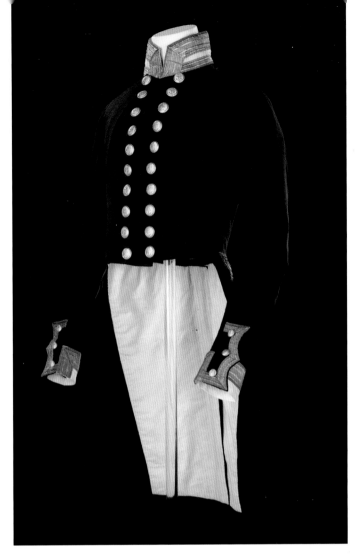

56
Full dress coat, rear-admiral
Wool, gilt brass, gold alloy, silk
UNI2864

Double-breasted coat of blue wool face-cloth, a plain weave wool with a napped pile. The sleeves are gathered at the shoulders and on each shoulder of the bodice are four eyelets for securing epaulettes. The sleeves terminate in a mariner's cuff. The slash is of blue wool edged with gold lace and has three small gilt-brass buttons. The cuff is of white twill wool with a wide border of gold lace. The coat has a stand-up collar of white wool edged in gold lace that fastens with a large brass hook and eye.

The collar is lined with blue wool and reinforced with four rows of running stitch. The breast of the coat is lined with blue wool and interlined with wadding, which is held in place by rows of running stitch. The shoulders have been interlined with extremely heavy-gauge red wool and buckram to give added support to the epaulettes. There is a label sewn into the collar with the following inscription written in ink: 'Coat worn by Captain George Ourrey Lempriere R.N. afterwards Admiral – Served under Lord Nelson at the Battle of Copenhagen in 1801 and under Sir Alexander Cochrane at the taking of Guadaloupe West Indies 1810 d. at Pelham January 16 1864.'

57
Epaulettes, captain
Gold alloy, sheet metal, gold bullion, wood, base metal, silk, velvet
UNI3219

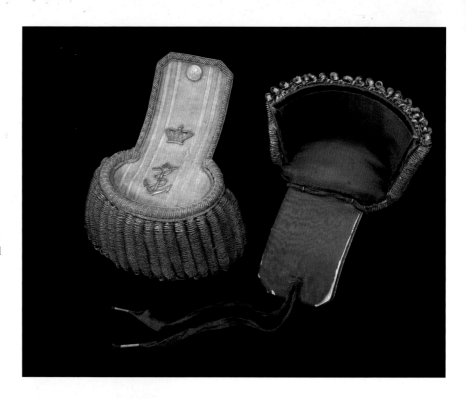

One of a pair of epaulettes marked UNI3219 and UNI3219.1 belonging to Captain G. O. Lempriere. The epaulette is of wide gold lace over sheet metal. The strap is edged with dull and bright twisted purl which is bordered on either side with small, thick twisted gold wire. The crescent is edged with twisted gold purl, alternating dull and bright, wound around a wood core and bordered on either side with bright twisted gold purl. Attached to a bonnet are 20 large gold bullions on the outside and 19 small bullions on the inside. Applied to the crescent is a flat silver-coloured base metal fouled anchor. Above is a silver-coloured base-metal crown embellished with red fabric. At the end of the strap is a small gilt-brass button.

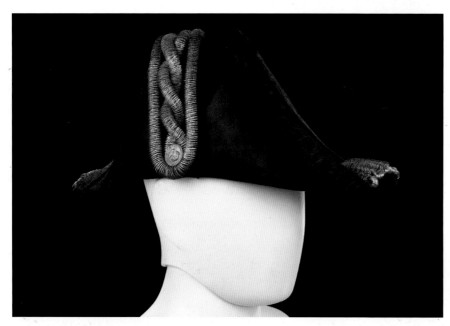

58
Cocked hat, captain
Beaver felt, gold bullion, gilt brass, gold thread, silk thread, silk, paper, wood
UNI0253

Cocked hat in its original metal box belonging to Captain William Hans Blake (d. 1874). The hat is of beaver felt and, in keeping with the regulations of 1843 for the rank of captain, its edges are bound in black silk woven with an acorn and oak leaf pattern. There are two loops of gold bullion, the centre one twisted, which also indicate rank. The loops fasten over a domed gilt-brass button with the insignia of a crown over a fouled anchor. At both ends of the hat are tassels of gold bullion, blue purl over a wood core. The hat is lined with cream silk with the maker's stamp: J. Adams & Son/Late/Batten & Adams/Devonport.

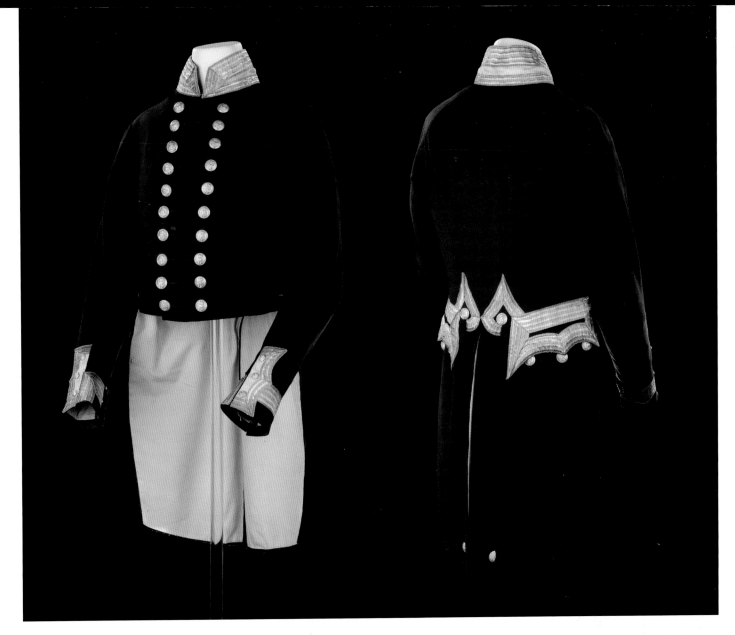

59
Full dress coat, captain
Wool, gold alloy, gilt brass, silk
UNI0262

Full dress coat worn by captain Thomas Lamb
Polden Laugharne (1786–1863). The 1843
changes to the regulations are clearly evident
in the white mariner's cuff and horizontal
stripe of distinction lace on the sleeve. This
coat also reflects changes in fashion, as the
tails are slightly shorter and have more of a
square cut instead of the longer tapering tails
of 1827; in addition, the shoulders do not
feature the full gathers seen in 1827, instead
the sleeves are of a fuller, looser cut and are
not tapered.

Rank is indicated by the width of lace on
the collar and cuffs and by the two rows of
10 buttons.

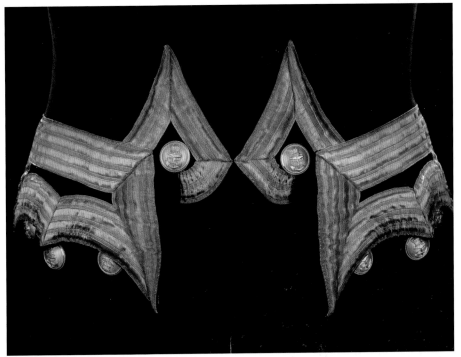

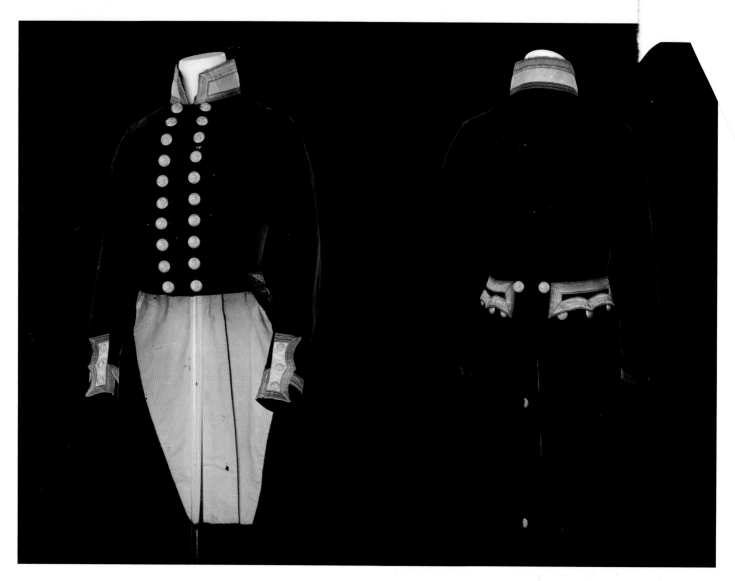

60
Full dress coat, lieutenant
Wool, silk, gilt brass, gold alloy
UNI0269

Full dress coat worn by lieutenant James Saumarez Mann (entered the Royal Navy 1835, d.1851). The fact that Saumarez was a commissioned officer is indicated by two rows of 10 buttons. His rank is indicated by the distinction lace on his sleeve which is narrower than that worn by a captain or commander. Like the coat worn by Commander Henry Bolton (UNI2851 / cat. 43), this appears to have been tailored in 1827 given the tapered tails and gathered shoulders, and the cuffs were altered in conjunction with uniform changes in 1843. Naval uniform was often advertised in papers like *The Times* when it was no longer needed by the wearer. It is possible that Saumarez acquired his in this way or from another officer. Certainly complaints about the cost of uniform, particularly the 1843 patterns with their extra gold lace, were sent to the Admiralty throughout the 1840s.

61
Epaulettes, vice-admiral
Gold thread, silver, leather, velvet, base metal, sheet metal
UNI0288

Pair of epaulettes worn by Vice-Admiral Charles Napier (1786–1860). The epaulettes are of wide gold lace over sheet metal with a padded crescent. The strap is edged with twisted gold purl, alternating bright and dull and bordered on either side with narrow twisted gold wire. The crescent is edged with twisted gold purl and *file* wound around a wooden core. On the strap is a crown of red velvet embroidered with purl and *file* above a metal crossed sabre and baton with two stars of purl and sequins below. There are 20 large outer gold bullions and 18 small inner gold bullions (one is missing). The underside of the epaulette is padded and covered in blue velvet, while the strap is covered in leather with the following stamp in gold: 'Galt & Son/Naval &/Regimental/Tailors/Portsmouth'.

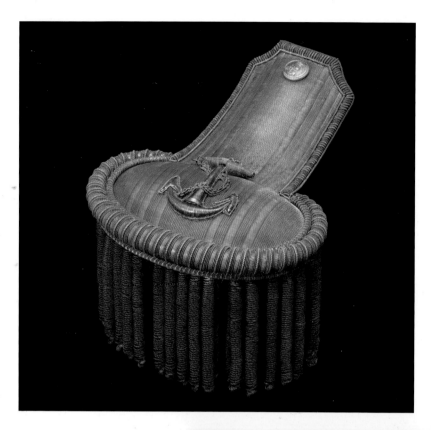

62
Epaulette, mate
Gold thread, sheet metal, base metal, gold
bullion, leather, velvet, silk, paper
UNI3374

Between 1846–56, mates wore a single
epaulette with a silver anchor insignia on their
right shoulder. The epaulette is of gold lace
over sheet metal with a crescent of twisted
gold purl, alternating bright and dark over a
wood core. The silver anchor is of base metal.
It has a double row of 40 loose bullions. On
the underside, the strap is lined with leather,
while the crescent is lined with padded blue
velvet. There is a maker's label on the back
which shows a garter with the motto 'True
und Fest' encircling the following inscription:
'Widdowson & Veale/Goldsmiths & Jewellers/
to H.R.H./Prince Albert,/73, Strand, London'.

63
Cap ribbon, rating
Silk, paint, gilt
UNI1755

Although they would have been worn earlier, cap and hat ribbons were an integral part of the dress of ratings by the 1840s. A portrait of the Prince of Wales in his sailor suit shows him in a sennit (straw) hat with the edges of the ribbon just visible. An illustrated plate of the 1846 regulations shows a seaman in the background, his sennit hat, with a broad black ribbon around the crown, in his hand. In 1857 cap ribbons became part of the regulated uniform for ratings. In the past, sailors painted the name of their ship and various devices on their hats and ribbons. This practice continued, as seen in this cap ribbon of 1852 where the name of the ship and its emblem have been painted and gilded. In 1868, new cap ribbons were introduced with the name of the ship woven into the ribbon using gold wire.

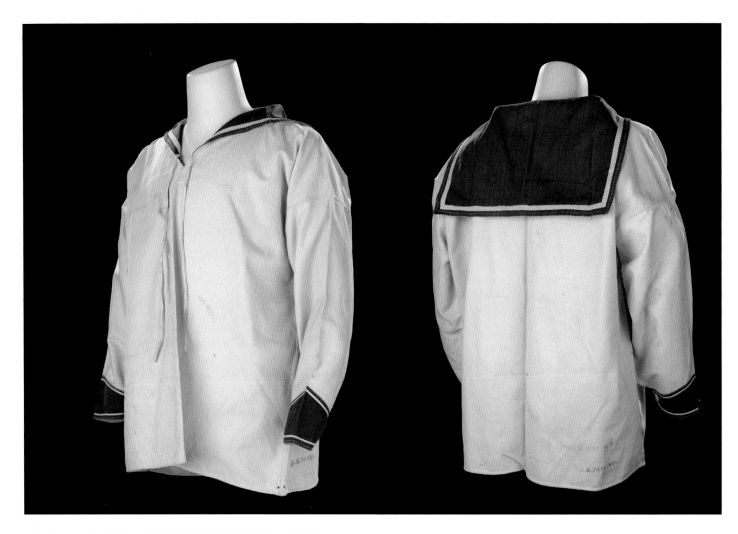

64
Frock, rating
Cotton, linen, metal
UNI3962

Hand-sewn and worn by Joseph Edwin Moore (1841–1920) who served as a seaman from 1854–65. This frock pre-dates regulations and features one row of white tape on each of the cuffs and a row on the collar. It is stamped 'J. E. Moore' at the bottom on each side. There are tapes for fastening a handkerchief at the neck. There is also one eyelet hole at each hip so that the garment can be tied to a washing line.

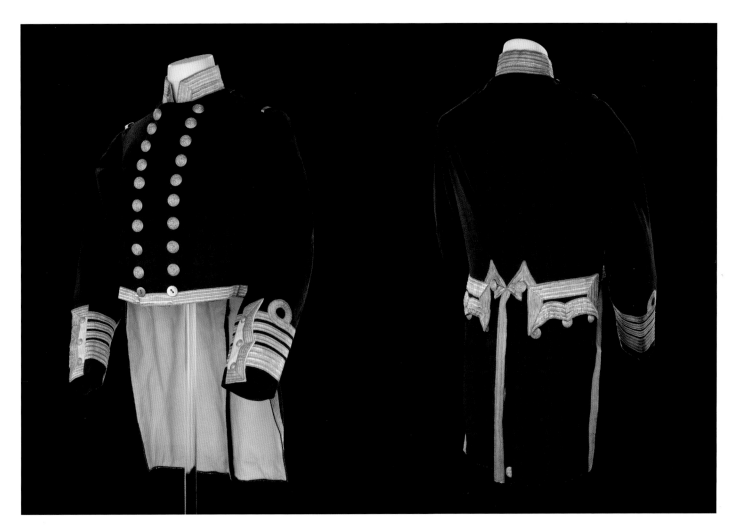

65
Full dress coat, admiral
Wool, gold alloy, silk, brass, gilt brass
UNI0320

Full dress coat worn by Sir Admiral Francis Leopold McClintock KCB (1819–1907). This illustrates the new regulations of 1856, particularly the curl on the top row of lace on the sleeve. Rank is indicated by the width of lace on the collar and cuffs as well as the number of rows of distinction lace on the sleeve. In addition, there is a wide band of gold lace on the three-point pocket flaps. There is further gold-lace edging around the hip buttons and back vent. There are metal binders for epaulettes on the shoulders. The double row of nine gilt-brass buttons indicates that this was the coat of a commissioned officer. The last row of buttons is not regulation, having been left plain because the buttons would have been covered by the sword belt. The tails are lined with white wool and, in keeping with changes in fashion in the mid-19th century, are increasingly square in cut and much shorter than previous regulations.

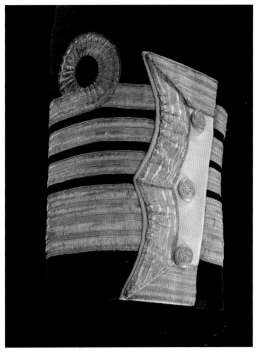

66
Full dress trousers, admiral
Wool, silk, lacquered metal, gold alloy
UNI0311

Pair of full dress trousers worn by Admiral Sir Francis Leopold McClintock KCB (1819–1907). The trousers are of blue wool and the waistband is of black silk. There is a wool gusset that is partially lined with black silk at the back to adjust the fit, and the top of the trouser edges are bound with black silk. They have a fly front with five lacquered metal button fastenings. There are also four buttons in the waistband for braces, and four buttons at the bottom of each leg for a strap which would fit across the instep. Rank is indicated by the 1⅝ inch bands of gold lace that are just to the front of the side seams on each leg.

67
Epaulettes, admiral
Gold alloy, gold thread, silver thread, gold bullion, sheet metal, velvet, silk, leather, base metal, brass
UNI0325

Epaulettes worn by Admiral Sir Francis Leopold McClintock, KCB (1819–1907). The 1856 regulations for epaulettes for the rank of admiral remain unchanged from 1846. They feature a crown above a base-metal crossed sword and baton above three stars embroidered in silver thread, purl and spangles. The epaulettes themselves are of gold lace over sheet metal. The crescent is a wood core with gold purl and thread twisted around it. There are 21 large and 20 small gold bullions on each epaulette. On the underside of the epaulettes, the strap is lined with black leather, and the crescent is padded and lined with blue silk. There are brass clips to attach them to the shoulders, and on each is the stamp 'Landon & Co/7 New Burlington Street'.

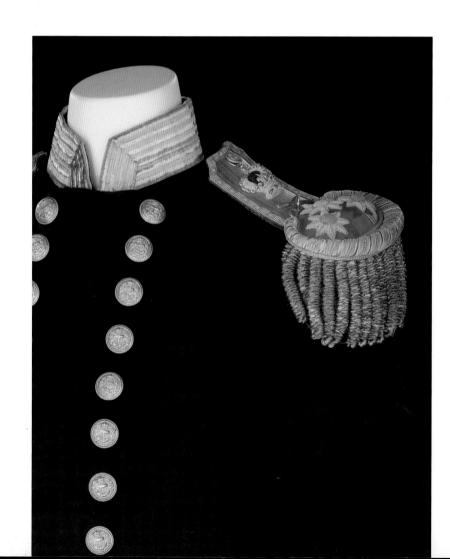

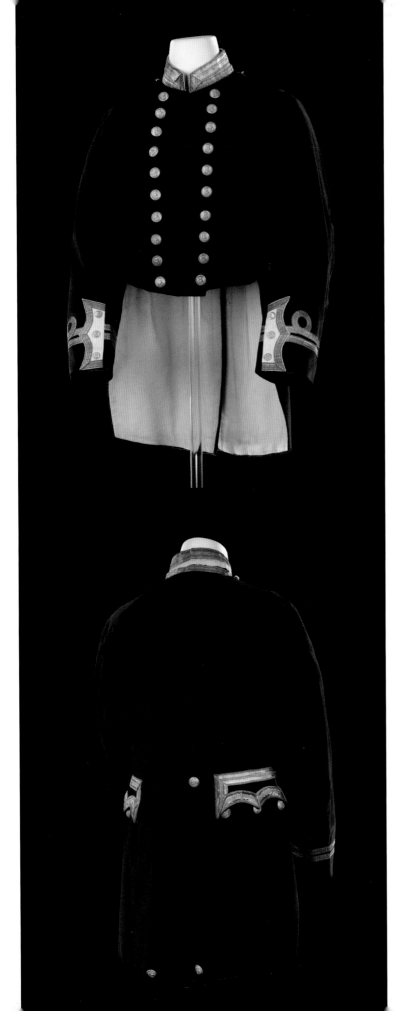

68
Full dress coat, lieutenant
Wool, silk, gilt brass, gold alloy
UNI2880

This full dress coat of a lieutenant illustrates the way in which distinction lace on the sleeves was a way of ascertaining rank. The lace is much narrower (½ inch) than that worn by senior officers. The sleeves feature two rows of lace, the top one with its distinctive curl, and the bottom row which indicates rank. There are two rows of ten gilt-brass buttons. At the back of the coat, a further indication that this is a junior officer can be seen in that the hip buttons are not outlined with gold lace and that the bands on the pocket flaps are again much narrower than those seen on McClintock's uniform (UNI0320 / cat. 65). While the style of the tailcoat may still be based on that worn in 1827, the shoulders have a much squarer cut, as do the tails, and the collar is not as high.

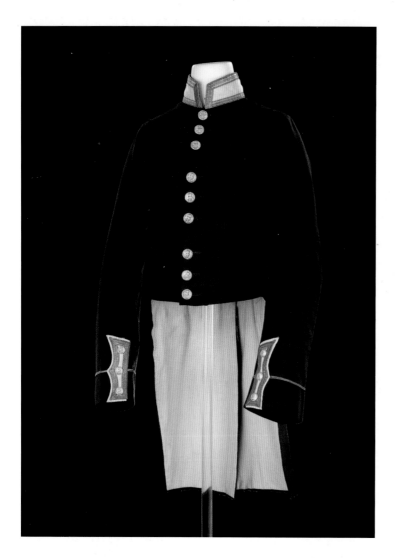

69
Full dress coat, assistant surgeon
Wool, silk, gilt brass, gold alloy
UNI0357

This full dress coat of an assistant surgeon is made of blue wool, while the tails, collar and slash on the mariner's cuff are faced with white wool. His rank is indicated by the single row of nine gilt-brass buttons grouped in threes and the extremely narrow band of gold distinction lace on his cuff. A further indication of his rank can be seen on the back of the coat, where the hip buttons are not outlined with gold lace and there are narrow gold-lace bands on his three-point pocket flap.

Non-regulation accessories and dress and ceremonial garments and accessories

70
Tricorn hat
Beaver felt, silver alloy, gold alloy, brass
UNI0008

By the mid-18th century, the hat was often carried under the arm to avoid the displacement of wigs and hair-powder. This example of a three-cornered hat is of a type of felt called 'half-beaver', which was made by adding beaver hair to felt. The edges are bound in silver lace and the cockade is of a black silk/cotton blend. The gold lace loop and button are of a later date. Hats were not mentioned in uniform regulations until 1795.

71
Shoulder belt-plate, 1794
Brass
UNI1527

This oval-shaped, cast-brass shoulder belt-plate is an example of the type of non-regulation accessory often worn with uniform. The outer edge is engraved with a serpentine motif worked in a combination of bright work and line engraving. The central reserve is engraved with a large fouled anchor enclosed by a double border and surmounted by an imperial crown. There are two sprays of laurel leaves below, bound by a ribbon. On the reverse are the fasteners and a hook above two studs.

72
Shoulder belt-plate, 1794
Gilt copper
UNI1528

This oval-shaped, gilt-copper shoulder belt-plate is an example of non-regulation accessories that were often worn with uniform. The outer edge is worked in bright work to create a repeating serpentine motif. In the central reserve is a large, line-engraved, fouled anchor surmounted by an imperial crown. Above this is the inscription, engraved in block letters 'QUEEN CHARLOTTE 1st JUNE'. Below the anchor is the date 1794.

73
Shoulder belt-plate, 1800
Silver gilt
UNI1531

This silver-gilt, oval-shaped shoulder belt-plate is another example of the non-regulation accessories often worn with uniform. The outer edge is worked with a combination of bright work and line engraving to create a repeating scallop motif. The central reserve is engraved with a large fouled anchor with a slanted stock. The back of the belt-plate features four stud fasteners. It is stamped twice with the maker's mark, 'H. B.'

74
Shoulder belt-plate, 1803
Gilt copper
UNI1535

This oval-shaped, gilt-copper shoulder belt-plate was worn by members of the 1803 Irish Volunteer Corps. The front is engraved across the top with a scroll motif. In the scroll, engraved in block letters, is the inscription 'LOYAL MARINES'. Across the bottom is another scroll with the inscription 'VOLUNTEERS' engraved in block letters. In the centre is a fouled anchor surmounted by a crown with the date 1803. The back of the belt-plate has two hooks and two stud fasteners.

75
Stock
Velvet, silk, gilt metal, linen
UNI0066

This black velvet stock, reputedly worn by Nelson (1758–1805) at the Battle of Trafalgar, is lined with white linen. At one end is a gilt metal buckle with four prongs secured to the stock by means of four corresponding buttonholes. The stock passed around the front of the neck and fastened at the back by means of this buckle. This stock is an example of the type of non-regulation garment worn with uniform.

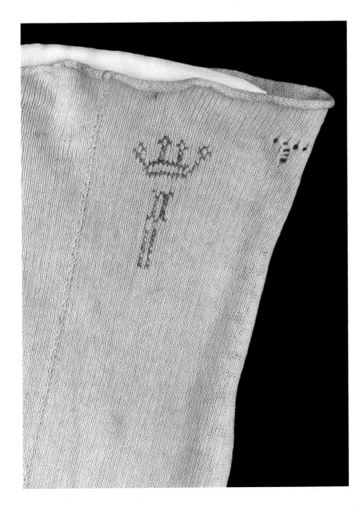

76
Stockings
Cotton, wool
UNI0067

Stockings worn by Nelson (1758–1805) at the Battle of Trafalgar. The stockings are finely knitted using white thread of a cotton/wool blend. At the top, where they would be secured with a garter, on both sides of each stocking is the numeral 'II' below an 'N', underneath a coronet. The toes, sole and heel have been knitted using a slightly heavier gauge of wool that is also slightly darker in colour. This would serve both to reinforce areas that received heavy wear and provide added warmth. The bloodstains are likely to have come from Nelson's secretary Scott, killed earlier in the action.

77

Sword belt, Order of the Bath, 1805

Leather, velvet, silver, gold

UNI0068

Sword belt of the Order of the Bath which belonged to Admiral Sir John Thomas Duckworth (1748–1817). The belt has a central band of blue velvet that has been embroidered with gilt thread in an acorn and oak leaf motif using satin stitch and couching. The buckles feature the badge of the Order of the Bath: a burnished band with the motto in raised letters 'TRIA JUNCTA IN UNO' ('Three Joined in One'), a thistle and rose issuing from a gold sceptre amid three crowns. All mounts are silver gilt and hallmarked London 1805/6. This belt would have been worn with the robes of the Order of the Bath on ceremonial occasions.

78
Shirt, 1807
Cotton, linen
UNI0081

This shirt is an example of the type of non-regulation garment that was worn with uniform. It is a rare survival, and illustrates the cut and style that was fashionable in the early 18th century. The shirt features a high collar, which fastens with two Dorset buttons. A stock would have been worn around the neck so that only the edges of the collar were visible. The full sleeves are pleated which enabled the wearer to fit into the relatively tight-armed coats of the period.

79
Trousers, rating
Ticken
UNI0092

This pair of trousers, made of blue-and-white-striped ticken, are typical of the clothing worn by a sailor in the early part of the 19th century. Ratings did not have an official uniform until 1857; however, they did wear clothing that was instantly recognizable as sailors' dress. In addition to trousers like these, or at an earlier date, petticoat breeches, this also included a checked or striped blouse, waistcoat, neckerchief, and a single-breasted blue coat. Much of this was ready-made clothing known as 'slops' and could be purchased from the purser of the ship in which the sailor was serving.

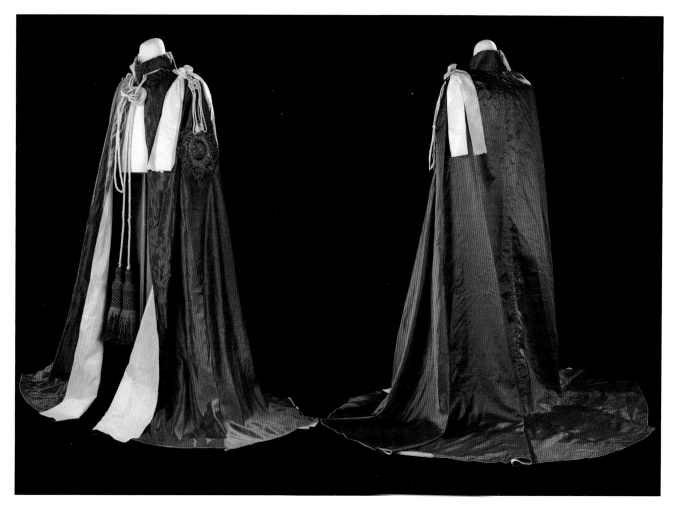

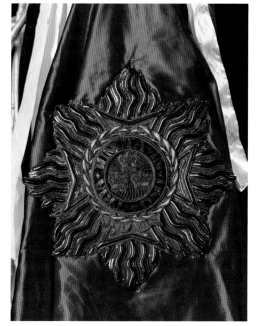

80
Robe, Order of the Bath
Silk, gold thread, silk thread, metal thread, wood
UNI0168

This robe is for a Knight Grand Cross of the Order of the Bath.
The order dates back to the medieval period when, as recorded
in 1399, it featured a ritual bath that symbolized spiritual
purification. The order fell into disuse after the reign of Charles
II (ruled 1660–85) and was revived in 1725 as a military order. It
was enlarged in 1815 with three classes of knights: Knights Grand
Cross (GCB), Knights Commander and Companions (KCB). In
1847 a civil division of Knights Commander and Companion was
introduced for distinguished civilians. The robe is of crimson silk
lined with white and has lacing on the left shoulder, below which
the star of the Order is worn. There are two tassels of crimson
and gold. This robe belonged to Sir Benjamin Hallowell Carew,
who was in command of the *Swiftsure* at the Battle of the Nile
in August 1798. At the height of the battle, the French flagship
L'Orient exploded; Hallowell had part of the mainmast retrieved
and made into a coffin which he sent to Nelson. He was made a
KCB in 1815 and a GCB in 1834. In 1828, he succeeded to the
estates of the Carews and changed his surname.

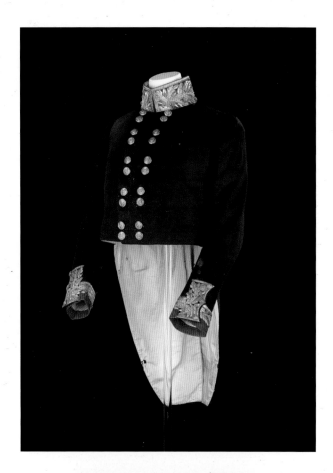

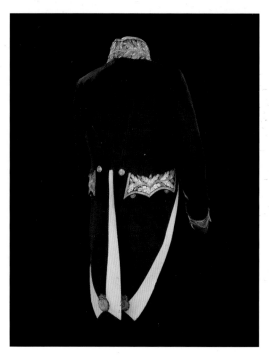

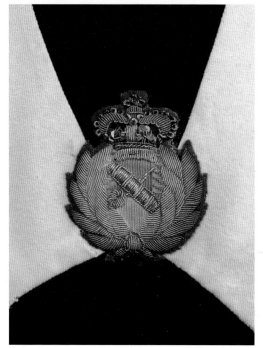

81
Court dress, civil uniform
Wool, silver thread, silk
UNI6979

Civil court dress coat belonging to Sir John Franklin. The double-breasted tailcoat of blue wool has ten silver buttons arranged in pairs. The sleeves are gathered at the shoulders and terminate in a mariner's cuff of red wool, embroidered in silver with a strip above of acorns and oak leaves. The slash is of blue wool heavily embroidered with acorns and oak leaves and has three small silver buttons in the same pattern.

The coat is entirely lined with cream silk twill. The collar is interlined and quilted in a *guilloche* pattern. The yoke and breast are padded and quilted in a series of lines and arcs. There is a central back vent and the tails are edged with white wool to give the effect of a turn-back. There are two badges at the base, both on a ground of red wool. They are embroidered in silver thread and feature a crossed sword and baton circled by laurel leaves and below a crown of red velvet and gold and silver embroidery. By this date, the sword pleats were usually stitched closed. Small openings provided access to the pocket bags, which are of white linen.

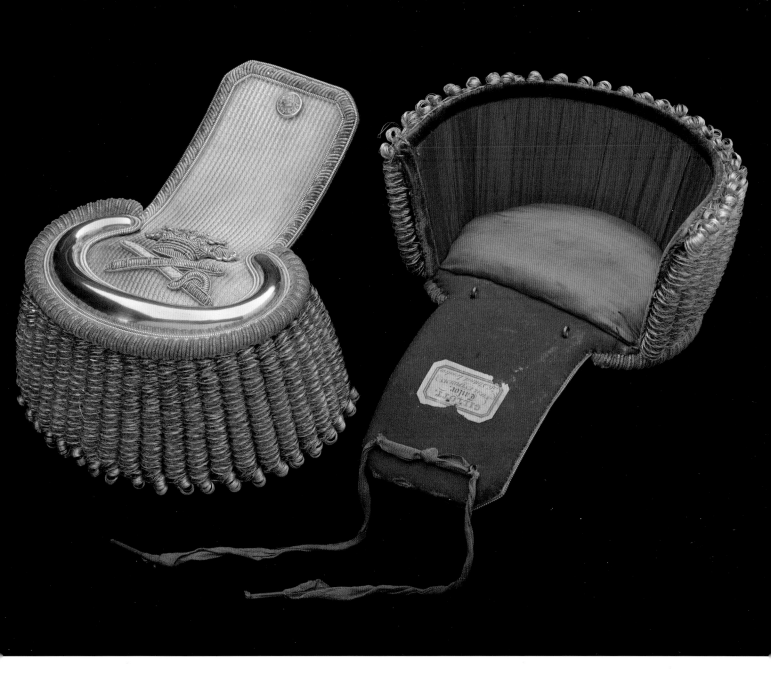

82
Epaulettes, civil uniform
Silver wire, silk, wool, sheet metal
UNI6980

This pair of epaulettes was part of the court dress worn by Sir John
Franklin as Governor of Tasmania. The epaulettes are of silver lace, edged
with a twist of silver purl alternately dull and bright. They feature a very
rigid silver crescent with silver wire edging and inside the crescent is a
crown above a sword and baton, both in silver and gold purl. Twenty-
eight bright silver bullions are fixed over a rigid bonnet. The bonnet is
edged in red velvet and lined in ruched red silk. The crescent is of padded
red silk, while the strap is of scarlet wool with the maker's label: 'Gillott/
Tailor/Naval Uniforms/36 Strand London'. The strap has four metal
eyelets through which tapes passed to secure the epaulettes to the coat.

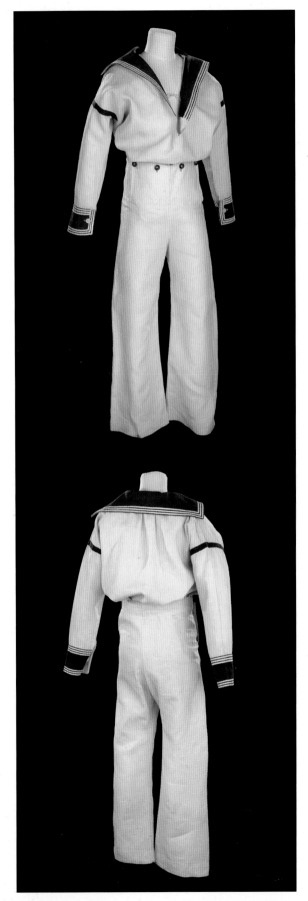

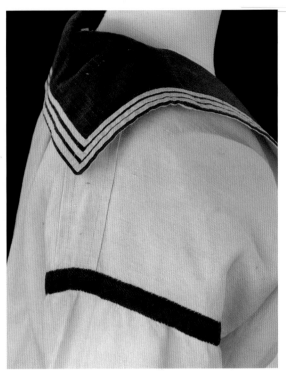

83
Child's sailor suit, 1846
Linen, cotton, metal buttons, mother of pearl
UNI0293, UNI0294

This sailor suit was worn by the Prince of Wales in 1846. It consists of a frock of white linen with side gussets. At the shoulder, encircling the upper arm, are the strips of the watch made of blue-twill tape. The sleeve terminates in a cuff of blue jean edged with three white tapes and fastened with a mother of pearl button. The collar is of blue jean with three white tapes and near the edge of the v-neck are two white tapes on each side to secure the black silk.

The trousers are of white linen with a flap front fastened by four buttons. Behind this flap is a three-button central closure as well as a concealed pocket of white cotton. The flap front is partially lined and this is secured in a decorative arcade pattern of running stitch.

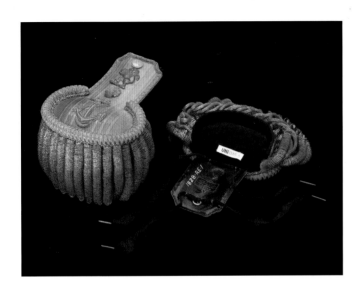

84
Epaulettes, commodore
Gold thread, gold bullion, silver, velvet, leather, sheet metal
UNI0153

One of a pair of epaulettes belonging to Commodore Robert Oliver of the Royal Indian Navy. As the Royal Indian Navy evolved from the marines of the East India Company, the epaulettes featured their insignia. The epaulettes are of gold lace and purl over sheet metal. The bullions are fastened over a stiff bonnet, and the undersides are covered with padded velvet and leather. The underside of the strap has the maker's label: 'WILSON/LATE BODLEY & ETTY/30 & 31 Lombard Street/London'.

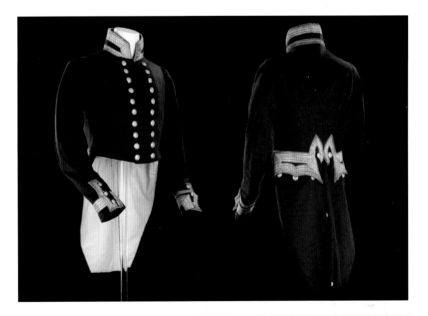

85
Full dress coat, commodore
Wool, cotton, silk, tweed, buckram, linen, brass, gold alloy
UNI0151

Full dress coat worn by Robert Oliver (d. 1848) as a commodore in the Royal Indian Navy. This double-breasted tailcoat is the 1828 regulation pattern, although it was made in 1837, and reflects the fashionable cut of men's clothes in the late 1820s. The sleeves feature a puffed shoulder and terminate in a mariner's cuff edged with gold lace. The cuff also features two rows of distinction lace (the top band of lace is missing on the right cuff). The chest and shoulders have been padded to give a rounded effect, the wadding held in place with rows of running stitch. The tails are lined with white wool. The back of the coat features two three-point faux pocket flaps; the pocket bags are accessed through the tails. The hip buttons are outlined with padded gold lace.

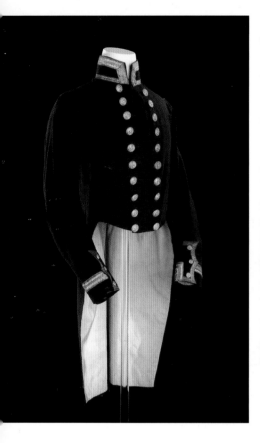
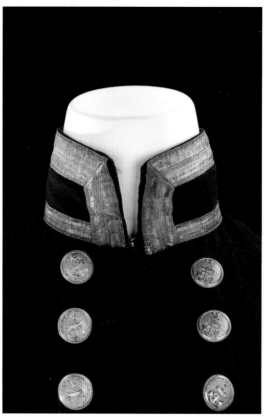

86
Full dress coat, lieutenant
Wool, silk, gold alloy, gilt brass, linen
UNI0152

Full dress coat of Lieutenant Andrew Nisbett, Royal Indian Navy. Double-breasted cut-away tailcoat with very slightly gathered sleeves. Epaulettes would have been secured to the coat through a series of six eyelets on each shoulder, through which tapes would pass. The bodice of the coat is unlined, with the exception of the breast and small of the back, which are both lined and quilted – again to create the fashionable body shape of a full chest.

87
Epaulette, lieutenant
Gold thread, gold bullion; gilt brass, sheet metal, silk, leather
UNI0154

Epaulette worn by Lieutenant Andrew Nisbett of the Royal Indian Navy. The epaulette is of gold lace over sheet metal, the crescent is slightly padded, and the bullions are over a bonnet. The button on the end of the strap features the insignia of the Honourable East India Company, as the Indian Navy was formed from its marines. The underside of the epaulette is lined with padded velvet and leather.

88
Jacket, Honourable East India Company, captain
Silk; metal thread, gilt brass
UNI0165

Single-breasted jacket worn by Captain Alexander Nairne of the Honourable East India Company. The jacket is of indigo-dyed *peau de soie*, a textured silk, with black collar and cuffs of the same fabric. The stand-up collar features two embroidered twists of silver thread on each side. The sleeves are loosely gathered at the shoulder and terminate in a round cuff, which is also embroidered with two silver twists. In the centre of each twist is a small gilt-brass button of the East India Company pattern. Each cuff fastens with a small black self-covered button.

The bodice and collar are lined with cream silk twill and are quilted in vitruvian scroll, interlace and wave patterns. The breast is also padded to create a fashionable rounded effect.

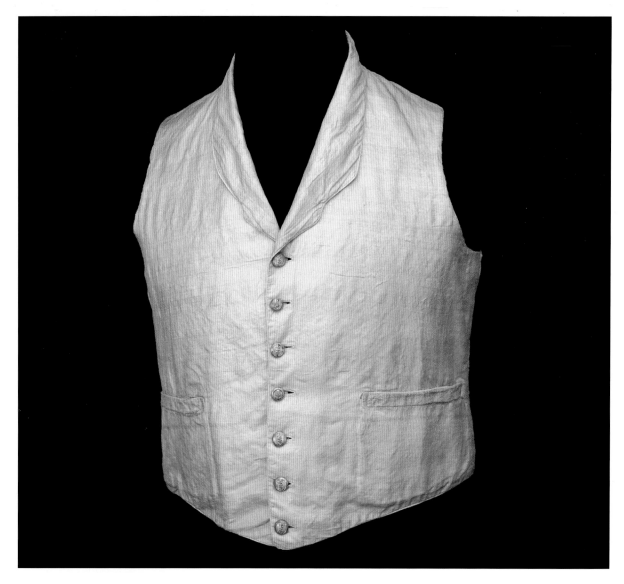

89
Waistcoat, Honourable East India Company
Silk, cotton, linen, gilt brass
UNI0166

Single-breasted waistcoat, with a shawl collar, of white or cream silk interlined with buckram. The waistcoat has seven small domed gilt-brass buttons with the H.E.I.C. coat of arms on a lined ground and surrounded by a narrow, raised border with a flat top inside a rope-twist border. The buttons are fastened to the waistcoat through an eyelet and then secured by a brass pin through the shank. The buttonholes are edged in white thread. There are two pockets on the front, both lined with a white cotton/linen fabric. The front is edged with a fine tabby-weave white cotton piping.

Dressed to Kill

Patterns

**Waistcoat, captain
with over three
years' seniority**
UNI0001

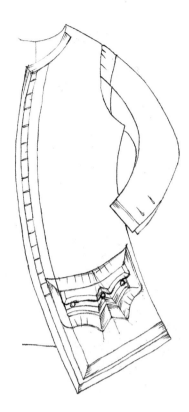

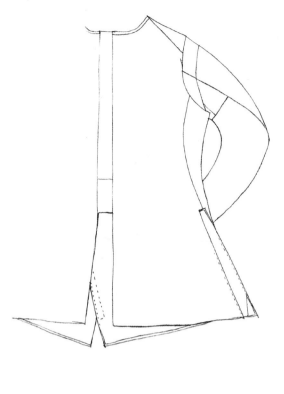

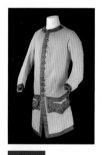

**Waistcoat, captain
with under three
years' seniority**
UNI0002

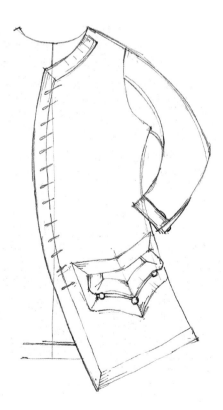

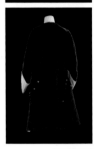

4

**Dress coat,
lieutenant**
UNI0003

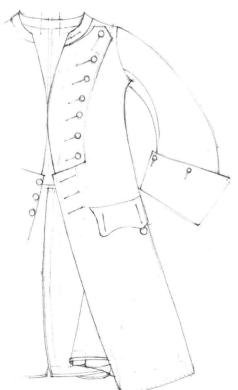

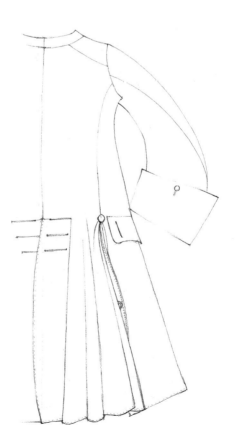

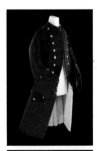

5

**Undress coat,
lieutenant**
UNI0004

6

Waistcoat, lieutenant
UNI0005

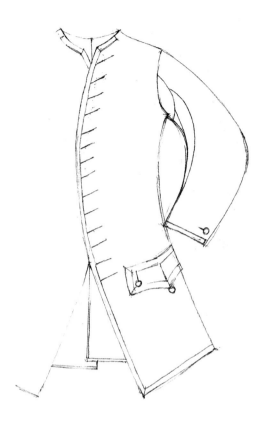

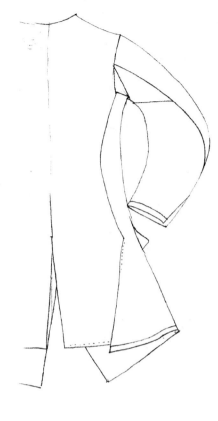

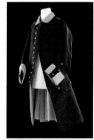

7

Frock, midshipman
UNI0006

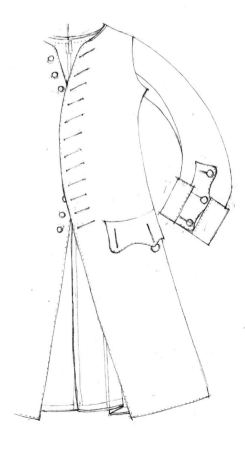

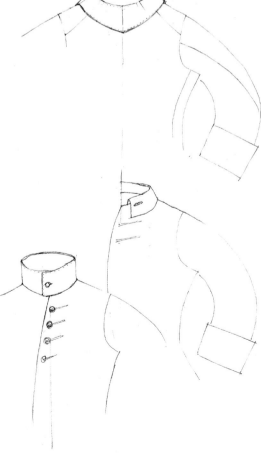

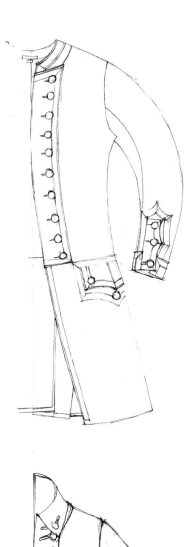

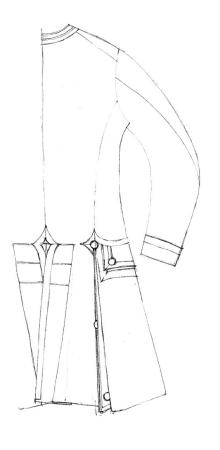

Dress coat, captain
UNI0011

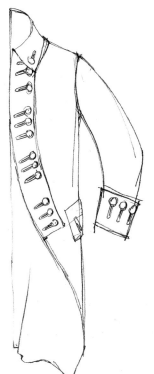

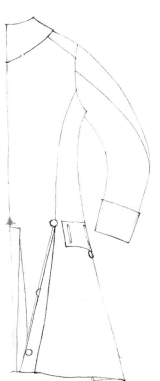

**Undress coat,
captain with
over three years'
seniority**
UNI0012

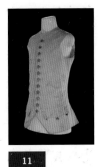

11

Waistcoat, captain
UNI0013

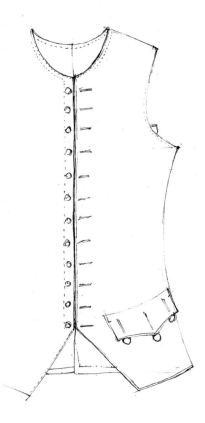

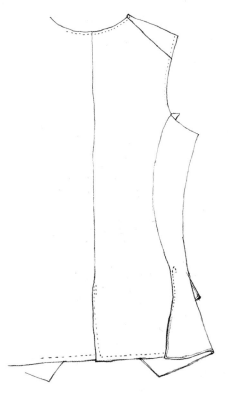

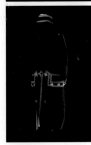

12

**Dress coat, captain
with over three
years' seniority**
UNI0018

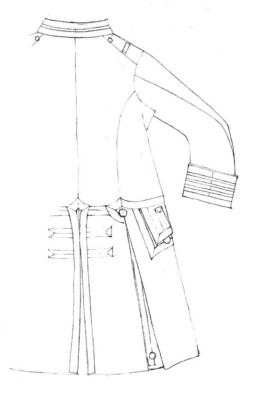

14

Dress coat, admiral
UNI0027

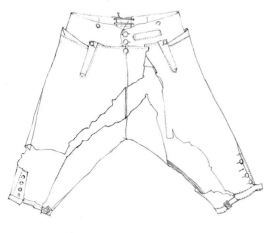

16

Breeches, flag officer
UNI0021

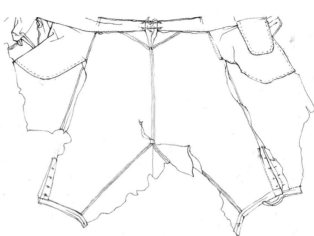

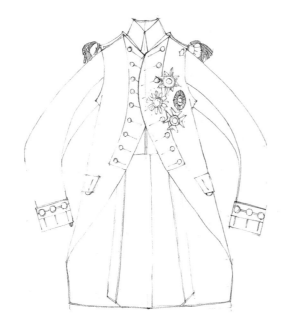
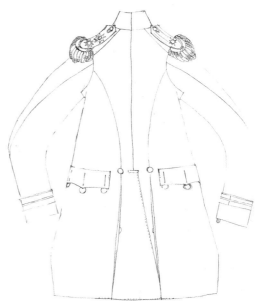

17

**Undress coat,
vice-admiral**
UNI0024

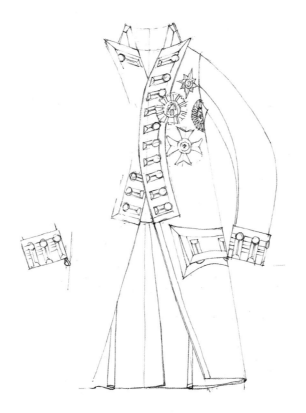
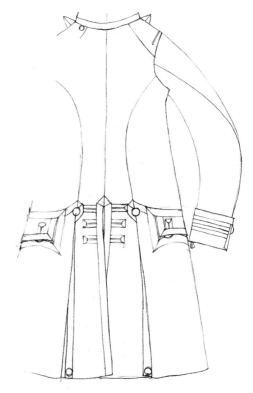

21

**Dress coat,
vice-admiral**
UNI0023

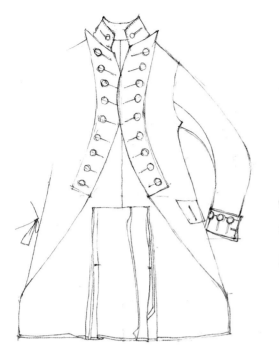

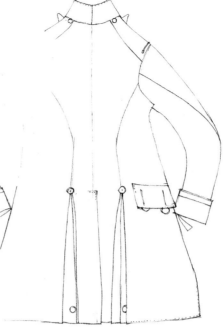

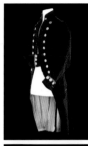

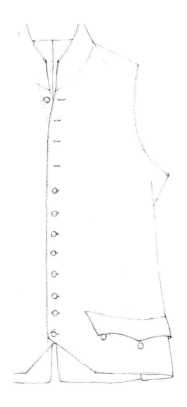

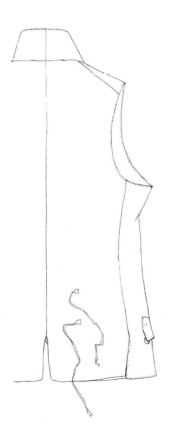

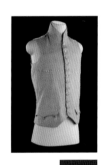

24

**Dress coat, captain
with over three
years' seniority**
UNI0043

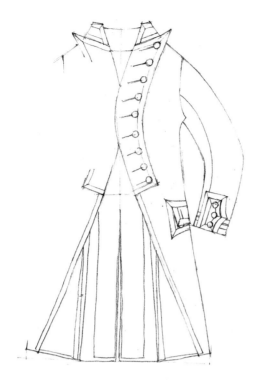

25

**Undress coat,
captain with
over three years'
seniority**
UNI0042

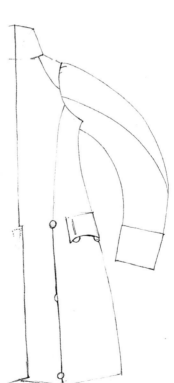

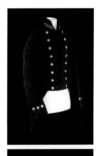

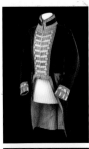

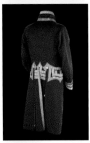

34

**Dress coat,
rear-admiral**
UNI0094

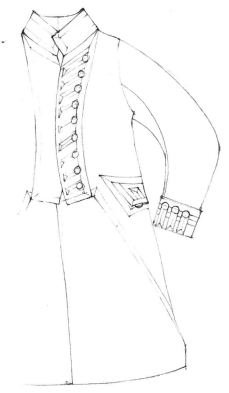

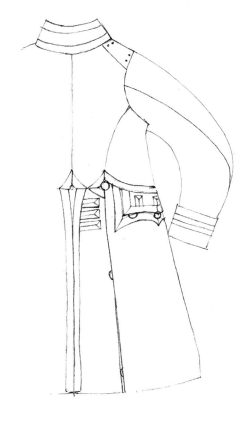

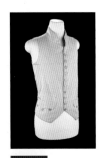

35

**Waistcoat,
flag officer**
UNI0095

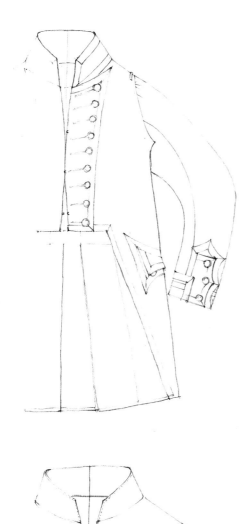

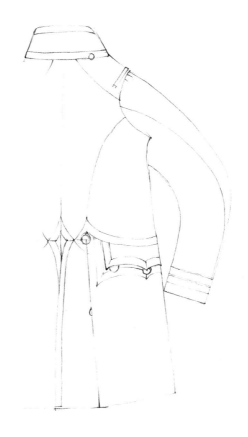

36

**Dress coat, captain
or commander**
UNI0096

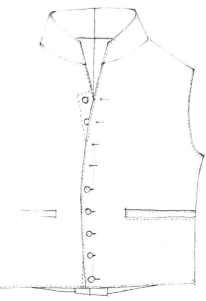

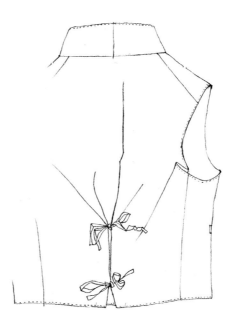

37

**Waistcoat, captain
or commander**
UNI0104

48

**Undress coat,
lieutenant**
UNI0216

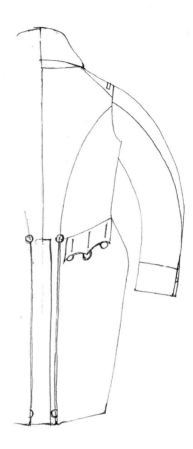

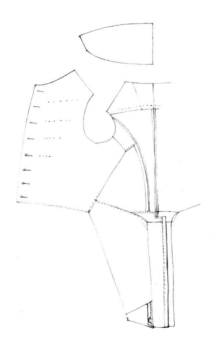

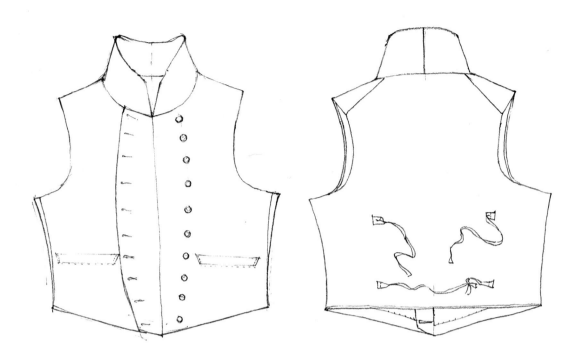

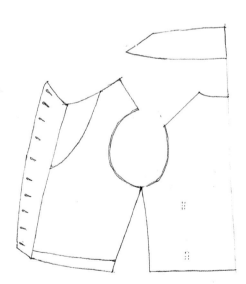

50

**Trousers,
lieutenant**
UNI0228

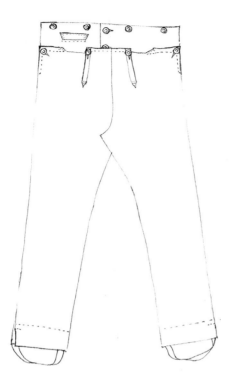

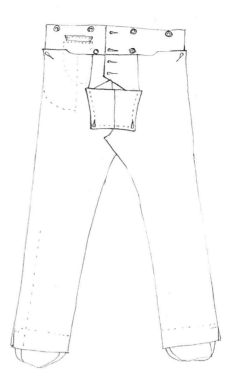

**Boat cloak,
lieutenant**
UNI0232

59

Full dress coat, captain
UNI0262

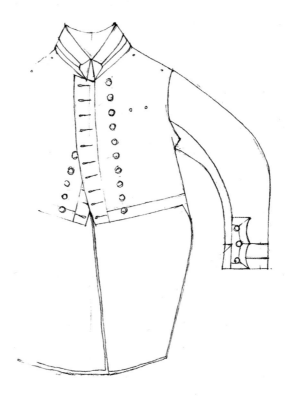

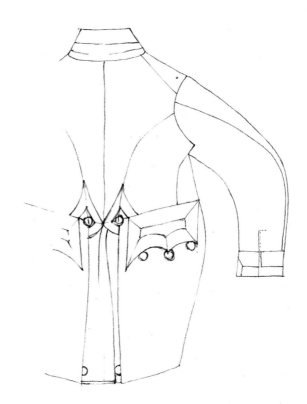

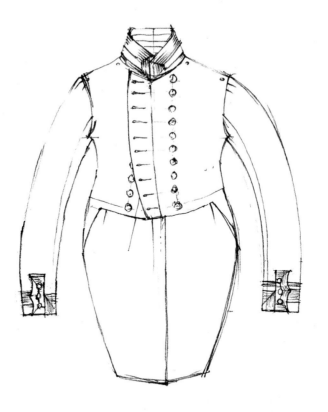

85

Full dress coat, commodore
UNI0151

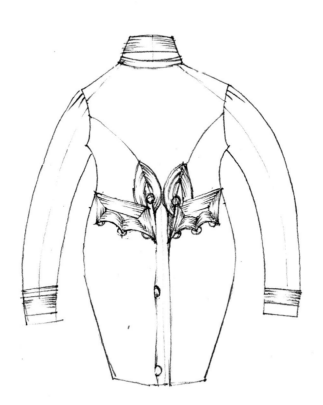

Index

Supporters of the National Maritime Museum*

The Museum gratefully acknowledges the assistance of those listed below:

DEPARTMENT FOR CULTURE MEDIA AND SPORT

Heritage Lottery Fund
Department for Education and Skills

MAJOR DONORS

Lloyd's Register Educational Trust
Science & Technology Facilities Council
ReDiscover
The DCMS/Wolfson Foundation Gallery Refurbishment Fund
The Millennium Commission
The Peter Harrison Foundation
The Weller Settlement Fund
The Weston Foundation
The Wolfson Foundation
Trinity House

DONORS

Tessa & John Manser, Morgan Stanley International Foundation, Bruno Schroder, Society for Nautical Research, John Swire & Sons Ltd, The Art Fund, Arts Council England, The Asprey Family Foundation, The Cowley Charitable Foundation, The Donald Forrester Trust, The Edinburgh Number 2 Charity Trust, The Embassy of Denmark, The William Falconer Charitable Trust, The Friends of the National Maritime Museum, The Haberdashers' Benevolent Foundation, The Headley Trust, The Lord Iliffe, The Inchcape Foundation, The Inverforth Charitable Trust, The Joseph Strong Fraser Trust, The Kirby Laing Foundation, The Leathersellers' Company Charitable Fund, The Leverhulme Foundation, The MacRobert Trust, The Mercers' Company, The Henry Moore Foundation,
The Risby Charitable Trust, The Sackler Foundation, The Basil Samuel Charitable Trust, The Sir John Fisher Foundation, The Tanlaw Foundation, The Vandervell Foundation, The Veneziana Fund, Worshipful Company of Shipwrights

BEQUESTS

Mr P. J. Murray Testamentary Trust

DONORS TO 'A UNIVERSAL APPEAL' TO REDEVELOP THE ROYAL OBSERVATORY, GREENWICH

Michael Brown, Caytrust Finance Company Ltd, James Gaggero, Maxi Gainza, Julia Harrison-Lee, Lady Hardy, Sir David Hardy, Lady Harris, Lee MacCormick Edwards PhD, Dr Robert Massey, John W. Oelsner, Captain C. H. H. Owen RN, David Ross, Patricia Rothman, John Sharman, N. Squibb & Dr L. Mansfield, The Quarmby Fund, The Reeves Charitable Trust, The Shauna Gosling Trust, The Horace Moore Charitable Trust, The Society for Popular Astronomy, David Wells

And all those other donors, too numerous to mention, who have so generously supported the campaign but who wish to remain anonymous.

SUPPORTERS OF THE AMERICAN FUND OF THE NATIONAL MARITIME MUSEUM AND THE ROYAL OBSERVATORY GREENWICH (EIN 30-0190984)

C. Richard Carlson, Edwin Goodman, Lee MacCormick Edwards PhD, John W. Oelsner, The Carlson Family Trust, The Dmitro Foundation, The Gladys Krieble Delmas Foundation

* As of May 2007.

SPONSORS

Accurist, Blackwall Green, The Crown Estate,
Evergreen Shipping Agency (UK) Limited, Farrow & Ball,
John Swire & Sons, Maritime & Coastguard Agency,
National Physical Laboratory

CORPORATE BENEFACTOR

BP Shipping, Evans & Sutherland

CORPORATE MEMBERS

Accor UK, Braemar Seascope, Evergreen Shipping Agency
(UK) Ltd, General Maritime Corporation, Hapag-Lloyd
(UK) Ltd, Liberty Syndicates, Lloyd's Register, Morgan
Stanley International Limited, Shell International Trading and
Shipping Co. Ltd, Swiss Re, The Baltic Exchange, Yang Ming
Marine Transport Corp

ASSOCIATE MEMBER

Cheeswrights

CORPORATE LOAN HOLDERS

Conran Holdings plc – The Orrery Restaurant, Lloyd's of
London, Mandarin Oriental Hyde Park Hotel, Morgan
Stanley International Limited, Pemberton Greenish, Rathbone
Brothers plc, Simpson, Spence and Young Ltd,
The Leathersellers' Company

PATRONS

Dayton Carr, Amelia Chilcott Fawcett, Stephan Frank, Gary
and Beth Glynn, Lady Gosling, Howard and Patricia Lester,
Clive Richards OBE DL, Susan T. Zetkus

First published in 2007 by the National Maritime Museum
Greenwich
London
SE10 9NF
www.nmm.ac.uk/publishing

Text © National Maritime Museum, London, 2007

ISBN: 978-0-948065-74-3

A CIP catalogue record for this book is available from the British Library.

Images (unless otherwise stated) are © National Maritime Museum, London. Images from the NMM
collection may be ordered by writing to the Picture Library, National Maritime Museum, Greenwich
SE10 9NF or online at www.nmm.ac.uk. Please quote the image number provided alongside the
relevant image caption.

Illustrations are also reproduced by kind permission of the following:
© City of London: *figs 4, 9, 11*
© The Bridgeman Art Library: *fig. 49*
Copyright © British Museum: *fig. 34*
Courtesy of The Lewis Walpole Library, Yale University: *fig. 19*
The National Archives, Kew (ADM7/620): *fig. 69*
© 2007 The National Gallery, London: *fig. 62*
© National Portrait Gallery, London: *figs 28, 33, 50*
Platt Hall © Manchester City Galleries: *fig.17*
Scottish National Portrait Gallery, Edinburgh, by kind permission of the Earl of Mar & Kellie: *fig. 26*
© V&A Images, *fig. 24*

Uniform photography: Ben Gilbert, Darren Leigh, Jon Stokes and Tina Warner
Pattern line drawings: Alexander Day

Front cover image: detail of full dress coat worn by captain Thomas Lamb Polden Laugharne
(1786–1863). UNI0262
Back cover image: detail from *Things as they were, 1757. Things as they are, 1827.* H W (engraver),
S W Fores (publisher), 1827. PAF3724

Project Manager: Sarah Thorowgood
Designer: Alex Lazarou
Picture Researcher: Sara Ayad
Production Management: Geoff Barlow